Who Let Them In?

PRAISE FOR *WHO LET THEM IN?*

"What makes *Who Let Them In?* a splendid read is discovering what these pathbreaking women did once they got inside—after pushing past the barriers, physical and emotional, which men put in their way whenever they showed up to write and broadcast sports."—**Melissa Ludtke, award-winning journalist and plaintiff in** *Ludtke v. Kuhn* **(1978)**

"I worked with Joanne Lannin at the *Portland Press Herald* in the 1980s and quickly came to admire her as a dedicated, professional, inquisitive, and thoughtful journalist with a flair for telling stories. All those attributes are on display in her new book. It's an homage to all the women who dreamed big dreams and broke barriers in a world that wasn't as open-minded or welcoming as it should have been. This book is a necessary read for aspiring journalists or anyone with an interest in the history and evolution of the sportswriting profession."—**Jerry Crasnick, senior advisor, Major League Baseball Players Association, and former sportswriter, ESPN**

"It's all here in Joanne Lannin's terrific book, *Who Let Them In? Pathbreaking Women in Sports Journalism*. Read the history of the fearless, authentic, undaunted women who had a passion for sports and the talent to express it. The *Boston Globe* gave Jackie MacMullan and me a chance to do what we loved more than forty years ago, about the time we met Joanne Lannin—we're all grateful for each other."—**Lesley Visser, Hall of Fame sportswriter and sportscaster**

"Jo has given readers a wonderful book that is part history, part storytelling, and all perseverance. This book is an extension of Jo's own journey, and her extraordinary access brings the reader into the careers, hearts, and minds of some of the most impactful women sports journalists of our time. Women who, Jo accurately says, 'stuck it out and climbed the ladder.' Jo Lannin's due diligence shows in tremendous fashion, and the result is a marvelous, impactful book."—**Ann Schatz, veteran sports broadcaster and speaker**

"Chances are you know all about Jackie MacMullan, Lesley Visser, and Suzyn Waldman. But now, thanks to Joanne Lannin, we have an opportunity to learn more about Mary Garber, Claire Smith, Karen Guregian, and other women sports journalists who refused to accept the press box as a male domain. Lannin's writing is lively, anecdotal, and, yes, important."—**Steve Buckley, senior writer, the** *Athletic*

Who Let Them In?

Pathbreaking Women in Sports Journalism

Joanne Lannin

ROWMAN & LITTLEFIELD
Lanham • Boulder • New York • London

Published by Rowman & Littlefield
An imprint of The Rowman & Littlefield Publishing Group, Inc.
4501 Forbes Boulevard, Suite 200, Lanham, Maryland 20706
www.rowman.com

86-90 Paul Street, London EC2A 4NE, United Kingdom

British Library Cataloguing in Publication Information Available

Library of Congress Cataloging-in-Publication Data

Names: Lannin, Joanne author.
Title: Who let them in? : pathbreaking women in sports journalism / Joanne
 Lannin.
Description: Lanham, Maryland : Rowman & Littlefield, 2022. | Includes
 bibliographical references. | Summary: "A timely and eye-opening look at
 women in sports journalism, this book provides valuable insight on the
 obstacles women have had to overcome in order to succeed within the
 'masculine' world of sports and the challenges they continue to face
 today. The stories of their struggles are at times infuriating, at times
 triumphant, but always compelling"— Provided by publisher.
Identifiers: LCCN 2021042407 (print) | LCCN 2021042408 (ebook) | ISBN
 9781538161449 (cloth) | ISBN 9781538161456 (epub)
Subjects: LCSH: Women sportswriters—United States—Biography. | Women
 sportscasters—United States—Biography. | Sexism in sports
 journalism—United States.
Classification: LCC GV742.4 .L36 2022 (print) | LCC GV742.4 (ebook) | DDC
 070.4/49796—dc23
LC record available at https://lccn.loc.gov/2021042407
LC ebook record available at https://lccn.loc.gov/2021042408

To all the little girls who dream big dreams
and don't take no for an answer

Contents

Contents

Foreword

Most groundbreaking women I know didn't wake up one morning and declare, "I want to be a pioneer when I grow up." It happened organically, usually from chasing a dream that required uncommon courage, passion, and a healthy dose of resilience. That last virtue comes in particularly handy when a host of naysayers try to tell you—again and again—that your hopes will go unrealized and that your efforts are not welcome, not now, not ever.

I didn't know about any of that when I was ten years old. All I wanted to do was play street hockey with the guys. Our rules were simple: Report in a timely fashion to the flat part of the pavement on Stanford Drive, stick in hand, and you had dibs on the morning's first game. I was the only girl, but nobody seemed to care until one day an older boy from the city moved to our suburban neighborhood and declared that I was out and he was in. "No girls!" he sneered. "She doesn't belong here."

My neighbors—my friends—turned around and studied me, as if they were seeing me for the very first time. Did I imagine a moment of hesitation? After all these years, I can't be sure. Thankfully, the retort was satisfactory: "She's okay. She's one of us."

I stayed, I played, and I absorbed a series of cheap shots from our newcomer: a hip check, a kick in the shin, and then finally the not-so-subtle whack of the stick across my knuckles, the blood pooling between my fingers as my tears formed. "You gonna cry?" the boy taunted me. Yes, I would—later—when my hand began to swell and my raw, red wounds began to throb. But not in front of him. I would not give him the satisfaction.

The bully moved away after a year. By then he'd grown tired of antagonizing me, because it was clear I wasn't going anywhere, especially after my dad bought me a net for my birthday, which amounted to a street hockey golden ticket in those days.

When I think back on that experience, it reminds me of the indignities the women in *Who Let Them In?* have endured. They pursued what they loved, excelling in their field, and yet there always seemed to be someone who wanted them gone. Excluding us simply based on our gender made absolutely no sense, and the harassment that ensued was cruel, unnecessary, and, quite frankly, heartbreaking.

That's why the buoyancy exhibited by Mary Garber as a young journalist in the 1940s and '50s, navigating her career amid an avalanche of detractors, has long been cherished by every female sports scribe. Garber remained steadfast in honing her profession, regardless of how she was treated. Some ignored her, others tried to humiliate her, and she was, at various points of her career, barred from the press box, the locker room, and the "old boy" inner circle. And yet, over time, the subjects she covered grew to trust and respect her. Why? Because Mary Garber was damn good at her job.

Garber wasn't thinking about making history when she joined the ranks of a male-dominated field. She was merely tapping into something that resonated with her. The same held true for Claire Smith, who became enamored with Jackie Robinson as a young girl, then blazed trails, as he did, as a young Black baseball reporter. Susan Fornoff loved baseball, too, and deserves to be recognized as a fearless and insightful writer, not the victim of a neanderthal stunt from the boorish Dave Kingman. Each of their stories, so poignantly chronicled by Joanne Lannin, is a glimpse into a movement that slowly, steadily, changed the landscape of journalism as we know it.

There's a kinship among women who love sports and crave competition. We can immediately identify it in one another. I was never happier as a child than when I was sitting next to Dad, watching Jack Nicklaus sink a putt, Billie Jean King finish off a cross-court winner, or goalie Gerry Cheevers of my beloved Boston Bruins skate the length of the ice with the puck, even as my dad and I roared, "What's he doing??!!"

My father was a traveling salesman and a newspaper junkie, so when he came back from his New York swing, I'd devour the sports sections of the tabloids tucked under his arm. I can't recall exactly when I decided, "Maybe I can do this . . ." but when I became a sports journalist, I discovered the women I encountered in the business had experienced similar epiphanies.

Our solidarity in those early years helped deflect the weight of that pit in our stomach when yet another "incident" unfolded. We all experienced

them: mine included everything from a security guard physically removing me from a college locker room to an All-Pro NFL player berating me with sexually explicit insults for having the nerve to ask a question. None compared to the threatening letters mailed to my home address, anonymously, specifically including the names of my two young children.

Those of us who survived these onslaughts quietly compared notes (and scars), offered support, then moved on.

The world is much different today. Our business is flooded with bright, young, inquisitive female sports journalists and broadcasters. There is strength in numbers, and they do not stay silent if they have been harangued. They demand accountability and often receive it. Their voices resonate.

Their power and their credibility have sprouted from the seeds planted decades before them, by women who would not be broken by ignorance or discrimination, who exhibited enormous strength even though they were always outnumbered.

Their stories matter. And now, finally, they will be told.

—Jackie MacMullan

Acknowledgments

The suggestion that ideas visit us and invite us to develop them has resonated with me ever since I read Elizabeth Gilbert's *Big Magic: Creative Living beyond Fear*. So when the idea of writing about women in sports journalism came knocking, I paid attention. I envisioned the book as a chronicle of the progress women have made over the last forty years, and, as in my last book, *Finding a Way to Play: The Pioneering Spirit of Women in Basketball*, I hoped to bring these women and their stories to life.

Despite believing there was a story to tell, I wasn't convinced that I was the one to tell it. Then I talked to Jackie MacMullan, and during our conversation she said, "This is the perfect book for you to write" (or something to that effect). It felt like an observation Don Murray, our shared mentor at the University of New Hampshire, might have made. Her words convinced me that I could pull it off and kept me on course when I felt my confidence wane. I'm also indebted to Jackie for agreeing to write the foreword to this book. She's without peer as a writer and storyteller.

The hardest part of any project is getting started. I made the right choice in calling Melissa Ludtke and scheduling her as my first interview (and my last in-person interview, thanks to COVID). Melissa was generous with her time and so open to my questions—even though she is writing her own book about her experiences (which I can't wait to read). In the ensuing months, she has provided me with phone numbers, e-mail addresses, and photographs, and she was generous enough to make suggestions for ways to improve parts of the book.

Christine Brennan is among the busiest people I know, but when I e-mailed her, she responded almost immediately, giving me ideas for

people to talk to and pledging to help me in any way she could. Lesley Visser also pledged her help early on. Every time I talked to her, I came away energized and enthused all over again.

Rachel Lenzi, a former colleague at the *Portland Press Herald*, was invaluable in suggesting people to talk to and helping me get in touch with them. Rachel also suggested ways to find photos for the book. Subsequently, photographer Arianna Grainey generously provided me with the key to her archive of photos taken at several recent Association for Women in Sports Media conventions. Going through them all was like being a kid in a candy store.

I also want to thank Marie Hardin, the dean of the Donald P. Bellisario College of Communications and a professor of journalism at Penn State University, for sharing her research with me. Special thanks go to all the other pathbreakers who took the time to talk to me, especially Claire Smith, Lisa Nehus Saxon, Andrea Kremer, Karen Guregian, Paola Boivin, Reina Kempt, Iliana Limón Romero, Amber Theoharis, Gina Mizell, Amie Just, Kate Scott, Betsy Ross, Ann Schatz, and Suzyn Waldman. They shared so much of themselves during our talks and they helped me improve the narrative and make sure I got everything right.

I'm grateful to the people who willingly read the book in its various forms. The Fairchild Gang, women I have known since college, were excited to read the chapters as I wrote them. Linda Trenholm, Gloria Leveillee, Carol Stiles, Susan Kasprak, and Cindy Haudel-McNeil were my cheerleaders during our weekly Zooms throughout the writing process. Carol, a former librarian, dug up some valuable information about the pioneers of women's sports journalism in Australia, where she lives now.

Allen Lessels, an assistant sports editor when I was writing sports for the *Portland Press Herald*, came out of retirement to comb through the text and save me from myself several times. He also encouraged me to expand on certain points, as he did so often when we worked together. The book is better for his insights.

My twin sister, Madeline Lannin-Cotton, was relentless in going over every word of the manuscript in its final stages—twice. She also told me when I needed more details, and she helped me hash out ways to liven up the narrative. We talked almost daily about the ups and downs of reporting, researching, and writing this book. She also created the index, for which I will forever be in her debt.

When I married my husband, Rik O'Neal, thirty-seven years ago, I knew I was marrying someone whose advice I could depend upon. I didn't know he would also be a combination IT guru/personal counselor. He solved my technical problems time and again and supported me whenever I lost a file, couldn't navigate the latest version of Microsoft Word, or just generally felt that my project was doomed. His suggestions

for changes to the text were also perceptive and helpful. That he did all this while in the hectic final stages of his own documentary film project still amazes me.

I also want to thank Christen Karniski, my acquisitions editor at Rowman & Littlefield. A former professional soccer player, she excels at teamwork and collaboration. She and her assistant, Erinn Slanina, along with production editor Jessica McCleary, were respectful and flexible throughout the process of creating this book. I am grateful for their willingness to always keep me in the loop and for the enthusiasm they showed right from the very beginning.

Finally, I'd like to thank Andy Merton, the professor at UNH who pushed me to be the writer he knew I could be, as well as Dave McNabb, the sports editor who hired me and championed my efforts so long ago. Without them, this book may never have come into being.

Introduction

Growing up in the 1960s and '70s, I was a tomboy through and through. My twin sister and I spent countless hours on our asphalt driveway, perfecting our bank shots off the backboard nailed to our garage (just like Celtics sharpshooter Sam Jones). We played catch with our dad, touch football with our brother, and pickup basketball games with the neighborhood boys. We'd perch a transistor radio on the lip of the bathtub so we could listen to the Boston Bruins while we took our Saturday night bath. On Sunday afternoons, we were glued to the TV set for the Red Sox doubleheader.

A lover of books and the written word, I devoured Bob Ryan's Celtics columns and Peter Gammons's baseball notes in the *Boston Globe* sports section every Sunday. But like most girls growing up before the women's movement, writing about sports was never on my radar. I came from a family of teachers and felt quite sure that teaching English and coaching basketball at the high school level was the best I could do to combine my love of sports and the written word.

I suppose I could have seen the handwriting on the wall if I'd looked hard enough. When the spirit moved me, I often took pen to paper to voice my thoughts. The first time I saw my name in print was on a letter to the editor of my campus newspaper complaining about the dearth of coverage afforded my women's varsity basketball team at the University of New Hampshire. The men's team was below .500 that year, and by way of our stellar season, we were on the way to a postseason tournament. I beamed with pride when my letter was published. But I was too busy playing basketball, preparing for my teaching career, and pulling

all-nighters with my dorm mates to wonder if I could have helped the campus newspaper diversify its coverage.

Still a daily reader of the *Boston Globe*, I noticed Lesley Visser's byline back in 1974 when she started writing sports. I even used some of her feature stories in the writing classes I taught over the next few years. I was impressed with her attention to detail, her use of quotes, the metaphors she employed. But it wasn't until after I left teaching to write for a weekly newspaper in Manchester, New Hampshire, that I began to contemplate following in her footsteps. That was in 1978, when *Sports Illustrated*'s court case against Major League Baseball on behalf of Melissa Ludtke was making headlines. I'd been covering high school sports for the weekly and I'd also written a few features on local sports notables such as Baltimore Orioles pitcher Mike Flanagan and sports broadcaster Bob Lobel. On my own dime, I went to the 1980 Olympics in Lake Placid and wrote about the experience. Just the thrill of being in the Olympic Village, trading pins with people from all over the world and celebrating the US hockey team's Miracle on Ice made me realize that I wanted to be covering sports for a living.

When the weekly newspaper ran into financial trouble and laid off most of its staff, I contemplated returning to teaching for about two seconds. The writing bug had bitten me, and I set my sights on a job with a daily newspaper. Lo and behold, the *Portland Press Herald*, Maine's largest daily newspaper, was hoping to find a woman to "integrate" its sports department. My feature writing clips were the draw that got me in the door. For one of my first assignments, I went to a high school summer football camp where players were doing two-a-days in the merciless August heat and wrote about the dangers of heat exhaustion. I wouldn't call it an exposé, since no one even fainted that day. But the football coach was unhappy with the thrust of the article, while my editor was pleased.

Needless to say, I was in the right place at the right time. Sportswriters are tasked with getting beyond the competition on the field to write stories with a narrative arc. My training as an English teacher and my experience as a coach helped me connect with athletes and tease out the quotes and details that made for a good story. I didn't really think about it at the time, but I was part of a trend: a new breed of sportswriters, an increasing number of them women, who were making a name for themselves not just by their ability to cover a beat, but also with their penchant for digging deep to find stories that would resonate with readers. I spent a day with US Olympic hockey hero Mike Eruzione a few years after his hockey career ended, when he'd become a highly sought-after motivational speaker. I sat in the modest kitchen of his childhood home, perusing family photos and listening to stories about his growing up years. I met another legend in Boston sports history that same year. I'll never

forget sitting in Boston Celtics coach Red Auerbach's office and having him gruffly inquire, with a harrumph, what I could possibly ask him that no one else had asked. Without missing a beat—although my heart was pounding—I expressed an interest in the collection of letter openers displayed on the wall behind his desk. I couldn't scribble fast enough to keep up with the conversation that flowed after that. I also interviewed 1984 Olympic marathon champion Joan Benoit, twice. She was gracious enough to allow me to interview her a second time after the tape of my first interview somehow disappeared into the ether.

Like most of the early woman sportswriters, I benefited from the support and encouragement of my male colleagues. Early on, the editor who hired me and his assistant editor pushed me out of my comfort zone, into locker rooms and other places a once shy Catholic girl might have hesitated to go. But when they moved on, things changed and I suddenly felt adrift. The new editor had been a beat writer and was brand new to managing. He was a nice enough guy, but he wasn't the one who hired me. He didn't think anything of taking the male writers working the day shift out golfing on Friday afternoons, leaving me to "man" the office with the agate clerks. One Friday afternoon he strolled in after the golf outing and realized he'd forgotten to assign anyone to cover the American Legion baseball game that night. He pleaded with me to stay late to cover it, but I couldn't understand why he didn't just ask one of the golfers to do it since they hadn't actually worked that day. He appealed to my sense of myself as a team player, but I wasn't feeling like part of the team, so I stood my ground and said I had plans for the evening.

It wasn't the best career move. I should have parlayed the favor into some choice assignment instead. That became clear the following January when my editor told me he was sending someone else to Red Sox spring training, even though I had been assured that I was on deck and would get my chance. I suppose it made sense from a management standpoint to send the person who'd established connections the year before. American League clubhouses were open to women, but what if the players refused to talk to me? Still, I was convinced that my old editor would have championed my cause, maybe by sending another reporter along with me to pave the way. Newspapers were printing money in the 1980s, and lots of papers were sending teams of reporters to cover big events. In my impatient mind, this decision signaled that my career as a sportswriter had stalled. As soon as the opportunity presented itself, I applied for a position as a staff writer for the Sunday paper. Hiring a woman as staff writer would be a first for that department too. Previously, the women in that department were called "women's page writers."

Of course I had other concerns beyond an aborted trip to spring training. In the mid-1980s, magazines were full of articles about the perils of

working women trying to have it all. A day job seemed more conducive to having a life outside of work, and all these years later, it's a choice I don't regret. I got to walk my son to kindergarten every day and pick him up most afternoons. I rarely missed a concert, a play, or a Little League game. Thanks to some great editors, I learned a lot about the craft of writing as I explored the nooks and crannies of Maine during the next two decades. I traveled to Nova Scotia to report on the ongoing lobster wars between Maine and Canada and to Concord, New Hampshire, to interview Christa McAuliffe after she was chosen to be the first teacher in space. I continued to write sports stories when given the chance. I spent a day with Travis Roy at Boston University after he returned to school following the tragic accident that left him paralyzed. I talked the sports editor (a new one) into sending me to the 1997 NCAA Women's Final Four in Cincinnati to write columns about the growing interest in women's college basketball. I also wrote two books about women's basketball, in the process interviewing such legends as Pat Summitt, Nancy Lieberman, and Cheryl Miller. I snagged an interview with Billie Jean King at the US Open for my young adult biography of her life. Still, I've always wondered where my sportswriting career might have taken me if I'd stayed on the road I'd started down.

I embarked upon the writing of this book because I wanted to find out what the lives of the women who stayed the course and climbed the ladder—despite all the odds against them—have been like. What did it take? What did they sacrifice? Who did they turn to for help? Did they have any regrets about the life they chose? I also wanted to tell their stories because I admire their chutzpah, their resolve, and their passion.

The women in this book, and the stories they shared, reflect the changes that have occurred over time, as well as the major issues women have faced and still face today. Each one of these women could write a book of her own, and a few of them have. One thing all these women seem to share is a sense of responsibility to the next generation of female sports journalists. They understand that the hard-won gains of the last forty years have opened doors for women in sports media, and they are determined to do their part to keep paving the way. Likewise, I hope that telling their stories will help to keep opening doors for women in a media landscape that is changing every day.

1

Why Mary Garber Matters

On September 24, 1926, an eleven-year-old girl visiting her grandparents in Ridgewood, New Jersey, picked up a copy of the *New York Daily News* and started reading about the Jack Dempsey–Gene Tunney fight in Philadelphia the day before. The girl was Mary Garber, who had been born in New York City but moved to Winston-Salem, North Carolina, with her family when she was eight years old. Mary was enthralled with the details of the boxing match between the two heavyweight titans. This was the golden era of boxing and this match was the talk of the town weeks before Dempsey, the defending champion, went into the ring against Tunney. After the bout, people continued to discuss the fight and the outcome. It had not ended in a knockout, but Tunney was said to have completely dominated Dempsey and the decision was never in doubt. Because Mary was so well versed on the details, she held court on the subject when it came up in conversation at dinner with her grandparents' friends a few nights later. "They asked me a lot of questions and I was able to answer them from what the newspaper story had said," she told Diane Gentry of the Washington Press Club in 1990. "All of a sudden I was the center of attention and all the men were listening to what I had to say. . . . That was when my interest in sports really began."[1]

Mary Garber would turn her love of sports into a fifty-seven-year career as a newspaperwoman in Winston-Salem, North Carolina. Though she never left the midsize paper where she got her start, "Miss Mary," as she was called by many, paved the way for the wave of women in the 1970s and '80s who began infiltrating sports departments (and team locker rooms) in ever-growing numbers. Her tenacity, her integrity, and

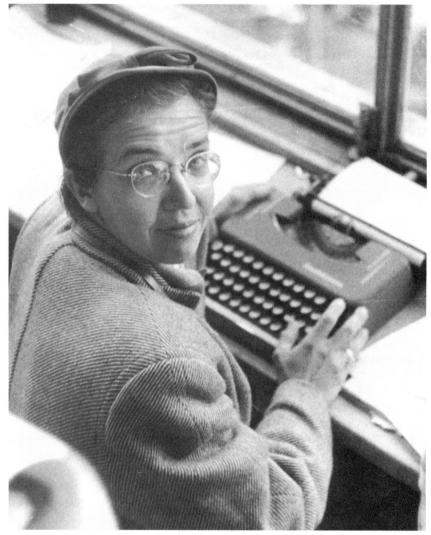

Mary Garber's childhood love of sports turned into a half-century career as a sports-writer for the *Winston-Salem Journal*. *Photo courtesy of Forsyth County Public Library Photograph Collection, Winston-Salem, North Carolina*

her ability to get the story were instructive and inspirational to those who came after her.

Garber wasn't the first female sportswriter in America, but the historical record of women covering sports before her is sparse at best. Sadie Kneller Miller covered the Baltimore Orioles baseball team for the *Bal-*

timore Telegram in the 1890s, likely the first (and only) female covering a professional sports beat back then. In the early 1920s, advancements in radio expanded the public's appetite for sports news, and a few newspaper editors decided to position their coverage to appeal to women as well as men. Margaret Goss wrote a daily column called "Women in Sport" for the *New York Herald Tribune*. Her column, which often ran alongside the legendary Grantland Rice's columns, highlighted the accomplishments of notable female athletes of the mid-1920s. Around the same time, Lorena Hickock wrote page one stories about the University of Minnesota's football team for the *Minneapolis Tribune*. "Hick," who is better known for covering the Lindbergh baby kidnapping and for her close friendship with Eleanor Roosevelt, had to watch the games from the stands because the press box was off-limits to women. Finally, Jane Dixon of the *New York Telegram* made a name for herself covering most of Dempsey's heavyweight boxing matches from 1923 to 1932. Her charge was to write about the fights from a woman's point of view.[2]

Garber's career at the *Winston-Salem Journal* transcended the limited positions the earliest pioneering women carved out for themselves in the first half of the twentieth century. Just like the men in the sports department, Garber was a beat reporter with advances, game stories, and columns to write on deadline. And she was tireless in pursuit of a good story. As Jenni Carlson, then president of the Association for Women in Sports Media (AWSM), wrote when Mary died in 2008 at the age of ninety-two, "Mary's legacy extends beyond the miles and the generations. She will always be an influence on women who, like myself, chose to work in sports media. We would not be where we are today without Mary."[3]

Garber, who answered to "Pip" as a kid, worked on the school newspaper at RJ Reynolds High School. A big football fan by then, her dream was to go to Duke University, two hours east of Winston-Salem, so that she could watch (and perhaps cover) the school's successful football team. But her father nixed the idea. He thought Mary, all 5 feet, 1 inch and 115 pounds of her, would be better off as a big fish in a smaller pond. He was right. At Hollins University, a women's college in Roanoke, Virginia, she was able to continue to play sports and became the college newspaper's sports editor. "I fell in love with the place," she said in 1990. "It gave me the feeling I had abilities and could do anything I wanted."[4]

Upon graduation in 1938, Garber came back to Winston-Salem. She taught in an after-school recreation program while seeking work at the local newspaper. After being badgered by Garber for a year, the paper's editor asked her to do a survey of women subscribers, perhaps to justify putting her on the payroll. A month later she was hired as the *Winston-Salem Journal*'s society editor for $60 a month. Anyone who knew Garber knew this wasn't her ideal job. Admittedly, this plain-featured,

plain-spoken young woman, who wore wire-rimmed glasses and blue tennis sneakers, knew little about fashion. But she made the most of it, sometimes having a friend come with her to society events to help her describe what everyone was wearing. When the United States entered World War II and young reporters and editors went off to serve in or report on the war, Garber switched from society to the news desk. Then she became sports editor, part of a two-person sports department, until the war ended in 1945. "I guess it was about the only choice they had," she recalled.[5]

After the war, Garber went back to the news desk, but her heart was still in sports. As soon as she finished her news stories for the day, she'd cross the room and ask the sports editor if there was anything she could do. Finally, the managing editor told her to quit moping around the newsroom and go write sports full-time.[6] Over the years, Garber became an integral part of the sports staff that covered major North Carolina universities, such as Duke, Wake Forest, and the University of North Carolina. But initially, like any beginning sportswriter, she covered the local high schools and small colleges in the paper's circulation area. She made a name for herself because of her interviewing abilities as well as her attention to detail in her writing. Right from the beginning she could spin a good yarn, as shown by the lead to this football story from the fall of 1947: "Coach Hal Bradley had to go into the Reynolds High cheering section last Friday night when his team played Greensboro to get Broughton Correll to fill in at end (for Billy Russell), as injuries just about exhausted the supply of flankmen. . . . Broughton and Billy swapped clothes, with Correll wearing Russell's uniform and Russell putting on Broughton's street clothes. . . . The game went on with Greensboro winning 6–2 and the announcer and sportswriters reporting that Billy Russell was playing end for Reynolds, when all the time it was Broughton Correll."[7]

Garber also had a knack for finding the interesting angle in her advances to upcoming games, as shown by another fall 1947 story: "A dark-haired, place-kicking center who has missed just once in 10 tries at points after touchdowns may have a big job to do Friday night when the Reynolds High Demons invade Charlotte for a tussle with Harding High. Sid Whitehart has rolled up a total of 12 points thus far, kicking the only field goal to be made by an AA Western Conference player in the past 2 years. That boot won the Danville game for Reynolds by a 3–0 score." Garber added, "Sid is a junior with another year of competition ahead of him. He is a catcher on the baseball team, and in his spare time gets in a few cracks on the golf course."[8]

In those early years, Garber became a local celebrity of sorts by covering Atkins High, the local all-Black high school. The exploits of Black ath-

letes had previously been relegated to the agate section of the daily paper and to the "Negro News" column of the Sunday paper. When Garber showed up, players and coaches were surprised and thrilled to see someone from the local paper at their games. Happy Hairston, who led Atkins to the basketball state championship in 1959 and went on to win an NBA championship with the Los Angeles Lakers, said what he remembered most about his high school days was Mary Garber being there to cover the games. The attention Garber paid to the Black schools and their athletes helped desegregate the sports pages of the *Winston-Salem Journal*—and caused other papers around the state to do the same. But Garber's efforts also helped her. The Black players and coaches accepted her as one of their own because as a woman writing sports, she too was operating outside the norms of society in the 1950s and '60s. They befriended her and encouraged her as she learned her craft and struggled to gain acceptance. She acknowledged how much their support meant to her over the years. "I didn't realize at the time how important it was," she recalled. "I never thought about being the only white person there [at the games]. People who condemn whole groups . . . they're the losers. They miss knowing a lot of perfectly wonderful people."[9]

One of Garber's biggest supporters, whom she considered a brother and a friend, was the legendary Clarence "Big House" Gaines. He coached both basketball and football at Winston-Salem State College, a historically Black school, and won a Division II national basketball championship in 1967. Gaines won 828 games in his forty-seven-year coaching career and was inducted into the Naismith Memorial Basketball Hall of Fame in 1982. Gaines always had time for Garber. Like Pooh and Piglet, they were friends whose disparate personalities were somehow a perfect match. One time Mary had trouble getting a coach to open up to her. In frustration, she asked Big House what she was doing wrong. "Big House said, 'Just keep doing what you're doing Mary,' and he was right," recalled Garber in 1990.[10]

Garber didn't often have trouble getting coaches and players to talk to her. Though she was barred from the locker room, she would make arrangements with the coach or a team official so that she could have access to the players she needed to talk to. Wake Forest basketball coach Bones McKinney would divide the locker room in half and tell the players: "Mary's coming in now." Another coach slipped her into the coach's office after his home games and brought players in to see her after they'd finished talking to the male reporters. Arrangements like these worked well until she started working for the morning paper and had a deadline within an hour or two after the game. She recalls calling McKinney and asking him if she could go into the dressing room before the team came in. They'd obviously still be dressed, but just as importantly, their adrenaline

would still be flowing. "I got a great story because I was there before the men writers, and boy were they mad!" she said.[11]

For away games against teams she didn't know well, she sometimes took high school coaches with her and gave them her credential to get into the locker room. She figured they'd ask good questions and be a big help. "I knew I wouldn't get anywhere if I lay down on the floor, screaming and kicking," she said. "I decided I'd have to find ways to make up for the restrictions."[12]

Persistence was her calling card, but another thing Garber had going for her was her earnest and obvious love for the sports and for the players she covered. She had a knack for getting players to talk candidly, and if she wasn't on deadline, she often stayed and talked to the young men about their lives after interviews ended. They often asked her for advice and told her things they wouldn't tell a male reporter. Some of those who paid tribute to Garber after her death mentioned what a pleasure it was to have been interviewed by her. "You never had to worry about a misquote from her articles," recalled Bob Galloway of Charlotte, North Carolina. "She raised the bar high for other females to pursue . . . in her own quiet way, [she] was simply the best."[13]

Garber believed that fairness and integrity were more important than a big scoop, especially in her column, "Skirtin' Sports." She never betrayed a confidence or played gotcha journalism. She made it a practice to find the positive in a team's experience, even after a tough loss. She realized that the relationships she formed earned her opportunities she might otherwise be denied if she were adversarial. She wasn't a pushover, though. One day, Bill Hildebrand, the Wake Forest University football coach from 1960 to 1963, handed out pregame notes and Garber noticed a change in the team's defensive alignment. "Bill didn't want me to write about it, because he didn't want the other team to know, but I said I had to," she recalled in 1990. Hildebrand asked Garber if she'd hold off and let him try to convince her managing editor not to run it. The editor acquiesced and Hildebrand got his way, but he apologized and assured her she'd win the next one.[14]

Most of Garber's difficulties came from those within her profession who didn't think she belonged in sports. In the late 1940s, when she began branching out from high school and small college assignments to cover Atlantic Coast Conference (ACC) games involving Duke, NC State, and Wake Forest, she was often escorted out of the press box and sent to the adjacent box where the wives and children sat. Another time, a police officer barred her from entering a press luncheon, despite the credential she wore around her neck. Finally, the *Winston-Salem Journal* went to bat for her and got her access to ACC press boxes, but male reporters mostly snubbed her. From time to time an out-of-town reporter would make

snide general comments within earshot of Garber about women who presumed to understand sports. "A lot of people never understood why I wanted to be a sportswriter," she recalled. "Why would a woman want to work those long hours and expend all that energy?"[15]

For many years Garber also was denied admission to the Atlantic Coast Sports Writers Association and the Southern Conference of Sportswriters. When she asked her editor to intercede on her behalf, he told her she could be a sportswriter without being in those groups. "I thought that was awful at the time," she recalled. "When someone has a prejudice against you, it can't help but destroy your confidence a little bit . . . all of a sudden, you think, 'Well maybe I can't,' and you have to keep telling yourself, 'Sure I can. These guys don't know what they are talking about,' but sometimes it gets a little hard."[16]

Fortunately, Garber had learned from an early age to believe in herself. When she was a little girl, her family would gather on New Year's Eve and go around the table telling each other what they'd done well that year and what they needed to improve upon. Her parents also encouraged their children (Mary was the middle child) to discuss and argue issues and to formulate their own opinions. Those experiences helped her develop a thick skin and gave her the confidence she needed to keep challenging norms. In 1954, Garber was finally admitted to the ACC sportswriters' group by virtue of a technicality: Her paper's new sports editor sent in her dues before he realized she had been barred from admission. The ACC held an emergency meeting and decided to keep the money and let her in. Years later, she became president of the group.[17]

In the mid 1970s, as women's athletics began to gain popularity, papers around the country sought to hire women sportswriters. Sport by sport, women began to gain access to college and professional locker rooms. After *Sports Illustrated* sued Major League Baseball on behalf of Melissa Ludtke in 1977, members of the national media made trips to Winston-Salem to interview Garber. She'd been writing sports since Billie Jean King was a toddler, and as president of the Atlantic Coast Sports Writers Association, her opinion mattered. Garber made it clear that she personally had no desire to enter the locker room unannounced. She preferred making arrangements with individual coaches and players, as she'd done for more than thirty years. Still, Garber insisted that all women sportswriters, especially those working in competitive, two- or three-newspaper cities, needed and deserved the same access as their male counterparts. "I don't see what the big deal is . . . All we're doing is trying to do our jobs," she said. "They try to make it a moral issue and it's not. It's a legal issue."[18]

By the time women sportswriters were a more common sight, Garber still stood out from the crowd. White-haired and wiry of build, she retired

from her ACC beat in 1985, at the age of seventy, but continued to write about tennis and small college sports until 2001. In the 1990s and early 2000s, the national sports community took notice of Garber's ground-breaking career. The ACC named its female athlete of the year award after her in 1990. The Association for Women in Sports Media created the Mary Garber Pioneer Award in 1999. In June 2005, she became the first woman to receive the Associated Press Sports Editors' Red Smith Award for major contributions to sports journalism. In 2008, she became only the second woman to be inducted into the National Sports Media Association's Hall of Fame. As she looked back over the landscape of her career and all the changes that have occurred since she began in 1944, Garber bemoaned some of the things that are different about covering sports. "Now I have to set up an appointment to see a coach," she said in 1990. "It was a much better set-up in the old days."[19]

Still, she admitted that she wished she'd been born twenty years later so that she wouldn't have been such a lone pioneer struggling not to make waves in order to secure her place in the sports department—and ultimately in history. In that way, she has said she emulated the great Jackie Robinson. "There are people who call us pioneers, but I have to laugh," said Christine Brennan of *USA Today*, who was the recipient of the AWSM Mary Garber Pioneer Award in 2004. "We didn't go through any of the difficulties Mary Garber went through."[20]

Mary, who never married, was beloved among her colleagues as well as the athletes and coaches she wrote about, and she continued to enjoy her friendships with all of them right up until she passed away in 2008.

"Others may remember her as a pioneer for women journalists, which she certainly was. Hopefully, she will also be remembered as one of those who helped bring the races closer together in Winston-Salem in an era when that was not the norm," wrote colleague John DeLong. "I will simply remember her sitting around the office, long after she retired, talking with that gleam in her eye, sometimes talking about current events and sometimes telling stories from years before. . . . We all loved Mary. We all loved her passion for sports and her passion for the newspaper business and her passion for people and her passion for whatever she was doing at the time. She lived a full life, and she lived it with joy, and we were all blessed to have known her."[21]

2

Lesley Visser Leads the Way

M ary Garber was a couple of decades into her sportswriting career when Lesley Visser announced to her mother that she wanted to be a sportswriter someday. She had no idea that any woman anywhere was covering sports, but she'd been to Fenway Park, where the towering green left field wall brightens the emerald green grass of the outfield. She'd grown up listening to Curt Gowdy call Boston Red Sox games, and reading the *Boston Globe*, the *Sporting News*, and *Sports Illustrated*—apparently failing to notice the lack of female bylines. Visser recalled years later in her 2017 memoir how her mother's response to her daughter's dreams energized her: "Instead of telling me it would be next to impossible, she said the greatest words I've ever heard: 'Sometimes you have to cross when it says don't walk.' It crystalized everything for me. . . . I was ready to lasso the moon."[1]

Visser's forty-seven-year (and counting) career has reached heights that no woman had reached before. She is the only sportscaster—male or female—to have been on the network broadcasts of the men's NCAA Final Four, the Super Bowl, the World Series, the NBA Finals, the Triple Crown, the Olympics, the US Open, and the World Figure Skating Championships. She made the transition from print to TV look easy at a time when there were few women role models in either field. She admits it was an insane challenge, but one that has earned her numerous awards, membership in seven halls of fame, and countless tributes to her groundbreaking career.

Visser came of age in the early 1970s on the cusp of the women's movement. With Title IX improving opportunities for girls, she stood

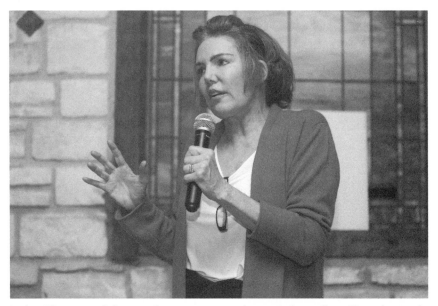

Lesley Visser paved the way for many women in sports journalism. Here she speaks about her career at an Association for Women in Sports Media convention. *Photo courtesy of Arianna Grainey*

out as an athlete on her high school teams. Along with some of her high school classmates, she attended a women's rights rally in Washington, DC, and was enthralled by Gloria Steinem's call to action. She watched *The Mary Tyler Moore Show* because it was about a single woman working in a newsroom (albeit behind the scenes). She whooped and cheered with her roommates at Boston College when Billie Jean King defeated Bobby Riggs in the "Battle of the Sexes" in 1973. She wrote sports for *The Heights*, BC's student newspaper, and in 1974, she applied for and won a Carnegie Foundation grant given to twenty women nationwide who wanted to work in a career that was 95 percent male (as most white-collar jobs were). The grant entitled her to work as a summer intern at a local newspaper, and she chose the *Boston Globe*, which boasted a daily sports section renowned for the quality of its writing. She was only twenty years old.

Visser covered high school games in towns so small or out of the way that her stories were often swapped out after the early editions. She tackled every event as if it were the World Series, and her enthusiastic style led to some crazy first-person assignments. She went hang gliding off a cliff for one story and spent three days in the woods orienteering for another. While some might have felt they were being marginalized by these

feature assignments, Visser saw them for what they were: opportunities to learn and to pay her dues.

"Someone wrote to me at the *Globe* and said, 'You wrote the hell out of badminton,'" she said in our 2019 interview. "My theory of everything I did was that I would make every at-bat a quality at-bat. . . . So if it was Martha's Vineyard or Nantucket or Acton-Boxborough . . . I was thrilled. It was such great training."[2]

Visser was in the right place at the right time to make a name for herself. Newspapers in the mid- to late 1970s were hiring more women for reporting jobs. But sports was another story. An editor couldn't just drop a female writer, even a very good one, into a sports department where she might be second-guessed by fans, dismissed by players and coaches, and resented by fellow writers. Visser proved through those early experiences that "right place/right time" was only part of the equation. She was also the right person to be confronting those barriers. Her father was Dutch, but Visser also had lots of Boston Irish in her blood. Fearless and confident but also disarmingly friendly and funny, she readily displayed what longtime coach and friend Rick Pitino has called her "wit and charm offensive."[3]

Nell Scovell worked at the *Globe* as an intern before becoming a television and magazine writer. She recalled how the mood always brightened when Visser charged into the office. "She was easily the most glamorous person there and lit up the room with her big smile," Scovell wrote.[4] Visser also impressed the veteran writers in the sports department, including well-known tennis writer Bud Collins and Will McDonough, who covered the NFL. McDonough was so impressed with Visser that he insisted she be promoted to the afternoon paper's New England Patriots beat. No woman had ever covered a professional sports team in a sports-crazed city like Boston. But looking back years later, Vince Doria, then the paper's assistant sports editor, said he had no qualms assigning Visser to the NFL in 1976. With McDonough paving the way, Doria sensed that she'd hurdle any obstacles she might face on the strength of her personality, which makes it almost impossible not to like her.

"She has a way of making people feel immediately that they're her best friend," Doria told a reporter in 2006, on the occasion of Visser's winning the Pro Football Hall of Fame's Pete Rozelle Radio-Television Award, the first woman to do so.[5]

It wasn't all wit and charm, though. Visser had few problems on the football beat because she outworked her competition. "The *Globe* didn't hire people who couldn't cut it," she says, explaining all the hours she spent down in the library going through the yellowing clip files before she headed out for an interview. "Everybody at the *Globe* worked insanely hard. It was the example they set."[6]

It was also helpful that she wasn't the type to take umbrage, even when players reacted to her presence in surprising ways. After a Patriots-Steelers game at Three Rivers Stadium, Visser waited in the parking lot to interview Pittsburgh quarterback Terry Bradshaw. (NFL locker rooms didn't open to women until 1985.) Bradshaw came out of the locker room and saw her standing there with her notepad. Assuming she was a groupie, he grabbed her pen and signed his name on her notepad as she sputtered, "'But, but I'm a reporter . . .' We laughed about it afterwards and have become great friends," she says. "It was a new scenario for the players and coaches too."[7] After football season, Visser's versatility paid dividends. She covered Wimbledon with Bud Collins and the NBA with Bob Ryan, and did college football and basketball features. She was having fun and earning her stripes in one of the country's major sports markets. One of her most disheartening experiences, though, came on New Year's Day in 1980 when she ventured to the Cotton Bowl in Dallas to cover the Houston-Nebraska game. After Houston pulled off a last-minute comeback to win, 17–14, Visser headed to the locker room to interview the winners. As soon as Houston coach Bill Yeoman saw her, he yelled out, "I don't give a damn about the Equal Rights Amendment. I'm not having a woman in my locker room." Yeoman marched Visser out of the room as TV cameras pivoted from the celebration to Yeoman's tantrum. Instead of getting the story, she became the story. To escape, she recalls, she went to the top row of the eighty-thousand-seat stadium, with empty wrappers blowing all around, and cried.[8] But for Visser, there was precious little time to dwell on such indignities. She knew, as Dolly Parton might have put it, that if she wanted the rainbow, she had to put up with the rain.

As the 1970s progressed, Visser had more company on the sidelines and in the press boxes. Sports departments in other media markets with pro teams began bringing women on board. Among them were Robin Herman at the *New York Times* and Betty Cuniberti at the *San Bernardino Sun*, both hired in 1973. Melissa Ludtke joined *Sports Illustrated* in 1974. In 1975, Jane Gross began writing for *Newsday*. In 1979, Susan Fornoff joined the *Baltimore News American* and Michelle Himmelberg began writing sports at the *Fort Myers News Press*. They were followed by a second wave of women in the early 1980s, including Kristin Huckshorn at the *San Jose Mercury News* in 1980, Christine Brennan at the *Miami Herald* in 1981, and Jackie MacMullan at the *Boston Globe* and Claire Smith at the *Hartford Courant* in 1982, to name a few.

"That first handful of women were so close that we were on each other's holiday lists," Visser said in her memoir. She said they passed a milestone when they no longer knew the names of every woman in the press box.[9]

By the mid-1980s, Visser was testing the waters of another facet of sports journalism: the broadcast career for which she has become best known. In 1984, CBS came calling. They'd had a couple of females—Phyllis George, the former beauty queen, and Jayne Kennedy, a former *Playboy* cover girl—in the studio for NFL pregame shows. But as time went on, the network realized it needed someone who didn't just look good on camera but actually knew a blitz from a zone. Visser was the logical candidate, but when Ted Shaker and his boss came to the *Globe* to offer her the job, she almost said no. "They looked at me cross-eyed and said, 'Lesley, there are only twenty of these jobs in the country,'" she recalls. "But I was torn. [Print] journalism is really the love of my life . . . but I went."[10]

There was no learning curve for Visser when it came to covering football. She had become conversant in the sport thanks to Patriots players such as "Sugar Bear" Hamilton, who played for the Patriots from 1973 to 1981. "They would make me sit down and watch eight-track tapes," she says. "They would quiz me, saying, 'Lesley, what is this guy doing to get to the edge. What kind of move does he have to get to the quarterback?'"[11]

Standing in front of a camera didn't come quite as naturally. She felt stiff and out of sync at first. "It was like I had rigor mortis. I was like a female Ted Baxter," she told fellow pioneer Betty Cuniberti in 1994.[12] At first, she would stop talking when she heard the voice in her ear telling her where to look or what to do next. And frigid temps were often a distraction. "Your teeth freeze, which is another thing people don't realize," she says.[13]

Visser split her time between CBS and the *Globe* until 1987. She began appearing regularly on *The NBA on CBS*, March Madness college basketball broadcasts, Major League Baseball, college football, the US Open Tennis Championships, and the Olympic Winter Games. In 1992, she became the first woman—and as of 2021 remained the only woman—to handle the postgame presentation ceremony at the Super Bowl.

Visser became a celebrity of sorts as a sideline reporter, and in many ways she pioneered how to handle and excel in the role. One incident that showed Visser's ability to think on her feet occurred after an NCAA men's basketball tournament game. After Indiana beat Temple, 67–58, Visser approached Indiana coach Bobby Knight for some insights. She started with a general question—"How were you able to defeat Temple?"—to which Knight sarcastically retorted, "We scored more points than they did." Realizing he was starting to go off on one of his rants against the media, Visser cut him off, saying, "Yeah, yeah, yeah, yeah— how did you get around that matchup zone? What did you tell your team?" Knight seemed stunned for a second but he changed his tune and actually answered the questions. Associated Press reporter John Nelson

devoted part of his column to the exchange the next day. "Every once in a great while in TV someone says something we can all be proud of. So thank you Lesley Visser."[14]

Visser takes issue with people who consider sideline reporters somehow less skilled than the people in the broadcast booth. She's never had a desire to do play-by-play or to host an NFL show. She has always loved being near the action, interacting with players and coaches and thinking on her feet. From a dozen potential angles, she has to quickly choose one or two questions because of the time constraints. "For people to say, 'Why are they just on the sideline?' It's because they are damned good," she says.[15]

Visser's career stalled briefly after a horrific fall while jogging in Central Park in June 1993. She had to have surgery on her shattered hip and more than twenty stitches in her face. In the meantime, CBS had lost its exclusive right to broadcast National Football Conference games to Fox Sports that same year. Most of her colleagues ended up with Fox. But Visser latched on with the more established ABC Sports. For a sports junkie like Visser, it couldn't have been a better fit. In 1995 she became the first woman ever to report from the sidelines during a Super Bowl. In 1998, she became the first woman ever assigned to *Monday Night Football*. She also covered the Super Bowl for ABC in 2000.

"*Monday Night Football* was the number one show on television. I also got to go to the Olympics, got to work with Al Michaels, covered the Triple Crown and the World Series. It turned out to be great for me," she says.[16]

Visser patrolled the sidelines before Twitter trolls; instead, her critics were fellow journalists. Visser had replaced NFL veteran Lynn Swann, and some media critics, especially those who had covered Swann during his Pittsburgh Steelers days, decried ABC's move. "The sure sign of the apocalypse is the choice to replace him: Lesley Visser," wrote John Steigerwald in the *Pittsburgh Post-Gazette*. His petty diatribe went on to criticize the hats she wore on sub-freezing days.[17]

The slights never kept Visser from moving forward. Ask any woman in broadcast journalism and they'll tell you it's a fickle medium. After three years on the sidelines for ABC, Visser, then forty-six, was replaced in 2000 by Melissa Stark, a reporter twenty years her junior. ABC said she could work on the evening news or a Sunday show, but after more than two decades of covering football, she had no interest in leaving sports. As luck would have it, two pals booked her a flight to Paris to clear her head, and on the same flight was the CEO of CBS, whom she'd known from her first stint with the network. He assured her there'd be a place for her at CBS when she got home.

As of 2021, Visser was still working for CBS doing feature stories and Barbara Walters–like exclusive interviews with sports figures in the news.

In February 2020, she was honored by the Academy of Television Arts and Sciences, becoming the first woman to win an Emmy for Lifetime Achievement in Sports. Past recipients include Ted Turner, John Madden, Dick Ebersol, and Dick Vitale. That was just another in a long list of firsts she has garnered in her career.

Visser is also first in the hearts of many younger journalists. She takes seriously her role as a mentor to other female journalists. She and colleague Christine Brennan, a past president of the AWSM, donated their speaking fees in 1990 to start a scholarship fund for young female journalists. "There's no doubt that any of us who appear before the camera have Lesley Visser to thank," said Brennan in 2006. "Lesley made it easier for all of us."[18]

Jane McManus, now a columnist with the *New York Daily News* and the director of the Center for Sports Communication at Marist College, can attest to that. When she was just starting out as a sports reporter, McManus remembers meeting Visser at Madison Square Garden. She'd been a big fan of Visser since she first began contemplating a career in journalism, so she was a bit intimidated when she spied the journalist holding court with other reporters in the press room before a Big East tournament game. McManus took a deep breath and approached her idol anyway. To her surprise, Visser took the time to field all her questions about the business as well as to ask her questions about her interests. What really impressed McManus, though, was that more than a year later, Visser remembered her name when they bumped into each other again. McManus said it "meant a ton" to her. She was so impressed with Visser that when she started playing roller derby, she adopted the name Lesley E. Visserate. (Given the "necessary roughness" of roller derby, the pun was an apt one.) McManus sent Visser a picture of her jersey emblazoned with the nickname; Visser turned it into a screen saver.

"Being able to connect with people and remember who they are when you're dealing with hundreds of people who are going to know who *you* are is really an important skill," says McManus, "and it's part of what has made her so successful."[19]

3

Prying Open the Locker Room Doors

Until the mid-1980s, women sports journalists needed a scorecard to keep track of the hodgepodge of policies governing locker room access. A few professional sports teams provided access to women reporters without reservation, many were lukewarm to the idea, and some were openly hostile. In some places, even though a phone call had paved the way, an officious underling still thought it his prerogative to bar the door to women. Lesley Visser, then with the *Boston Globe*, and Christine Brennan, then with the *Washington Post*, recall doing their fair share of standing around in the cold after games waiting to interview NFL players. After one game involving the New York Giants, Visser and Brennan waited in the weight room (the pun was not lost on either of them) for Giants quarterback Phil Simms and linebacker Lawrence Taylor to be brought out to them for interviews. After what seemed like an eternity, a player in a spotless uniform, a face they'd never seen before, emerged. Brennan looked his number up in her roster guide and realized their first interviewee hadn't played in the game.

"How horrified should the NFL have been in 1984 that the representatives of the *Boston Globe* and the *Washington Post*, who happened to be women, were being shut out of doing their jobs," says Brennan, now a columnist with *USA Today*. "That's why it was untenable, and that's why this could not continue."[1]

"They just didn't want women in this world. Period," said Betty Cuniberti in 2013. Cuniberti started out writing sports for the *San Bernardino Sun-Telegram* in 1973. She recalled how determined she was to get her stories without making waves by arranging to have players meet her

17

outside the locker room. But without locker room access, she realized she couldn't compete with the men on the same beat from rival newspapers. "It was death by a thousand cuts," she said.[2]

Most women will tell you that over the course of a season, they spend less than 5 percent of their time in athletes' locker rooms. Most consider their time in those sweaty confines to be a necessary evil and would opt out of the experience if they could. Yet every female sportswriter and sports broadcaster believes that access to the locker room is crucial to her ability to do her job. As the numbers of women writing about sports slowly increased in the 1970s and '80s, they realized they needed to level the playing field between themselves and their male colleagues. The locker room became the battleground on which they fought for equal treatment and equal access.

Robin Herman was the first female sports reporter at the *New York Times* in 1973. Two years later, she and Canadian reporter Marcel St. Cyr became the first women allowed in a men's professional locker room—at the NHL All-Star Game in Montreal. More often, though, Herman stood outside locker room doors for a worrisome amount of time waiting for a player to come out and talk to her. As her deadline approached, she would have time to ask only a couple of questions before rushing up the stairs to the press box to write her story. Exhausted by it all, she left sportswriting behind four years later. "Sixty percent of my time used to be spent on just trying to get to the players instead of on what I was writing," she told writer Roger Angell in 1979. "It's emotionally draining. It uses you up."[3]

Jane Gross began writing for *Sports Illustrated* in the late 1960s and moved on to *Newsday* and then the *New York Times* to cover professional basketball. It was because of Gross that NBA commissioner Larry O'Brien encouraged NBA teams to open up their locker rooms to women in the mid-1970s. That doesn't mean Gross was welcomed with open arms. She was doused with buckets of water and once had a plate of spaghetti and meatballs thrown at her. She moved to news in the 1980s, she said, because she grew tired of the abuse.[4]

My locker room experiences were tame in comparison to those of the women I interviewed. As a feature writer, I was able to schedule most interviews elsewhere. But when the Boston Celtics came to Portland, Maine, for their annual exhibition in 1980, I was provided my first taste of what it was like to be inside a men's locker room. To say the least, it was uncomfortable. As I stood outside the locker room with several other (male) reporters, one of them asked me, "Is this your first time?" "I guess you could say that," I replied. Once inside, the first person I saw was Celtics center Dave Cowens, who was sitting by the door like Auguste Rodin's *The Thinker*, obviously naked but in a discreet sort of way. He was ignor-

ing me (or was he taunting me, I wondered?) I walked past him, looking for Kevin McHale, whom I found out had already departed. I interviewed a fully clothed rookie who was fighting for a spot on the team. Then I talked to assistant coach K. C. Jones and head coach Bill Fitch. The last player on my list was just exiting the shower with a towel pulled tightly around his waist. I would have waited for him to dress but my deadline was looming, so I screwed up my courage and approached him. He was friendly and cooperative and gave me what I needed to wrap up my game story. The next day, my editor had me write a column about my first foray into a male locker room. Predictably, I got some hate mail. One reader wrote that my column would have been more appropriate for *Playboy* magazine than for a family newspaper. "The next time you want a cheap thrill, try an X-rated movie," he advised, ending his rant with another piece of advice: "You should hang your head in shame."

My most unnerving experience came a couple of years later when I was sent to the University of Virginia to do a feature story on Rick Carlisle, who had transferred from the University of Maine to Virginia to play basketball after his sophomore year. I would have been perfectly happy to do the interview somewhere else, but I dutifully followed the sports information person into the brightly lit locker room, where each athlete had a wood-paneled space with his name on a plaque above it. I marveled at how these big-time college men's programs treated their athletes, a detail that added some context to Carlisle's decision to leave Maine. Carlisle was fully dressed when I arrived, and the locker room seemed empty as the PR person introduced us. Halfway through the interview, though, Ralph Sampson, Virginia's 7-foot center, emerged from the showers. He may have been as surprised to see me as I was to see him, but that didn't motivate him to take the towel slung over his shoulder and cover his private parts. I know this because his pelvic area was at eye level to me as I sat interviewing Carlisle. I also knew that I had committed the cardinal sin of glancing his way, even though it was a natural reaction to the sound of someone entering the room. I quickly changed my posture and kept my eyes glued to Carlisle's face each time I looked up from my notebook to ask another question. Sampson made no effort to distance himself from us. I don't know if he was glaring at the back of my head, but I imagined he was. I also imagined my face was bright red, and I was thankful when I finally heard the door to the locker room close, signaling his exit.

Until the late 1940s, the locker room was exclusively the players' domain. Dick Young, a reporter for the *New York Daily News*, gets credit for being the first to barge into a locker room after a game. Combative and abrasive, Young was part of a new breed of sportswriters dubbed "the chipmunks" because they were constantly ferreting out the story behind the story, not content with writing play-by-play accounts of games.[5] After

the game, players were still caught up in the moment and often willing to talk about their exploits. They hadn't had a lot of time to process what had transpired or to censor their reactions. You couldn't get the kind of quotes you got in the locker room anywhere else. Even Mary Garber had come to realize this. While she spent most of her career making arrangements to interview athletes elsewhere, she acknowledged that one of the few times she was allowed in with the first wave of reporters in 1978, she was amazed at how much information she got and what a difference it made.[6]

Given the times, the conflict over locker room access became part of the pitched battle raging in society over women's rights. The women's movement was gaining momentum and women were demanding equality in the workplace and on playing fields. The sexual revolution of the 1960s and the feminist movement of the 1970s were changing relations between the sexes as well as women's career aspirations. But the old guard—league commissioners, team owners, and many coaches—believed they were preserving old-fashioned family values by keeping women sportswriters at bay. Many thought they were also protecting the privacy of their players. They didn't understand why women would even want to enter such an intimate space. Diane K. Shah of the *Los Angeles Herald-Examiner*, the first full-time female sports columnist for a major newspaper, recalled California Angels manager Gene Mauch continually giving her the cold shoulder when she entered the locker room after a game. When she asked him why he wouldn't speak with her, he told her that she reminded him of his daughter—and then he began to cry.

"Believe me, my mother did not raise me to do business with naked men," Shah told him. "But here I am and I have a job to do." It took Shah a few more months to get Mauch to talk to her, but he finally did.[7]

Some male reporters also were conflicted about those first female sportswriters. "The liberal in me says that women reporters are entitled to be in the clubhouse and get all the courtesies I get," said Jerome Holtzman of the *Chicago Sun Times*, fifty-two at the time, in a *New Yorker* article in 1979. "But I feel there's something unwholesome about it." Maury Allen of the *New York Post* provided a colossal overreach and a great example of faulty logic in the same *New Yorker* article. Allen, one of the original "chipmunks," was forty-six at the time. "I think that just as I can't become pregnant, women shouldn't become sportswriters," he said.[8]

For several years, the locker room issue percolated below the surface as individual reporters tried to make inroads with the teams they covered. Some teams issued bathrobes to their athletes, while others instituted "cooling off" periods when no one was allowed inside. But women were still subject to the whims of a given coach on a given day. Until along came Melissa Ludtke of *Sports Illustrated*, an unlikely crusader in the fight for equal access.

Left to right, **Michelle Himmelberg, Melissa Ludtke, Claire Smith, and Christine Brennan** were among the earliest groundbreakers for women in sports journalism. *Photo courtesy of Arianna Grainey*

After graduating from Wellesley College in 1973, Ludtke drew her salary as a secretary for *Harpers Bazaar* but spent as much time as she could doing gofer-type jobs for ABC Sports. From there, she latched on with *Sports Illustrated* as a researcher/reporter. Fact checker was the entry-level position at most magazines, but for women it was often a dead-end job, a starting and stopping point in their careers as they watched younger men be promoted to writers over them. The times were slowly changing, however, as more women began objecting to their stalled careers. *Newsweek* magazine had been sued by women in its research department in 1970 because they often went out into the field to conduct interviews but were never compensated for it. Women at *Time* reached a settlement with management over these same issues a year later. The *New York Times* was also sued by the women in its newsroom in 1974. Magazines and newspapers slowly began to see the wisdom of offering women a semblance of upward mobility if it could keep them from filing lawsuits.

Ludtke had grown up playing sports. She describes the brand of six-player basketball girls played back then, which confined four of the six players to one half of the court, as an apt metaphor for her working situation. "The boys had all these opportunities. They could zig and zag and

do all kinds of fancy moves, and if they wanted, they could go all the way to the basket," she says.[9]

Ludtke's love of baseball came from her mother, who was obsessed with the Boston Red Sox even in those decades when they were the also-rans of the American League. As a girl, her mother would send away for copies of the black-and-white player portraits taken at spring training every year and tack them to the walls around her room. She would imagine each one at bat or on the pitcher's mound or in the field as she listened to the games on the radio and kept score in a notebook. Ludtke still has her mother's collection of black-and-white photos.[10]

At *Sports Illustrated*, Ludtke was assigned to the baseball beat. As a baseball reporter, her primary job was still to check facts in baseball stories, but she also was given access to the press box and the field before Yankees baseball games. For a while she blended into the woodwork, just observing how the male reporters went about their business on the field before the games and in the press box during them. After a while, she was able to spend more time with Yankees manager Billy Martin, as the Yankees PR person made it possible for her to be in his office with the other reporters after games.

When she returned to her office, she sometimes suggested a story to a colleague or an editor. As time went on, they started telling her, "You go write it." Ludtke never challenged her lack of access to the locker room: better to fly under the radar and continue to learn on the job. "I didn't even think about making an issue of it," she says now. "Baseball was a bastion of male privilege. . . . I recognized I didn't have power there, and I also knew I didn't have power back in the office."[11]

When the Yankees won the pennant in 1977, though, the team issued her a locker room pass for the AL Championship Series. When they made it to the World Series against the Dodgers, Major League Baseball also issued her an all-inclusive credential. This surprised Ludtke and, in an effort to head off any controversy, she approached Dodgers manager Tommy Lasorda before the first game of the series and asked if he'd be okay with her going into the Dodgers locker room if she needed to interview a player. She also told him the Yankees had no problem with her presence, "but he wanted nothing to do with it," Ludtke says. "He brushed me off and said, go talk to Tommy John. . . . He's the player rep."[12]

John polled the players, and while it wasn't unanimous, they agreed that Ludtke had the right to be in the locker room after the game. But when Dodgers officials notified Commissioner Bowie Kuhn, he revoked her locker room access for the whole series, meaning she was not only barred from the Dodgers locker room but also could no longer go into the Yankees locker room. Bob Wirz, who ran media operations for Major League Baseball, told Ludtke that players' wives might be offended to

hear of her presence in the locker room, and the players' children might be ridiculed by classmates.

At the time, Ludtke didn't mention the incident to her editor, assuming it wouldn't change anything. She just went about her business as she had before she'd been issued the credential. But her editor got wind of the revocation and attempted to negotiate with Commissioner Kuhn before the series returned to New York for Game 6. The negotiated plan was one that the early pioneering women were all too familiar with: Ludtke would stand in the cacophonous cement hallway as her "runner" brought players out to her to be interviewed. It sounded good in theory to the men making the decisions, but Ludtke knew it would be an exercise in futility. With dozens of male reporters in the locker room, the idea of a player breaking away from the celebration to talk to her was unrealistic. Sure enough, after the Yankees won the series that night, Ludtke could hear the celebration inside the locker room and realized that everyone in America watching the game on TV could see what was going on inside while she waited alone for someone to come out for an interview. She tried to go down to Billy Martin's office via a side door, as she had done during the regular season, but that door was now barred to her. She wanted to interview Reggie Jackson, who had hit three home runs, all on the first pitch, earning him the nickname Mr. October. But by the time Jackson came out of the locker room, close to ninety minutes after the game, he was all talked out. "Which I totally understood," Ludtke says. "And that was it for the season."[13]

But it wasn't the end of the issue. After further negotiations with Major League Baseball failed, Time Inc., which owned *Sports Illustrated*, filed the now famous court case against MLB in December 1977: *Melissa Ludtke and Time, Incorporated v. Bowie Kuhn, Commissioner of MLB et al.*

In September 1978, Judge Constance Baker Motley ruled that Kuhn's actions had violated the equal protection and due process guaranteed by the Fourteenth Amendment by "substantially and directly" interfering with Ludtke's liberty to pursue her profession as a sportswriter. It was a watershed moment for women sportswriters, and the decision became national news. Ludtke, who'd always tried to downplay her role, was once again thrust into the glare of an unrelenting spotlight, as she had been the previous December when the case was filed. She became the fodder for snide remarks as writers made light of women in the locker room. "Most of the male writers viewed it as a comedy, led by the Pulitzer Prize–winning Red Smith," says Ludtke. "They did everything they could to avoid dealing with it as an equity issue. . . . They wrote things like, 'We'll know we've achieved true equality when we can go into Chrissie Evert's locker room.'"[14]

Brushing off those comments was easy, but the columns that did get under Ludtke's skin were the ones that questioned her knowledge

and her love of sports. "Did she ever spit in a baseball glove? Was her life absolutely dominated by sports when she was a kid?" wrote Leigh Montville of the *Boston Globe* the weekend after the Ludtke decision was handed down.[15] "It was like asking someone who was about to cover a moonshot whether they'd ever built a spacecraft," Ludtke says.[16]

Ludtke stayed with *Sports Illustrated* for only another year. She went on to work at CBS News and as a correspondent for *Time* magazine. She became a Neiman Fellow at Harvard University, after which she wrote her first book, *On Our Own: Unmarried Motherhood in America*. She also was editor of the quarterly journal *Neiman Reports* as well as the executive editor at the Schuster Institute for Investigative Journalism at Brandeis University. In 2010 she won the Yankee Quill Award for Lifetime Achievement, the highest individual honor bestowed on journalists in New England. She also was honored with the Mary Garber Pioneer Award by the AWSJ in 2003. Her impressive résumé notwithstanding, the court decision will always be Ludtke's legacy, though she knew at the time that it was only the beginning.

"I began to understand as time went by that it was going to be a longer process," she said in 2018 on the fortieth anniversary of the court decision. "And by that, I mean—going into court and affirming a right, what has to happen after that is a buy-in. A societal buy-in of cultural change."[17]

Not everyone was aware that the Ludtke decision only applied to Yankee Stadium. Other teams were still free to exclude women. But slowly, as more women challenged team policies by citing the case, the doors to locker rooms began to open. When baseball reporter Claire Smith was berated and shoved out of the San Diego Padres visiting locker room at Wrigley Field during the 1984 National League Championship Series, that was the last straw. Peter Ueberroth, who'd replaced Kuhn as MLB commissioner and had only been on the job for a few days, declared all MLB locker rooms open to female reporters.

That didn't mean all the players liked it. Some made it their mission to harass the women who dared enter their domain—or at least make the experience uncomfortable. Those who objected most strenuously were not big fans of the media anyway. But when it came to letting women in, some felt they were losing something precious: their all-male bastion, which conferred on them the right to act like little boys.

Before sports teams became megamillion-dollar enterprises, locker rooms were often just a semicircle of wooden cubicles leading to a shower room, housed in the cement slab of a stadium or arena basement. Sweaty, smelly, and somewhat claustrophobic, they were man caves before that term was coined, places where young men from different backgrounds formed bonds that led to their becoming a cohesive team. Often, there was plenty of "locker room talk"—the banter, boasting, and sexual innu-

endo that some athletes employ to build rapport with each other. Part of this phenomenon also involved the players literally strutting their stuff as they came out of the shower and lounged around after the game.

While some dismissed this behavior as "boys being boys," many believed it was part of a larger societal struggle. In her 1994 book *The Stronger Women Get, the More Men Love Football*, Mariah Burton Nelson devoted a chapter to the battle for equal access to the locker room. She asserted that women reporters were a major threat to the status quo: "She enters their locker room not to be seduced but to ask questions and to report those answers. . . . [A]s such she presents a threat unless the men can successfully sexualize her."[18]

Just about every one of the first wave of women sportswriters has stories about the way they were sexually harassed, or at the very least embarrassed, by the unwanted sexual innuendo they endured in those early days. In 1990, Jennifer Frey, as an intern for the *Detroit Free Press*, was told by Detroit Tigers pitcher Jack Morris, "I don't talk to women when I'm naked unless they're on top of me or I'm on top of them." When the newspaper complained about Morris's treatment of Frey, Tigers president Bo Schembechler accused the newspaper of displaying a "lack of common sense" by assigning Frey to interview Morris.[19]

Even after NFL commissioner Pete Rozelle opened all National Football League locker rooms to women, some players were resentful and refused to talk to them. Others would test a female reporter as if she were a substitute teacher in a rowdy classroom, pulling pranks, throwing jock straps, and dropping towels to see what her reaction would be. Paola Boivin was three years into her career with the *Arizona Republic* when she first stepped into a professional clubhouse. Within a couple of minutes, a player was in her face, asking her if she was there to interview someone or just to "look at a bunch of guy's dicks."

"At that moment, I felt something hit my shoulder. It was a jock strap and it stuck on my shoulder, unfortunately," recalls Boivin. "That day I almost quit. I wondered if that was what I was going to have to be dealing with." Boivin, twenty-five then, did everything she could after that to make herself invisible. "I never wore perfume," she recalls. "I didn't want anyone to even smell that there was a woman in the room. . . . I probably didn't ask the toughest questions as I should have either, because I didn't want there to be any confrontations."[20]

In those days, confrontation was to be avoided at all costs. Joan Ryan, a feature writer for the *Orlando Sentinel* in 1985, became the victim of harassment when she entered the locker room of the Birmingham Stallions of the United States Football League to conduct an interview. She had asked the person in charge of PR to bring a player out to the hallway, but he'd told her he couldn't accommodate her request. Once inside, several

Paola Boivin in the early days when she wrote for the *Arizona Republic.* She now is the director of the Cronkite Phoenix Sports Bureau at Arizona State University. *Photo courtesy of Paola Boivin*

naked players closed in on her and began making sexual remarks. She managed to ignore them as she sought out the player she was there to interview. But when she felt the blade of a razor gently stroking her leg, she fled the room, passing the owner of the team, Jerry Sklar—who was standing in the doorway, chuckling.

In her subsequent column about the incident, Ryan called the players little boys who never grew up, who equate manliness with power. The column was titled, "And Sometimes We Wonder Why We Call Them Animals." Later, when Ryan confronted Sklar, he called her unladylike for being in the locker room and said any woman who enters a locker room just wants to look at naked men.[21]

In June 1986, Susan Fornoff of the *Sacramento Bee* made headlines after a pink corsage box containing a live rat was delivered to her in the press

box by an usher. The usher said the box was from the Oakland A's designated hitter Dave Kingman, with whom Fornoff had previously had run-ins over her presence in the locker room. The box had a card attached to it that read, "My name is Sue." When Fornoff took the cover off, the tissue paper inside rustled. She realized it was alive and closed the lid.[22]

"It's just another in a long line of harassments from him," Fornoff said later that year. "He thinks a lady should be a lady. He just doesn't think I belong in the locker room."[23]

The publicity from that incident may have helped to improve things in the Oakland locker room, but like many sportswriters, Fornoff still faced harassment on the road. She recalled one night when she was in the Boston Red Sox locker room trying to interview Dwight Evans after a game in which he had thrown out a runner at home plate to preserve the Red Sox victory. Players started chucking rolls of athletic tape at her and one came up behind her and kept up a steady wolf's howl until she abandoned the interview. A few players apologized after she complained to management, citing their exuberance after winning the game.

"But why was all that excitement directed at me?" Fornoff wondered.[24]

Lesley Visser made it obvious in her congenial way that she had a job to do by yelling out the name of the player she needed to interview before approaching his locker. But even she endured the occasional unwelcome sexual innuendo from a churlish player. She recalls one day close to Christmas when Chicago Bears quarterback Jim McMahon called her over to his locker. Thinking she was getting some candy canes or cookies, she cringed as she unwrapped a black negligee.[25]

Some women were able to avoid unwanted harassment by forging alliances with the athletes they covered. Shah says she never had a problem in the locker room because she'd always felt more comfortable around men than women as a kid. She could banter with the best of them and usually got the last laugh. One day, a teammate told baseball player Willie Wilson to keep his pants on because Shah was in the room. Wilson said, "Oh you know what they say, you've seen one, you've seen 'em all." Shah countered with, "No Willie, you're wrong. It's always a pleasure."[26]

Christine Brennan managed to stay above the fray by taking a philosophical approach to the situation. This was the men's locker room, after all, and as such, she was the invited guest who needed to mind her manners, no matter how rude the players were. During football season, she usually wore a long wool coat that looked just like those the men wore. She used peripheral vision to confirm that players she needed to interview were at least partially dressed before she approached them. She always carried an 8.5 x 11 notebook that hid a player's midsection when he was standing in front of her (just in case his towel came loose or some prankster yanked it off).[27]

No female sportswriter wanted to be branded a "looker." With the confidence and outsized egos that helped make them successful athletes, many players assumed that women sportswriters must be "lookers"— groupies with press passes, there to check out the scene or lay the groundwork for a hookup with a player. That mindset prompted members of the New England Patriots to harass Lisa Olson of the *Boston Herald* in September 1990. In an incident that Olson later called "mind rape," three players approached her as she was trying to conduct an interview with a fourth player. The players positioned themselves inches away from Olson and dared her to touch their private parts. Ringleader Zeke Mowatt, standing on a scale an arm's length from her, said, "Is this what you want?" as the others stood by and egged him on.

Plenty of those first women sportswriters had heard similar remarks from across the room while they interviewed players. But this incident was unique in terms of its aggressiveness and Olson's sense that she could not ignore or escape from it. Early in the season, players had begun spreading rumors about Olson "being a looker." Olson, twenty-five at the time, has said that she did not conduct herself in the compliant manner that the athletes might have expected of her. While the earliest female pioneers believed they needed to act like stenographers, staring down at their notebooks and only occasionally looking up to make eye contact with the players they were interviewing, Olson believed that telling a good story meant going beyond mere quotes by painting a picture of the player's actions and reactions immediately after the game. And that necessitated observing her surroundings. "I was naive enough to think the Patriots understood what it meant to be a reporter," she wrote in a column a few days after the incident. "That they knew it was my business to look around the locker room. . . . It is my job to observe who is injured, to see who is throwing chairs, to capture the mood of the day."[28]

Indeed, Mary Jo Kane, a sports sociologist, theorized that Olson's only "crime" was acting like all the male reporters in the locker room after a game. "When women enter the male domain of the locker room (and act like they belong there) the gender order is upset," wrote Kane. "This was a performance designed not to teach Olson *not* to look, but to teach her *how* to look."[29]

The incident occurred long before Twitter, but it garnered plenty of press nationwide as the NFL decided to investigate. Team owner Victor Kiam fanned the flames by calling Olson a "classic bitch" and referring to the incident as a "flyspeck in the ocean." He later apologized, but the remarks enabled players to continue to taunt Olson and unleashed the vitriol and misogyny of Patriots fans. In the civil lawsuit she filed months after the incident, she testified that her tires were slashed, her apartment was broken into, she received more than one hundred obscene phone

calls, and she was spat upon while covering other events. In November, the National Football League issued a sixty-page report on the incident that corroborated much of Olson's account. The NFL's investigation led to minimal fines against the three players that Olson named, along with a $50,000 fine against the Patriots organization. But most of the fines were never paid and the threats and harassment didn't stop. Olson's lawsuit was eventually settled out of court after she had moved to Australia. She lived there and wrote for another Rupert Murdoch paper for six years before coming back to the United States to write for the *New York Daily News*.[30]

Thirty years later, Olson is a freelance writer living in Arizona, near the place where she grew up and dreamed about being a sportswriter. She has never liked talking about her 1990 ordeal, but she is grateful when people recognize her career and her courage, as the AWSM did in 2013 when the group presented her the Mary Garber Pioneer Award.

"Few people in the world have résumés as illustrious and international as the one Lisa Olson has compiled over the course of her career," said Stef Loh, the president of the AWSM, in announcing the award. "Lisa started her career at a time when sports media was a very different, much

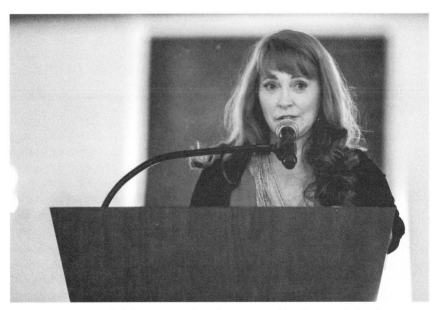

Lisa Olson was awarded the Mary Garber Pioneer Award by the Association for Women in Sports Media in 2013. In her acceptance speech, she said, "I was so blessed to have this incredible army of women behind me—they're still behind me." *Photo courtesy of Arianna Grainey*

less welcoming environment for women, and her longevity in the industry and body of work is testament to the impact she's had in the field of sports journalism. . . . The sports world would be a different place without her."[31]

To a new generation of women sports reporters, going into a male locker room is still an initially unnerving rite of passage, but the continual conflicts that dogged the early pioneers are mostly a thing of the past. Male athletes grow up seeing women sportswriters and broadcasters on TV sports shows, on the field before games, and in their locker rooms. They don't find a woman in their midst as jarring as many of them did forty years ago.

Lisa Horne, a college football blogger, remembers her first time entering a men's locker room at the University of Southern California in 2009. She was the lone female there and admits she was petrified. After about ten minutes, though, she realized that the men were strolling around in various stages of undress, nonplussed by her presence. "The key is to gain the players' respect and trust," she wrote in a *Bleacher Report* column in 2009. "Prove to them you know your stuff, and you will have proven to them why you belong there."[32]

Individual reporters still run up against locker room issues from time to time, and there are still individual athletes that women learn early on to avoid. Boivin, now the digital director of the Walter Cronkite News Phoenix Sports Bureau at Arizona State, still advises her students to dress conservatively and be super-prepared for their interviews. She thinks it's still an important conversation to have even though she says, "This is a group of sports journalists that are more confident and comfortable in their skin, and I love that about them."[33]

In 2014, Diana Nearhos encountered boorish behavior from the minor-league hockey players she was covering in Glens Falls, New York. Some of the players would drop their towels in unison and stand there gyrating their hips as she interviewed their teammates. Instead of reacting, she just ignored them. But when she moved on to her next job, she told the head coach about her past experiences and received assurances that the locker room would not be an issue. "She handled it very well," says Rachel Lenzi, who writes for the *Buffalo News*. "I was impressed at how she made a really bad situation better by being proactive."[34]

Lenzi was part of a panel about sexual harassment at a recent AWSM conference. While things have improved greatly, she says, women still have to set boundaries for themselves with coaches and players. She told the story about walking into the Portland (Maine) Pirates minor-league hockey locker room one day and having a player walk by stark naked. In a strident tone, he said, "So we just let anyone in our locker room now, don't we.'" Lenzi ignored him as she sought out another player to inter-

view. But she approached him later and told him how unprofessional he'd been. The player apologized. "It was weird because I'd talked to him over the phone that summer and he'd said if you need anything, give me a call," she says. "I tell the young women don't be afraid to advocate for yourself."[35]

These days, a female reporter is hardly ever the lone female in the locker room, and if she is, she might announce her presence the way Lenzi did one night in 2014. On deadline after a long game, she raced into the Pirates locker room, only to find the player she wanted to talk to starting to undress. "Keep your pants on Alex . . . I'm on deadline," she told the young player who'd scored the winning goal. "Eight guys just busted out laughing," she recalls. "And I'm like, 'I'm sorry but I need a quote.'"[36]

4

Claire Smith:
Hall of Fame Baseball Writer

Claire Smith was in the right place at the right time when the court decision that opened the New York Yankees locker room to women in 1978 was handed down. The decision put within reach her enduring dream of covering a Major League Baseball team. In 1983, the *Hartford Courant* assigned Smith to the Yankees beat, making her only the second woman to cover MLB on a full-time basis. (Alison Gordon in Toronto was the first, in 1979).

Smith grew up in Bucks County, Pennsylvania, during the 1960s. She was the only Black child in her middle school class, which pushed the already shy child further into her shell. But she loved writing and she loved listening to the Los Angeles Dodgers on her transistor radio. Years earlier, she'd fallen in love with Jackie Robinson after the nuns took her third grade class down to the school's basement to show them the movie about Robinson (in which he played himself). "I put a voice and a face to the legend," she recalled in 2017. "It probably helped me in some subconscious way to want to be a storyteller and tell stories such as that."[1]

When she was nine years old, Smith's parents gave her an antique typewriter. Still, she didn't make the connection between her love of writing and her passion for baseball until halfway through college. At first, she thought she might want to be a lawyer. But nothing excited her the way baseball did. Smith and her college friends would hit the road in her car any time Los Angeles was playing on the East Coast so that she could watch her beloved Dodgers. Their wildest trip was from Penn State to Cincinnati and back in one day. "I had the car and the fanaticism. . . . They were just along for the ride," she recalls. "In those days, the team

Baseball writing pioneer Claire Smith, right, sits with Rachel Robinson, the widow of baseball pioneer Jackie Robinson, during the 2017 Baseball Hall of Fame induction ceremonies in Cooperstown, New York. Smith was awarded the Baseball Writers Association Career Excellence Award during the proceedings, the first woman to earn the honor. *Photo courtesy of Reed Saxon*

bus pulled right up to the stadium, so if you were a fan, you could stand outside and chitchat with the players."[2]

After two years at Penn State, Smith was drifting toward a career in baseball, but she still wasn't sure what shape it would take. She wrote to Chicago White Sox owner Bill Veeck to find out if he had any jobs for her in the front office or the clubhouse. Veeck was known for his innovative thinking when it came to promoting his teams. Back in 1946, he had been the first American League owner to sign a Black player (Larry Doby) when he owned the Cleveland Indians. The following year Veeck signed Negro League star pitcher Satchel Paige, then forty-two, making him the oldest player to start a career in Major League Baseball. Smith had what she describes as the "daffy" idea that Veeck might be receptive to a woman on staff. He didn't offer Smith a job, but he did write her an encouraging reply. Dodgers first baseman Steve Garvey, with whom Smith

had become friendly during their postgame chats, also encouraged her to pursue a career as a writer.[3]

Her parents also supported her desire to do something in baseball. They had instilled in her the notion that she could be whatever she wished. Her father, William, was a sculptor and a painter, and her mother, Bernice, worked for General Electric as a rocket scientist, helping to build fuel cells for NASA.

"I come from a family of dreamers, but also people who acted on that dream. So, it was push, push, push ahead and they weren't going to let things like gender or race stop them," she said in 2017.[4]

With her parents' blessing, Claire transferred to Temple University in Philadelphia. She still thought she might find her way into baseball by working in a team's front office, so she began taking courses in public relations. After an introductory course in journalism, however, she shifted gears and made it her goal to land a job as a sportswriter with the *Philadelphia Bulletin*, the paper she read growing up. In 1979, she was hired as a news reporter by the iconic publication, but her path into the *Bulletin*'s sports department seemed blocked. Soon after, when she told the *Bulletin*'s managing editor that *New York Newsday* had offered her a job covering high school sports, the editor sent her down the hall to the sports department.[5]

Around the same time the *Bulletin* folded in 1982, the *Hartford Courant* was looking for a baseball writer to cover the Red Sox, Yankees, and Mets. Sports editor Jim Smith decided to take a chance on Claire. She didn't disappoint. By midseason, she had become the full-time reporter covering the Yankees. Her energy and her ability to establish rapport with players and coaches got her plenty of "inside baseball" scoops and her writing, sprinkled with wordplay, was a delight to read. In one column for example, as San Francisco Giants slugger Barry Bonds chased the all-time home run record while continuing to deny his use of steroids, Smith wrote: "Barry Bonds may enter the 2007 season second only to Hank Aaron on the all-time home run list, but in the story line that should matter the most, Bonds is still pleading the Fifth."[6]

Outside of baseball, Smith is probably best known for an incident in 1984 that served to break down the final barrier to women covering baseball. Soon after the 1978 court decision involving Melissa Ludtke of *Sports Illustrated* and the Yankees, the other American League teams fell in line and allowed women into their locker rooms. But National League commissioner Chub Feeney had a laissez-faire approach, leaving it up to individual teams to make their own policies. When Smith was assigned to cover the San Diego Padres–Chicago Cubs National League Championship Series in October 1984, she wasn't sure what the situation would be.

Before the first game at Wrigley Field in Chicago, the *Courant*'s editor had been assured by Feeney that Smith would have full access to both teams. But the Padres, managed by curmudgeonly veteran Dick Williams, were not about to lift their long-standing prohibition against women in the locker room. Maybe it had something to do with the fact that Williams's Padres had just lost to the Cubs, 13–2. But for whatever reason, when Smith walked into the Padres locker room, players began cursing at her and yelling, "Get her out of here!" Suddenly she felt a hand placed in the middle of her back, pushing her firmly out the door. Williams walked in as she was exiting and basically ignored her pleas. The thirty-year-old beat reporter stood outside the locker room, imploring team officials who happened to walk by to bring players out for her to interview. But no one did. As Smith grew frustrated to the point of tears, her old friend, Padres first baseman Steve Garvey, emerged from the locker room. He said he would help her get some quotes, but she had to calm down and remember that she had a job to do.[7]

Smith got her story, and her banishment made news as well. The next day, MLB commissioner Peter Ueberroth decreed that all locker rooms would be open to women. Smith surmises that Ueberroth, who had directed the highly successful 1984 Olympics in Los Angeles, was embarrassed by the bad publicity. "The next day, he said, 'The clubhouse is open. This is nonsense,'" Smith recalled in 2013.[8]

There were still pockets of resistance among ballplayers and club owners, but just like Jackie Robinson, the ballplayer she'd admired most while growing up, Smith proved to be the perfect person to change attitudes and lead the way in making equal access to women reporters the norm. Her dignified and respectful style won over most ballplayers and other writers.

Smith went on to work for the *New York Times* and the *Philadelphia Inquirer*, becoming a noted commentator on the national baseball scene. When Barry Bonds was chasing Hank Aaron's home run record, Smith was one of the few writers granted an interview with the recalcitrant hitter.[9]

It wasn't easy being a single-minded baseball writer and a single mother at the same time. Smith often had her young son and her two godsons in tow during spring training. She also took them to MLB all-star games and the World Series. They spent a vacation in Colorado so that Smith's son, Joshua, whose godfather is former Yankee Don Baylor, could hang out in the dugout and stand on the field "to see life from that vantage point."[10]

Smith is retired now, the victim of the COVID-19 layoffs at ESPN in November 2020. She began working for ESPN in 2007, becoming part of a "merry little band of newspaper expats" who traveled the country as editors, helping provide details and context to events ESPN was covering. Smith spent part of her time with Joe Morgan and Jon Miller as part of the

MLB Game of the Week crew. She'd gotten to know them via an on-air appearance during MLB's first-ever Civil Rights Game in Memphis in 2007. She talked about Effa Manley, the first female owner of a Negro League baseball team and the first woman ever to be inducted into the Baseball Hall of Fame. "It turned out they didn't know anything about her, so Joe said you should come on the air and talk about her," she recalls. "What was supposed to be a half-inning interview turned into a full inning."[11]

There isn't much Smith doesn't know about baseball history. But she is always pointing out that she was actually in the second wave of women sportswriting pioneers. The doors, she says, were already cracked open when she came along. She is also quick to note that other women, such as Lisa Nehus Saxon, Alison Gordon, Melissa Ludtke, and Susan Fornoff, were covering baseball in the 1970s and '80s, if not always traveling with their teams. None of them, however, was still doing it more than two decades later.

Smith holds the distinction of being the only female baseball writer—and one of only four African Americans—recognized by the Baseball Writers' Association of America with its Career Excellence Award. Her name and artifacts from her career are in the permanent Scribes and Mikemen exhibit in the library of the National Baseball Hall of Fame in Cooperstown, along with those of such notables as Red Smith, Damon Runyon, and Roger Angell. Smith also earned the Mary Garber Pioneer Award from the Association for Women in Sports Media in 2000 and the Legacy Award from the National Association of Black Journalists in 2011.

"Reading her gave me the confidence to find my own voice," said Jemele Hill, a colleague of Smith's during her time with ESPN. "She's not just somebody that covered the game. Claire has become a part of baseball history."[12]

Smith credits her legacy and longevity to those who believed in her. She also acknowledges the role persistence played. In the back of her mind there was always a voice telling her never to let anything stop her. And since that day outside the Padres locker room, nothing has.

5

Pioneers in
Sports Broadcasting

Many sports fans think of Phyllis George as the trailblazer when it comes to women sportscasters on the national stage. George, a former Miss America, joined CBS's *The NFL Today* broadcasts in 1975 and proved to be just what CBS was looking for in a cohost. It didn't matter that she knew few of the technical details when it came to football. She was bright, warm, and friendly, and her interviews were often lively and fun to watch.

But George was by no means the first woman broadcaster to rise to the national sportscasting scene. Just as women sportswriters were making inroads in sports departments during the 1960s and '70s, so too were women sports broadcasters. Women such as Jeannie Morris in Chicago, Andrea Kirby in Baltimore, and Jane Chastain in

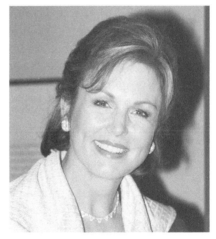

Former Miss America Phyllis George was the first woman to cohost a National Football League pregame show when CBS hired her in 1975. Her mere presence, for a total of seven years, influenced a generation of girls to pursue careers in sports broadcasting. *Photo courtesy of John Mathew Smith and www.celebrity-photos.com*

Miami were reporting from the sidelines and anchoring sports broadcasts in major local markets. Each of them briefly broke through to the

national stage and proved that women could deliver the scores, conduct interviews, provide behind-the-scenes details, and most importantly, win acceptance from viewers. For these pioneers, however, acceptance was often hard won, and they endured many of the same indignities that female sportswriters faced. Nevertheless, over the course of their careers, they opened doors for the many women who followed.

Jeannie Morris, one of the earliest pioneers, was a sports fanatic growing up in Southern California. She became an expert on professional football thanks to her husband, Johnny Morris, who played for the Chicago Bears from 1958 to 1967. Morris began her journalism career accidentally in 1967 at the age of thirty-two. An editor at the now-defunct *Chicago American* asked her husband if he would write a weekly column. Johnny recommended his wife, who was home raising their four children at the time. She gladly took on the job. The column, "Football Is a Woman's Game," ran on the Women's page of the paper, under the byline Mrs. Johnny Morris. Her columns were well received, and she was soon being invited to do on-air appearances at the local TV stations. Sometimes she was paired with her husband, who'd begun his own broadcast career while still playing for the Bears.[1]

Overall, Jeannie Morris spent more than twenty years as a sports reporter, producer, and host. In 1973, she was the first woman to report live from a Super Bowl. That was an inauspicious start, however. She participated in NBC's pregame show in the studio but was relegated to the stands to interview the players' wives after the game. Some might conclude that Jeannie rode Johnny's coattails into sports journalism, and his popularity surely didn't hurt. But Jeannie made a name for herself early on as a dogged and determined reporter. One day she was assigned to write about former Red Sox slugger Ted Williams, who managed the Texas Rangers/Washington Senators from 1969 to 1972. According to Morris, when Williams saw her approaching the Rangers visiting dugout, he said, "This is my dugout, get out of here. No women in my dugout." But Morris stood her ground and replied, "This is not your dugout. It belongs to the Chicago White Sox and they said I could be here. Okay?" To which Williams grumbled, "Okay."[2]

Another time, early on in her career, she was denied entry to the press box for a Bears-Vikings game. She sat outside on the roof of the press box instead. As she recalled later, it wasn't much fun, but it certainly made for a good story.[3]

Morris said she was never intimidated by anyone she covered, whether it was Chicago Bears coach Mike Ditka or irascible Bears quarterback Jim McMahon. "I think after being the wife of an NFL player for 10 years . . . I knew that all these guys were among the most insecure people in the world," Morris said in 2014. "And I was just naturally curious." Ditka

once followed her off the set after a TV interview and berated her for asking him a question he thought was a little too tough. They ended up becoming good friends. McMahon flipped Morris off during a postgame interview, thinking he was making it impossible for her to use the segment. Instead, she made the exchange part of her report (blurring out McMahon's middle finger). She said McMahon didn't speak to her for the rest of the season.[4]

Because of her success and popularity in Chicago, Morris found her way onto NBC's national broadcasts from time to time. In 1975, Carl Lindemann Jr., the network's vice president in charge of sports, exposed the attitudes that prevailed in terms of women's national broadcast opportunities. "She's really a pretty lady and highly articulate," said Lindemann. "I'll use Jeannie as often as I can."[5]

Morris was the first woman to win the Ring Lardner Award for excellence in sports journalism in 2014. She also wrote books about Brian Piccolo, the Bears player immortalized in the movie *Brian's Song*, and Carol Moseley Braun, the first African American woman to become a US Senator. "Jeannie Morris changed sports journalism," said Billie Jean King when Morris died in December 2020. King got to know Morris when she lived in Chicago after her tennis career ended. She called Morris a true trailblazer, who was successful in a world where 95 percent of the media was controlled by men. "She paved a way for future generations of women in sports journalism and once told me, 'All it takes is for one little girl to see it to know it is possible,'" King said.[6]

Another woman who moved the needle for women broadcasters was Andrea Kirby. Around the same time Morris was breaking into broadcasting, Kirby was beginning her sports broadcasting career at a small station in Sarasota, Florida. After graduating from the University of Alabama in 1963, she was a weather girl for a local TV station in Atlanta. A few years later, divorced and living in Sarasota, she called up the WXLT-TV program director, who told her there were no positions on the weather desk, "and I said great because what I really want to do is sports," Kirby recalled in 2015. To prepare for her audition, Kirby knew she needed to find a way to stand out. She showed up on crutches and with her leg wrapped in an Ace bandage. She explained that she'd hurt herself playing tennis, describing how she sprawled on the court to win the final point of the match. She got the job and soon was learning all facets of broadcasting, from filming to producing to anchoring and directing the broadcast.[7]

Kirby says the audiences and people she interviewed almost always accepted her readily. But some of her colleagues at the station weren't so welcoming. Kirby recalled one time when a cameraman purposely forgot to take film with him on an assignment that featured her doing a first-person segment at a tennis challenge. The match pitted her against

former Australian Davis Cup player Doug Smith, the tennis pro at a lo-
cal club at the time of the segment. It was billed as another Battle of the
Sexes, and Smith played with a skillet instead of a racket. The match
wasn't close but it was full of laughs, and Kirby thought of it as a great
way to promote herself and the station. But instead of being able to show
film of the experience, she had to describe it from a desk in the studio.
She decided not to complain, figuring it was part of paying her dues and
earning respect. The cameraman was scolded by his boss but suffered no
lasting repercussions.

"I think it was a jealousy thing. Some of the cameramen and other re-
porters thought I was getting attention because of being a woman," she
said in 2014. "The fact is I was very good at what I did, so I got the respect
on the air which was what mattered."[8]

While in Sarasota, Kirby made a connection with ABC Sports producer
Chuck Howard, who was in town to film a segment of *Superstars*, a two-
hour show that featured ten top athletes from ten different sports compet-
ing in events other than their own. Kirby says when she knocked on the
door of Howard's trailer and a voice asked who was there, she replied,
"Tell him it's the first woman broadcaster at ABC Sports." Howard was
polite but basically told her she needed more experience, which she got
at her next stop, WJZ-TV in Baltimore. Four years later, after faithfully
sending Howard a birthday card each year, Kirby was offered a job on
Wide World of Sports and *College Football Scoreboard*. She worked for ABC
for three years, but her contract was not renewed. Kirby says she never
felt as though ABC had a plan for how best to develop her role. For the
next several years she had lots of freelance assignments and gigs with
NBC and the USA Network but was never able to land another full-time
network job. In 1985, she decided to carve out a new niche for herself by
starting the New York–based Sports Media Group to help sports figures
with media relations.

"I didn't think of myself [as a pioneer]. I was a sports fan my whole
life," she said in 2015. "I'm almost happy I was in on the beginning. Ev-
erything I did felt original, fresh. It was one of a kind."[9]

ABC also hired 1964 Olympic swimming champion Donna de Varona to
work first at one of its local stations and then on its iconic network sports
program *Wide World of Sports*. Other former athletes, such as Billie Jean
King and Mary Carillo, followed her.[10] But the other two major networks
were slow to hire women. Finally in 1974, spurred on by the successes
of women at local stations (and to fulfill quotas mandated by the Fed-
eral Communications Commission), Bob Wussler, head of CBS's sports
coverage, hired Jane Chastain to become part of its NFL broadcast team.
Wussler knew he was taking a chance putting Chastain on the network's
highest visibility sports program, but he decided the time was right.[11]

Chastain had started her broadcast career just two years after graduating from high school by predicting football game outcomes for an Atlanta TV station. When she was starting out, she said she came across as a shy child with buck teeth "who was always the class president but never asked to the school dance." She soon transformed herself into a confident savant when it came to sports prognostication.[12]

When CBS came calling, Chastain was working in Miami as a sports reporter at a local station and also doing a quirky daily show called *Girls Rules*, which was syndicated to 205 stations across the country. It was the kind of show designed to draw more women to the sports broadcast but also keep the interest of male viewers. To that end, Chastain dressed for the part in sexy sweaters and full-length gowns and filmed segments in grocery stores, in concert halls, and in her living room. For one segment, to explain what a basketball pick was, she staged a demonstration with little old ladies pushing around shopping carts, one blocking the aisle so that another could squeeze by to get a coveted item off the shelf. Another time, she demonstrated how an offensive line works by moving sugar cubes around during a tea party. But even with the quirks and comedy, it was obvious Chastain knew what she was talking about and that she was tireless in not only producing a good show but reporting on sports. The expertise she showed in these short daily segments won her a following, among them some of the members of the Miami Dolphins, whom she covered during the football season.[13]

CBS's Wussler was also a fan. Observing that Chastain had sex appeal and expertise to boot, he thought she might be the perfect woman to cohost an NFL football broadcast and break down the societal barriers holding women back. But her first appearance in a regionally televised game produced a rash of negative phone calls and seven hundred letters complaining about a woman in the broadcast booth. Some said they turned the TV sound off rather than listen to analysis being offered by a woman. The criticism unnerved her bosses (all male), and their reaction and subsequent advice to her was contradictory. For an upcoming game in Chicago, they decided she should play up her gender by not talking too much about the game, instead spending more time injecting comments about what the women were wearing. However, they also told her to play down her femininity by wearing her hair in a bun and by toning down her makeup. The conflicting directives unnerved Chastain, who'd spent the better part of the previous thirteen years as a confident, aggressive sports reporter.

"I kept getting shuffled around from producer to producer, and none of them knew what to do with me," she recalled several years later. "I found myself interviewing cheerleaders and ball boys. It was a terribly unhappy and sometimes humiliating experience."[14]

When Chastain got pregnant the following year, she was replaced by Phyllis George, whom Wussler had hired as an interviewer the previous year. A chagrined Wussler took some of the blame for Chastain's difficult experience, conceding he had made a mistake in thinking sports fans were ready to hear a woman talking about football.

"I knew from the day I said I was going to bring women in here . . . that the first woman would have her head handed to her," Wussler said in 2015. "Jane has had her head handed to her and has very calmly taken her head and put it back on her shoulders and she walks tall."[15]

Chastain returned to Miami and picked up where she left off, reporting sports on a daily basis until she and her husband moved to Los Angeles. There, she anchored the sports report for KABC-TV, helping to transform the broadcast from a scores-only segment to a program that spotlighted personal stories and human-interest angles. Chastain left broadcasting in 1981 and has become a political commentator and writer. Bernie Rosen, her former boss in Miami, blamed Chastain's unsuccessful stint with CBS on timing. "Nowadays," he said, "she'd be a superstar."[16]

Phyllis George, the 1971 Miss America, became the superstar that Chastain was not. George didn't pretend to be anything but a football fan when she joined *The NFL Today* broadcasts in 1975. In her seven years hosting *The NFL Today*, she proved to be a popular figure on the show, perhaps because her presence did not offend male viewers. *The NFL Today* became must-see TV for many people because of George's role. On the road, she got as many autograph requests as the players did. As a former Miss America, she had a classically charming Southern style that disarmed the football players she interviewed. Before George, national TV broadcasts did not delve into the personal lives of the players they covered. It can be said that George helped standardize the up-close-and-personal genre in TV sports that ABC's *Wide World of Sports* had pioneered in the late 1960s.

George radiated positivity on the set, but she proved that she was no pushover in the way she handled the crude comments and rude behavior from one of her cohosts, "Jimmy the Greek" Snyder. "He made my life miserable," George wrote in 2011. "I just put up with it until one day he really crossed the line and I said, 'That's it. It's either him or me.'" George accepted a compromise whereby Jimmy the Greek taped his segments, while Brent Musberger, Irv Cross, and George did the game day show live.[17] Perhaps not surprisingly, in 1988, long after George had left the show, Snyder was fired for his comments that African Americans were superior athletes because their slave ancestors had been bred for strength.[18]

By the time George left the show to pursue other interests, there were women covering football at various newspapers and TV stations around the country. Many hoped that George would be replaced by someone

perhaps equally as charismatic, but more knowledgeable about football. Instead, she was replaced by Jayne Kennedy, a former Miss Ohio, a Miss USA semifinalist, and one of the "Ding-a-Ling Sisters" on Dean Martin's TV variety show in the early 1970s. Kennedy was touted as the first female African American sports broadcaster on the national scene, and she won an Emmy for her coverage of the Rose Bowl Parade. But she left the show in 1980 to pursue an acting and modeling career.[19] George took one more turn in *The NFL Today* chair after Kennedy left and then moved on to other pursuits in 1983.

George has been hailed as someone whose career in sports did much to advance the cause of women in broadcasting. And there's no denying that her longevity was a turning point for women in sports broadcasting. Betsy Ross, best known for her work for ESPN as an anchor and a play-by-play announcer, began her broadcast career as a news reporter and anchor after graduating from Notre Dame in 1977. But her first love was sports, and seeing George on *The NFL Today* every Sunday spurred her to pursue the switch to sports journalism. "I thought, 'I can't be Miss America, but I can do interviews.' So she was the first one who gave me the idea that I can take this passion I have for journalism and somehow parlay that with the passion I have for sports," Ross said. "What she did and what she had to put up with made it possible for so many of us who wanted to get into sports journalism. . . . I'll always treasure that."[20]

Washington Post columnist Sally Jenkins also praised George as a groundbreaker. George may have been hired in part because of her beauty, Jenkins said in 2020, but "Phyllis owned herself. She owned it. People debate what real feminism is, but for me it is what she did. Nobody used her. She used her own image."[21]

Gayle Gardner, a pioneer sports broadcaster for ESPN, however, found fault with the image George conveyed. In a 1987 interview, she asserted that George's presence on a national broadcast betrayed the attitudes of most network executives toward women at the time as well as the stereotypes that it took years to undo. In essence, she said, George was being used to keep women in their place. "They didn't want a legitimate broadcaster," Gardner told the *Philadelphia Daily News* in 1987. "They wanted someone to whom they could say, 'Go do your little fluff thing. Talk to a celebrity or something.'"[22]

When I watched Phyllis George, I saw someone who was friendly, gracious, and by no means the empty head that some critics were calling her. She reminded me of Jane Pauley, who started hosting *Today* around the same time. However, Pauley asked tough questions when called upon to interview political figures, while George's style was nonconfrontational. In fact, she once admitted that her brief tenure as a coanchor on the *CBS Morning News* was not a comfortable role for her. Still, it is safe to say

that George advanced the ball for women in sports journalism. During her time at CBS, a growing number of women were hired at the local level, and women who were interested in broadcasting careers no longer had to start out on the weekend weather desk. With knowledgeable and talented female broadcasters in the pipeline, network executives slowly began to come around to the idea that the public, and specifically sports fans, would watch women delivering sports news and commentary—if they combined their expertise with good looks and an affable style. Lesley Visser, who was recruited by CBS while she was covering the NFL for the *Boston Globe*, was the best example. She was hired as a sideline reporter in 1984 and CBS gave her time to become a confident, polished broadcaster. When she appeared on *The NFL Today* in 1990, she was the first woman to do so since George had left. "I don't know if everybody is ready to hear a woman tell them that so-and-so is going to run off left tackle," Visser told Sally Jenkins. "But you know what, they're going to hear it."[23]

Still, it wasn't until a few years after a fledgling all-sports cable channel based in Bristol, Connecticut, came on the scene in 1979 that the doors were truly flung open to women in sports broadcasting.

6

ESPN: Game Changer for Women

In the early 1980s, many TV executives assumed that hard-core sports fans would balk at seeing a woman delivering their sports news. Forty years later, at ESPN, ESPN2, and their sister channels, women are writing, producing, editing, anchoring, cohosting, appearing on panels, and reporting from live events. There is little fear among executives that their expertise will be questioned. Instead of hoping to gain a foothold in a male-dominated environment, women at ESPN now find themselves vying with other women, as well as men, for some of the most coveted roles. The example set by the "Worldwide Leader in Sports" has changed the landscape for women in the industry exponentially.

That wasn't the case for the first decade or so of the twenty-four-hour basic cable sports channel's existence. When ESPN began broadcasting in 1979, it was typical of new and emerging technology start-ups. Most employees were young males willing to work long hours for low pay, and they treated their workplace, housed in buildings still under construction, as an extension of their college dorms or locker rooms. They pulled all-nighters in the newsroom and partied hard outside of it. While one of the very first scores reported on was Chris Evert Lloyd defeating Billie Jean King 6–1, 6–0 in the 1979 US Open women's semifinal, treatment of women inside ESPN's headquarters in Bristol, Connecticut, was fraught with sexism. There were few rules of comportment and people were rarely punished for inappropriate behavior toward women. In his 2001 book *ESPN: The Uncensored History*, Michael Freeman reports that between seventy-five and one hundred sexual harassment complaints were made by women throughout the company during a three-year period in

the early 1990s. This figure came from an unidentified former senior manager and was disputed by ESPN as "preposterous." The company would acknowledge only that between 1989 and 1993, eight women filed thirty formal complaints against fellow employees. Many more complaints never reached human resources and were settled off the record, according to John Walsh, who oversaw day-to-day operations in ESPN's production department.[1]

Just how bad were the early years? Karie Ross Dombrowski worked as a reporter and as a *SportsCenter* anchor from 1987 to 1989. Being an anchor shielded women for the most part from direct propositions or lewd comments. But on her very first night on the job, she was the butt of an offensive prank that was surely meant to test her. As she sat at a desk in the ESPN newsroom preparing her script, she heard what sounded like a man and a woman having sex behind her. Turning around, she saw fifteen male directors and producers, some staring at the bank of TV monitors overhead tuned to the Playboy Channel, others looking at her and laughing, as if to gauge her response. Dombrowski ignored both the screens and her ESPN colleagues and went back to writing her script. Soon, though, because of her high profile, she became a sounding board for behind-the-scenes female employees who suffered daily insults from both peers and superiors. They recounted how male colleagues would suggest to some women who needed to schedule editing space that they'd have a better chance by trading sex for time.

Dombrowski took employee complaints to management, but her superiors were either unable to comprehend the seriousness of the complaints or too busy to deal with them. Finally, in exasperation, she brought the complaints up in a full staff meeting in March 1989. In a jaw-dropping five-minute speech, a visibly shaken Dombrowski said employees were "acting like animals," called their behavior "criminal," and implored management to stop ignoring the toxic environment. Julie Anderson, a former production assistant described it as "incredible. Karie got up and really let people have it. I remember I was cringing when she was talking. I was scared but I was glad she was doing it."[2]

By the time Dombrowski parted ways with ESPN later that year (her contract wasn't renewed), management was still struggling with how to address what had been revealed to be a systemic problem. But a turning point of sorts occurred in 1993. While most of the problems were in the production department, where 97 percent of the staff were male, one high-profile anchor, Mike Tirico, was suspended for three months in 1993 after several women filed formal complaints of sexual harassment against him. After Tirico's suspension, the human resources department was overhauled and the company began to make strides in addressing the problems.[3]

As ESPN has expanded and gained a reputation for its professional sports coverage, its workplace has become more professional as well. There have still been charges of sexual harassment in the past ten years, and some harassers who were suspended following investigations still didn't lose their jobs, especially if they were in high-profile positions. Yet ESPN has also responded quickly at times to complaints of sexism. In 2017, several female employees criticized their employer's partnership with Barstool Sports, which has published misogynistic criticism of women who work for ESPN on its blogs and website. ESPN responded by cancelling the Barstool partnership after one episode. "I erred in assuming we could distance ourselves from the Barstool site and its content," said then ESPN president John Skipper.[4]

In terms of employment opportunities, it is safe to say that ESPN has been a game changer for female broadcasters and sports journalists. As one example, the 2018 Associated Press Racial and Gender Report Card, which surveyed 75 newspapers and websites, showed that of the eighty-nine women who were assistant sports editors, seventy-five worked for ESPN. And of the forty-four women who were columnists, thirty-nine worked for ESPN. ESPN trumpeted the statistics on its website, and Skipper was quoted saying, "At ESPN we understood that our work would be better and our business improved if we hired from the entire pool of talented editors, reporters and writers."[5]

ESPN's first dip into the small but growing pool of female broadcasters brought Rhonda Glenn to Bristol in 1981. Glenn, who was thirty-four, had been working in television since 1969, starting as a sports reporter in Norfolk, Virginia. Then, thanks to her amateur golfing experience, she began freelancing with ABC Sports as a color analyst at women's golf tournaments.

At ESPN, she often anchored the 11 p.m. and 3 a.m. *SportsCenter* segments with iconic ESPN anchor Chris Berman. Any concerns that sports fans wouldn't want their sports news delivered to them by a woman were dispelled by her straightforward but affable style. Berman described her as having a gentle way about her that made everybody feel at home. When she died in 2015, he said, "Everything she did was from the heart."[6]

Glenn's first love, though, was golf, which she continued to analyze for ABC. She moved on from ESPN after two years and eventually became a golf historian and manager of media operations with the United States Golf Association.

Just as CBS had done by hiring Phyllis George in 1975, ESPN had chosen to introduce its viewers to women broadcasters by hiring someone with a warm, inoffensive manner. But after Glenn, the formula ESPN employed in finding female anchors changed. In fact, it was close to the same formula the network used to find male anchors: Make sure you

know your stuff and can deliver information accurately, confidently, and in a way that communicates your passion for sports. Gayle Gardner, who joined ESPN in 1983, fit that formula to a T. Gardner arrived with much fanfare, having worked as a sports anchor and feature reporter in such major markets as Baltimore, Boston, and Detroit. During her twelve years in those local major markets, she won three Emmys for her work.

Right away, audiences welcomed Gardner's confidence and professionalism. An English and theater major at Brooklyn College with a master's degree in broadcasting from Boston University, Gardner easily matched wits with Berman, who was by then the best-known ESPN anchor. While she didn't have his booming voice, she used her Brooklyn accent and wry smile as a counterpoint during *SportsCenter* segments. Gardner had grown up playing and watching sports and could effectively place events in historical context. She has said that she never received a negative piece of mail as a sportscaster.

In 1987, ESPN news director Kirk Varner gave Gardner the ultimate compliment. "She's a consummate professional sportscaster," he said. "I don't have to make the distinction of competent 'woman sportscaster.' She knows her stuff."[7]

Gardner anchored the sports desk three times a day and also covered live events for ESPN. She became the channel's first undisputed female star and benefited from the fact that ESPN was expanding quickly, picking up the rights to major professional sports while still broadcasting live feeds from such events as the America's Cup. She was known for doing extensive reading and research in order to get up to speed on her assignments. The quality of Gardner's writing also set her apart. "What's driven me is the belief that a woman who was credible and knew what she was talking about would be accepted," Gardner said in 1987. "Audiences are much more sophisticated than the television executives give them credit for."[8]

ESPN had hoped to make Gardner one of the centerpieces of its expansion plans, but like many of the first women to work for the cable channel, she gained experience and visibility that drew attention from the big three networks. After four years, she left ESPN to work for NBC. The fact that NBC had the rights to the upcoming Olympics sealed the deal for Gardner. Her first assignment for NBC was as studio host for the New Year's Day 1988 Fiesta, Rose, and Orange bowls, which traditionally drew 60 million viewers. Other female broadcasters watching that day pinned their own hopes on Gardner.

Andrea Kremer, who was working for NFL Films at the time, remembers that New Year's Day vividly. "I literally said out loud, 'Please be great; please be great; please be great.' Because if Gayle Gardner was great, all of a sudden I thought there's going to be room for other people," recalled Kremer. "That was a real turning point for me, watching Gayle."[9]

Gardner *was* great that day. She went on to cohost NBC's coverage of the 1988 Seoul Olympics and became the first woman to do play-by-play for a Major League Baseball game in 1993. But Gardner's swift rise at ESPN was followed by an unexpected fall from grace at NBC. When Dick Ebersol took over NBC in 1990, he fired the whole cast of NBC's *NFL Live!* show, which included Gardner. He also started using rotating anchors and told Gardner she would no longer be a full-time anchor, as he believed her strength was as a reporter. Gardner was unhappy at this news and spent the next six months out of the spotlight. While she was eventually restored to many of her anchor duties, speaking up for herself had earned her a reputation as someone with whom it was hard to work. Nothing she did, including subbing on the news anchor desk from time to time for NBC's local New York City affiliate, could change that perception. Her experience reveals the continued tightrope women walked as they sought to make inroads in broadcasting.[10] Gardner herself was philosophical. "In the end," she told Sally Jenkins of *Sports Illustrated*, "I think you really only get as far as you're allowed to get."[11]

Despite her falling out at NBC, Gardner's obvious appeal to a broader, more casual audience had wide implications for women in sports broadcasting, especially at ESPN, which was expanding quickly. Doors at ESPN continued to swing open to women as the cable channel, like a baseball scout looking for the next phenom, scoured local TV stations for talent. Linda Cohn, Robin Roberts, Suzy Kolber, and Betsy Ross all came on board in the 1990s as ESPN increased its programming with such ventures as ESPN2, ESPN Sports Night, and ESPNews. The network added sports reporters such as Andrea Kremer, Lesley Visser, and Erin Andrews to its talent pool as well.

Just as it was for Gardner, ESPN has been a stepping-stone for many women. Some, like Robin Roberts, eventually left for more visible roles with other networks. In her twelve years at ESPN, Roberts anchored *SportsCenter* and was the studio host for women's basketball broadcasts. She also covered the US men's Olympic basketball team (the Dream Team) at the 1992 Olympic Games in Barcelona and the US women's soccer team's World Cup victory in 1999. By the mid-1990s, Roberts was also hosting ABC's *Wide World of Sports*, but ABC finally lured her away from the sports side to *Good Morning America*, the role for which she is best known, by offering her substitute hosting gigs over the next few years. By 2005, she was ready to make the switch to news a permanent one.

Others moved on because the grind of anchoring a late-night or early morning *SportsCenter* segment meant too much time away from their families. Betsy Ross came to ESPN in 1997. Her background was in news broadcasting, but having grown up in basketball-crazy Indiana, she was a sports fanatic at heart. She enjoyed the fast pace of ESPNews and the fact

that anchors wrote their own scripts for most segments. She stayed at the cable channel for five years, deciding in 2002 to return to local broadcasting closer to home in Cincinnati, where she still does college basketball play-by-play.

"It was a great experience to be in the middle of all these people who were as passionate about sports as I was," Ross says. "If you loved sports, that's where you wanted to be."[12]

One anchor who has made ESPN her permanent home is Linda Cohn. Her passionate love of sports has helped her carve out a career for herself at ESPN. In fact, she has anchored more *SportsCenter* programs than anyone at the station, male or female. As of 2021, she was making about $3 million a year according to the terms of her contract signed in 2018. Google any list of the best ESPN anchors and you'll find her securely in the top five.

Cohn began her sports broadcasting career at a New York radio station in 1981. Eventually, she became the first full-time female sports anchor on a national radio network. She switched to TV in 1989, when SportsChannel America offered her a position. Cohn turned down an offer to join ESPN soon after Gayle Gardner left because she had just taken a weekend

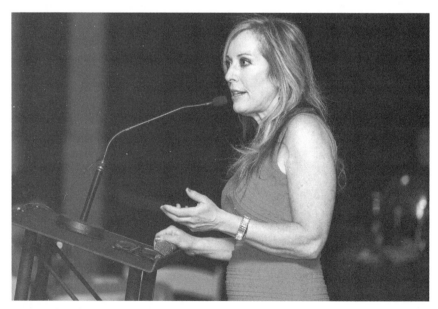

Linda Cohn of ESPN was a keynote speaker at the Association for Women in Sports Media convention in 2017. Since joining ESPN in 1992, Cohn has hosted more episodes of *SportsCenter* than any other broadcaster, male or female. *Photo courtesy of Arianna Grainey*

anchor job in Seattle. The offer remained open, though, and Cohn joined ESPN in July 1992.[13]

After a probationary year, in which she was coached to be more outgoing and personable, Cohn settled into her many and various roles as an ESPN anchor. Sports fans seem to love Cohn because her enthusiasm is so infectious and so genuine. She is not shy about the fact that she still roots for the New York teams she grew up watching as a child on Long Island.

Dianna Russini, an ESPN *SportsCenter* anchor since 2015, sums up Cohn's longevity and her appeal. "Yes, Linda has survived because she is one of the best ever to call highlights. Yes, she asks fantastic questions. But what makes her a notch above the rest? She's a fan of sports," Russini said in 2016. "She has lasted this long because she genuinely loves this and it shows. You can't fake it. Actually I take that back. You can fake it and make it in television, but you won't last."[14]

Thanks to pioneers such as Gardner and Cohn, the 2000s saw an influx of women into high-profile roles on ESPN. In the past decade, women such as Holly Rowe, Jackie MacMullan, and Hannah Storm have become household names among dedicated sports fans.

Holly Rowe is among the most versatile journalists at ESPN. She joined the network in 1998 and has since been one of the lead sideline reporters on ESPN Saturday Night Prime college football, men's college basketball,

Holly Rowe interviews Washington Mystics coach and general manager Mike Thibault during a game against the Minnesota Lynx in 2018. *Photo by Lorie Shaull*

Women's Final Four, Women's College World Series, NCAA indoor and beach volleyball national championships, and the WNBA. You name it and she has probably provided commentary for it, including ESPN's coverage of the Running of the Bulls. Rowe has been nominated for an Emmy in the outstanding sports personality category. She is beloved by athletes and fans for her work ethic and her openness in battling a rare form of melanoma. In December 2020, Rowe earned a measure of acclaim by jumping in and saving a college basketball broadcast. Rowe had just finished providing some sideline commentary when she realized the announcers' remote feed had been lost. Rowe let viewers know what had happened and then provided smooth, unhurried play-by-play and commentary for several minutes until Jay Bilas and Dan Shulman came back on the air. Rowe laughingly told Shulman that being left alone had been terrifying. But the veteran broadcaster certainly didn't show it, and viewers were effusive in their praise of her clutch performance. Said one follower: "Holly Rowe doing play-by-play, thank you 2020 for this gift!!!"[15]

Jackie MacMullan recently retired from ESPN, where she wrote a professional basketball column for the network's website for ten years and regularly appeared on the daily debate program *Around the Horn*. "For far too long, I was the only woman on that show—for far too long," she said in 2021. "I'm glad now that show has expanded with diversity and differing views. It's fantastic. It's time for people like me to give those guys room for another voice."[16]

MacMullan came to ESPN by way of the *Boston Globe* and *Sports Illustrated*, where she'd made a name for herself as a gifted writer and a trusted authority on professional basketball. Like a growing number of sports journalists, she established a rapport with athletes and coaches because of her own background as an athlete. She played basketball on a perennial state championship high school team in Westwood, Massachusetts, and went to the University of New Hampshire, where she played basketball on a partial scholarship. MacMullan, who has written five books about basketball, was the first woman to win the Naismith Memorial Basketball Hall of Fame's Curt Gowdy Media Award. She also does long-form narrative podcasts for *The Ringer* and often is a guest on Bill Simmons's podcasts. In 2019, she became the first female sportswriter to win the PEN/ESPN Lifetime Achievement Award for Literary Sports Writing, the honor of which she is most proud.[17]

Hannah Storm's many and varied roles at ESPN epitomize the direction in which sports broadcasting seems to be heading. It's a direction that more and more women in sports journalism are embracing as they reach the midpoint of their careers in an industry that admittedly values youth. When she graduated from the University of Notre Dame in 1983, Storm knew she wanted to be a sportscaster. She took her father's advice to "get

on the air" any way she could, starting out as a DJ at a heavy metal rock station in Corpus Christi, Texas. That's where she took the name "Storm," which sounded better on the radio than Storen. She moved on to Houston to spin records on the weekend and learn the ropes as a sportscaster during the week. She got her first network sports job at *CNN Sports Tonight* in 1989. From 1992 to 2002, Storm worked for NBC, where she hosted four Olympics and three MLB World Series. She decided to make a switch to news with a stint as cohost of CBS's *The Early Show* from 2002 to 2007.[18]

A return to sports was always on her mind, though. She looked for a position with a network that would allow her the flexibility to do many different things. Since 2008, she's been a *SportsCenter* anchor and a host or cohost of many events, including the ESPYs, Wimbledon, the US Open, the NBA Finals, the New York City Marathon, Veterans Day events, and the Super Bowl. She also has her own production company and has produced several documentaries for ESPN.

Storm's success shows how far ESPN has come since its early days, when being a female employee was sometimes a benefit but more often a liability. In the last forty years ESPN has provided opportunities for women that may not have otherwise existed. In a July 2021 memo to the staff, ESPN chairman Jimmy Pitaro noted that of 116 staffers hired in 2021, 52 percent were people of color and 42 percent were female. Pitaro also noted that 63 percent of ESPN's executive team were female and/or people of color.[19]

Yet it's not easy being the Worldwide Leader in Sports. Critics suggest that ESPN's commitment to diversity appears to be real until examined more closely. Female employees—especially women of color—continue to assail the company for pigeonholing women into certain roles. They insist that if all on-air roles at ESPN were open to women, there'd be no need to choose one woman over another. "The dynamics of this industry ends up pitting women against other women for jobs that shouldn't be as limited as they are," said Kavitha Davidson, a former employee at ESPN who is Black. "It's hard for us to find allies and it's hard for us to find camaraderie when it is as cutthroat as it is and it seems like there are finite opportunities for us."[20]

In 2021, ESPN came under fire for its handling of a controversy involving two of its female broadcasters. The issue stemmed from the promotion of Maria Taylor, a Black sportscaster who hosted the pregame show *NBA Countdown*, to a more prominent role during the NBA playoffs in 2020. Rachel Nichols, who hosted *The Jump*, a daily program about NBA basketball, said that she'd been promised that role in 2019. Nichols, who is white, inadvertently left her video camera on while she was alone in her room talking to an acquaintance on her cell phone. "If you [ESPN] need to give her more things to do because you are feeling pressure about your

crappy longtime record on diversity—which, by the way, I know person-
ally from the female side of it—like, go for it. Just find it somewhere else.
You are not going to find it from me or taking my thing away," Nichols
told Adam Mendelsohn, who also happens to be an adviser to LeBron
James. Unbeknownst to Nichols, the call was recorded at ESPN head-
quarters in Bristol by way of a webcam connection. Production employees
began passing copies of the conversation around. One of them, Kayla
Johnson, sent a copy of it to Taylor.[21]

The incident became public during the 2021 NBA playoffs, at which
time Nichols apologized to Taylor for suggesting she was a diversity
hire. Maria Taylor has not addressed the issue directly, but other Black
employees—and former employees as well—have. "We get a little tired
of people insinuating that the reason we have a job is because we are
Black," said Jemele Hill on *CBS This Morning* shortly after news of the
conflict broke. Hill was with ESPN for twelve years before she left in 2018.
"Especially in this business, especially in sports, where you don't see a
lot of Black women in the role she's in, she [Taylor] hears that a hundred
times a day."[22]

Taylor, considered to be a rising star in broadcasting, left ESPN for a
job with NBC Sports after her contract with ESPN expired in July 2021.
She covered the 2021 Olympics for NBC and is involved in NBC's NFL
coverage. At ESPN, Johnson, the employee who admitted sending the
tape to Taylor, was suspended without pay for two weeks for her role in
distributing the tape. She left the company soon after, along with several
other Black employees who had pushed for more support from manage-
ment. Nichols was not initially punished for her remarks, presumably
because she had not meant them to be public, but a month later, her show
was canceled and she was told she'd no longer be covering the NBA. The
New York Post reported that she was "essentially fired" with a year left on
her contract.[23]

Meanwhile, ESPN's image was once again tarnished and its commit-
ment to diversity questioned. But the company says it has taken a number
of steps to address issues of inclusion. "Change takes time, and I ask for
your partnership on this journey," Pitaro wrote to employees in a July
2021 memo. "Know that our leadership is committed to accelerating our
efforts and working toward a collective goal—an ESPN where everyone
feels they belong."[24]

Going forward, it seems clear that women—and especially women of
color—are likely to hold ESPN to its word.

7

Robin Roberts:
Her Roots in Sports

If you only know of Robin Roberts as the cohost of ABC's *Good Morning America*, you might be surprised to find that she was a sports broadcaster for more than twenty years. Leaving sports was not a decision she made lightly. "Not only did I love sports, but I still had that voice inside me saying I'd be letting women down if I left sports," she recalled in 2008.[1]

Far from letting women down, Roberts laid a solid foundation for women and minorities in sports broadcasting throughout her pioneering career. And it was her singular talent, her humor and grace, as well as her perseverance that laid the foundation for her own success.

"Robin is a national treasure, and working with her was a career highlight for me," said ESPN's Bob Ley, who coanchored *SportsCenter* with her in the 1990s. "Her skill and poise, her class, her values: they're all self-evident. And then there's her sense of responsibility to those who look up to her. That's a large part of who she is."

"She was an inspiration for me," added *SportsCenter* anchor Linda Cohn. "She never doubted herself. When I asked her once where does that inner confidence come from, knowing you are talking sports in a man's world, she replied, 'You have to believe you are the best at what you do, and that's where it comes from.'"[2]

Ley's and Cohn's remarks came in 2016, when Roberts became the first female broadcaster inducted into the Sports Broadcasting Hall of Fame, which includes such legends as Jim McKay, Howard Cosell, Chris Schenkel, and Vin Scully. Roberts is one of only four female on-air personalities to be chosen since 2007.

Biloxi, Mississippi, where her family put down roots in 1969, was the breeding ground for Roberts's love of sports, and it was her athletic career that gave Roberts the confidence to believe that she could become a sports broadcaster. When the family arrived in Biloxi, Roberts was just starting high school and her 5-foot-10 frame naturally made her a candidate for the basketball team. She'd only begun playing basketball in the eighth grade, but she had a knack for putting herself in position to grab the rebounds when they came off the backboard. She made All-State her senior year and was offered a scholarship to play basketball at Louisiana State University. But she chose Southeastern Louisiana University, a much smaller school compared to LSU, where she felt comfortable and was able to form the kinds of relationships with teammates, classmates, and professors that enabled her to grow in confidence.[3]

Studying journalism at SLU was a default decision of sorts. As a young girl, Roberts, also a very good tennis player, had harbored a secret desire to play at Wimbledon someday. Despite her high school success in both tennis and basketball, Robert realized her athletic abilities were not going to lend themselves to a professional career. She decided that if she couldn't play at Wimbledon, perhaps she could get there as a reporter.[4]

At that time, there were no African American women covering sports whose careers Roberts felt she could aspire to. Jayne Kennedy had taken Phyllis George's place on CBS's *The NFL Today*, but Kennedy, a former beauty queen, had no sports experience. It was obvious she had been hired for her looks, and Roberts thought *her* looks weren't going to convince anyone at the networks to hire her. Still, she couldn't get the idea of sports broadcasting out of her head. When she graduated from SLU, she was offered a full-time job as a news anchor at a TV station in Biloxi. Instead, she took a part-time job as a sports anchor at a local TV station 150 miles away in Hattiesburg, Mississippi. She recalls that her parents and many of her friends thought she should have taken the more lucrative news position. But Roberts was keeping her eyes on a bigger prize.

"I truly wanted to follow my passion and my heart," she wrote. "And that was sports, pure and simple."[5]

It proved to be a good decision, as nine months later, the Biloxi station came looking for Roberts to fill a sports anchor opening. A year later, she was offered a promotion to news anchor, but she chose instead to pursue a job at WSMV-TV, a bigger market in Nashville. There, she was not only a sports anchor but also the sports director for a two-hour live morning show. She wrote, produced, and anchored two sportscasts and hosted such events as paddleboat races between the staff and members of the local business community. It was a popular, lighthearted show in the vein of late-night TV, and Roberts gained such a following that stations from bigger cities started courting her. In 1987, she interviewed with both

ESPN (for an opening on its growing sports anchor team) and WAGA in Atlanta (for an opening as a sports reporter). Even though her ultimate goal was to be a sports anchor with a national audience, she chose the reporting job in Atlanta because of the chance to cover professional sports for the first time in her career.

"I don't know if I had gone [to ESPN] in 1987 if I would have been there for fifteen years. I get wanting everything right now. But it's so much more important to put in the work and have that staying power," she told an interviewer in 2010. ". . . [W]hen you are facing great odds, when you're seeing people who don't quite look like yourself, you have to make sure you have done the work and put the work in."[6]

Soon after she arrived in Atlanta, Roberts was the subject of a feature story in the *Atlanta Constitution*. During the interview, the reporter asked Roberts, then twenty-seven, if she thought being able to check off two boxes, the one for race and the one for gender, was a factor in her being hired. Displaying her youthful naivete, Roberts replied, "Yeah, I guess it is." To the consternation of her family back in Mississippi, Roberts was referred to as a "twofer" in the otherwise positive profile. Willie, her sister's husband, told Roberts never to believe that her gender or her race had been the driving forces behind her success. "You know how hard you've worked," he told her. "Nothing has ever been handed to you."[7]

Roberts's time in Atlanta showed her exactly what women in sports media were facing in the 1980s. She was covering the University of Georgia in the Southeastern Conference (SEC) basketball tournament, and Georgia, like many colleges, did not allow women in its men's locker rooms. Instead, female reporters had to make a request and wait for the athlete to appear in an interview room. On her first night, she stood waiting outside the locker room and watched TV reporters from competing stations heading out the door with tapes in hand. She realized they would make their deadlines for their 11 p.m. broadcasts, while she might not. "I did a slow burn and finally, I'd had enough. I turned to my cameraman and said, 'We're going in.'" A university official intercepted them, however, and agreed to bring out the player they wanted. Just minutes later, the player was standing outside the locker room as Roberts interviewed him, dripping wet from the shower he'd just been pulled out of.

"Was I trying to be a jerk? No, I was trying to keep my job," Roberts recalled in her memoir. After that, Roberts made arrangements for interviews beforehand when she could. When she found herself on deadline, she was able to create goodwill through her athletic background and her obvious passion for sports. "Part of it was they just wanted to be treated fairly by the media and they could sense that that's all I wanted too, to be treated fairly."[8]

Two years later, ESPN's John Walsh called again, and this time, Roberts felt ready to make the move professionally, even though she was torn about moving away from her family and from Atlanta. ESPN's headquarters are in Bristol, Connecticut, a small, East Coast suburb with sixty thousand residents. There wasn't much going on, even in nearby Hartford, in 1989 unless you were a hockey or a University of Connecticut fan. Roberts recounted how, during her first trip to a shopping mall in Bristol, she saw only one other Black person. (They waved at each other.) "I loved my life in Atlanta," she recalled. "But John [Walsh] . . . allowed me to see that I could flourish at ESPN."[9]

In 1990, some say ESPN was making up for lost time by hiring women to counter the perception that it had swept sexual harassment allegations under the rug. The new batch of female anchors were not subject to the harassment others had endured in earlier years. Michael Freeman, the author of *ESPN: The Uncensored History*, believes that another factor for Roberts was that she had a "physical and emotional presence that was almost intimidating." According to Freeman, she provided a counterpoint to the "testosterone-soaked atmosphere" with her "reasoned and calm insights." Poised and professional, she was still able to laugh at herself when she made a mistake.[10]

As she had at other jobs, Roberts kept looking for opportunities to grow. She started out anchoring both the 7 p.m. and 11 p.m. *SportsCenter* shows and quickly added *NFL Primetime*, *NFL Gameday*, and *Sunday SportsCenter* to her résumé. At first, when Roberts told Walsh she wanted to apply for the position on *NFL Primetime*, he was surprised and wondered if people would accept a woman delivering game highlights. But then he thought, "Why not?" If viewers were going to accept any woman, it would be Roberts.[11]

Roberts also wasn't afraid to show her human side. Back in Nashville, she had won over her audience with her candor the very first night she was on the air. She was so nervous right before her segment began that she didn't realize until two minutes to airtime that she had left her tapes in her office. She sprinted down the hallway and up the stairs to get them, and when the lights came on, she was still out of breath. She confessed what had happened and started laughing. She figured it was the beginning and end of her anchoring career, but "the phone lines lit up—I was a hit," she recalled. "They appreciated how I had found humor in a potentially embarrassing situation."[12]

Roberts was raised by an English teacher and a US Air Force colonel (one of the vaunted Tuskegee Airmen in World War II). Their influence grounded her but also gave her the confidence and humility to show that human side. Those qualities became Roberts's hallmark throughout her career. In 1993, Roberts had to announce on *SportsCenter* that Arthur

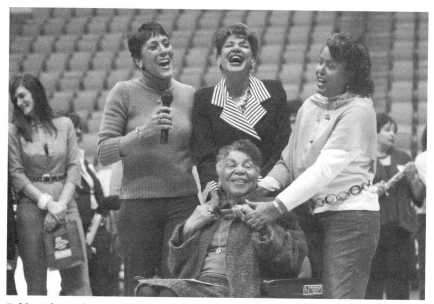

Robin Roberts, former ESPN anchor and current host of *Good Morning America*, shares a lighthearted moment with her family at her induction into the Southeastern Louisiana University Sports Hall of Fame. Roberts credits her family and her roots for her success. *Photo courtesy of Allyson O'Keefe Photography*

Ashe, by then a friend, had died of AIDS-related complications. Her voice was shaky and she had tears in her eyes as she read the news and provided details of Ashe's life. *SportsCenter* ended that night with a photo tribute to Ashe that she'd produced, and she signed off with the words, "God bless." Afterward, Roberts worried that she would be criticized for her show of emotion; instead, she was inundated with letters of support from viewers, both male and female.[13]

Roberts stayed at ESPN for fifteen years, and during that time, she covered the 1992 Barcelona Olympic Games and made it to Wimbledon several times to broadcast the event. She did play-by-play for men's and women's college basketball and hosted many ESPN documentaries and features. She also was able to take on another role as the host of ABC's *Wide World of Sports*, which ultimately led to her leaving ESPN for *Good Morning America* in 2005.

By then, it was becoming increasingly obvious to Roberts that her work as a sports broadcaster had begun to take her into the realm of news. She'd produced stories on such events as the O. J. Simpson trial, the baseball steroid era, and the AIDS epidemic. She was doing reports for *GMA* during the week and occasionally filling in for the cohosts. Still, when she

was asked to become a permanent regular in 2005, she wondered if she'd regret giving up the "thrill of victory and the agony of defeat." Billie Jean King, who'd become a friend and mentor, provided the perspective she needed. She encouraged Roberts, telling her, "When you do talk about women in sports, you'll have a bigger platform."[14]

Roberts's strong foundation in faith, thanks to her parents, also helped her make the switch to news. She has said that she believes everyone, no matter how they worship, should strive to live a life of meaning. Her bigger platform on *GMA* has made her an inspiration to millions of people as she publicly acknowledged her struggles with breast cancer in 2007 and a bone marrow disorder in 2012. She has also lent support to the LGBTQ+ community since she revealed (or, more accurately, confirmed) her long-time same-sex relationship in 2013.

"All of us, it doesn't matter [if you're a] man, woman, Black, white, gay, straight, we just want the same opportunities," she said in her induction speech to the Sports Broadcasting Hall of Fame in 2016. "You can wish hope and pray all you want—I'm a very spiritual person—but you know that you need the help of others to make your hopes, make your dreams come true."[15]

8

Pam Oliver: Sideline Reporter in a Class by Herself

Pam Oliver had a chance to try out for the Olympic track and field team back in 1984. She'd been part of a nationally ranked one-mile relay team, and her individual time in the 400-meter run was a Florida A&M University record at the time. But as a senior ready to graduate with a journalism degree, she looked around and saw a small but growing number of women advancing in local TV broadcasting careers. Her instincts told her that if she wanted to make her mark, she needed to get her career off the starting block as fast as she could.[1]

After several gigs as a news reporter, Oliver landed a job as a sports broadcaster first in Tampa and then in Houston. From there, her rise to the top—into one of the most visible positions in sports media—was swift. Since 1995 she's been a sideline reporter for Fox's

Pam Oliver has been a sideline reporter for Fox Sports for more than twenty years. She has overcome many challenges and is among the most highly respected sports broadcasters in the business. *Photo courtesy of Elvis Kennedy © All rights reserved*

NFL broadcasts as well as a senior correspondent for Fox Sports 1. As of 2021, only Terry Bradshaw and Howie Long have more tenure on Fox's football broadcasts than Oliver does. Her pioneering career has helped

open doors for women in general and for Black women in particular. She attributes her successful career to a strong work ethic, and she advises young women to be tenacious in their quest for success. "There's no substitute for working your ass off. That's all you can do, work your ass off, and let the rest of it take care of itself," Oliver said in 2019. "Whatever ambition you have, whatever goals you have, put those front and center, and never lose sight of them."[2]

Oliver, the youngest of three children, was born in 1961 in Dallas and moved with her family to Florida while she was in high school. It was during her brief time in Dallas that the roots of her interest in journalism may have inadvertently been sown. As the story goes, it was the morning of November 22, 1963, and she had just drunk some of her mother's hair dye, apparently thinking it was a strawberry milkshake. Poison Control directed her frantic mother to Parkland Hospital. They arrived just a few minutes before the ambulance carrying President John F. Kennedy, who'd been fatally wounded by a sniper's bullet as he rode through downtown Dallas that morning. Though she was only a toddler, she believes that hearing the story repeatedly from her mother about the chaotic scene in the ER that day gave her not only a connection to current events but also an ongoing interest in following the news.[3]

"It wasn't sports at that point, it was just news, news, news," she said. "I just have specific memories of leaving my activities outside or whatever my friends were doing, and I just wanted to go and sit in front of the TV and watch the news. I thought the reporters—what an exciting life they must have."[4]

There weren't many African Americans on air back then, and only a few women. Two whom she likely saw regularly were Iola Johnson of WFAA-TV, the first woman and the first Black news anchor in Dallas, beginning in 1973; and Carole Simpson, the first Black woman to anchor a national news broadcast (at NBC in 1975).

When she wasn't watching the news, Oliver was watching sports. She remembers Sunday afternoon football as a cherished time when she, her father, and her older sister gathered in the living room to watch the NFL, first in Dallas and then after they moved to Niceville, Florida.

Her own athletic career, which began in elementary school, earned her a track and field scholarship to Florida A&M, the only college in Florida designated a historically Black university. Going to an HBCU was an important piece of the puzzle for Oliver. There, she was strongly encouraged to pursue a broadcasting career, even though she was still seeing few faces of women and even fewer faces of African Americans on TV.

Oliver's first job was as a news reporter in Albany, Georgia, followed by stints in Huntsville, Alabama; Buffalo, New York; and Tampa, Florida. As a news reporter, Oliver covered everything from politics to murder

trials to protest demonstrations. It gave her a firm foundation in the fundamentals of journalism, but like so many women sports journalists who started out in news, her heart was always down the hall in the sports department. When the chance came to switch to sports in Tampa, she talked her boss into transferring her, even though he considered it a demotion.

"He said, 'This is the biggest step down you could ever take,'" she recalled in 2014. When she saw him years later, he sheepishly admitted he'd made a mistake.[5]

Right away Oliver knew sports was home. The action on the field during a game was sometimes as fast and furious as a breaking news event. But she also enjoyed the more regular schedule and the time afforded her to plan for pregame features and interviews and to develop good working relationships with sources.[6]

Those working relationships set Oliver apart during her two years at ESPN and then at FOX Sports and earned her the respect of not only the people she worked with but also the athletes and coaches she covered. They saw a woman driven to be the best she could be, someone who wasn't afraid to press an interview subject to go beyond rehearsed sound bites and to reveal themselves honestly. One example was an exchange she had back in the mid-1990s with Deion Sanders, who was also playing baseball at the time. Sanders gave a canned response to a question about what motivated him to keep playing two professional sports, to which Oliver replied: "Oh come on, you do it for the money." Sanders smiled and said, "Well, there is that."[7]

"She is a fearless interviewer," said David Hill, the CEO of Fox Sports back in 2002. "She does her homework as well as anyone I have ever seen, and she has a way of making talent relax when they are talking to her."[8]

When Oliver began doing sideline reporting, some fans considered it the low rung on the sports broadcasting ladder, perhaps because women usually occupied that role. They were only called upon a handful of times during a game to offer observations or to relay comments from coaches garnered before the game or in a rush at halftime. But because of her relentless research and preparation, along with the connections she had made over the years, Oliver often elevated those brief conversations into interesting and meaningful insights.

"There's an understanding in the room: If you're going to sit down with Pam, you better be ready," said Charles Davis, one of her more recent broadcast partners at Fox Sports.[9]

Oliver's journey hasn't been without its struggles. Ever since she was twenty-five, she has battled migraine headaches so debilitating that she got to know where the emergency rooms and walk-in clinics were in many of the NFL cities to which she traveled. In 2013 she took a blow to the head from an errant football pass on the sidelines during an

interview before a preseason game. She shook it off and covered the game as Twitter lit up with YouTube replays of the incident under the hashtag #toughlady. The next day, though, Oliver had a pounding headache and nausea, and she couldn't bear to look at even the lowest light setting on her phone or computer screen. She was diagnosed with a concussion and slept almost constantly for five days. She missed the last weeks of the preseason but was back on the sidelines for the opening weekend of the regular season.[10]

Oliver has also dealt with infertility. She went through early menopause after treatment for painful fibroids. She briefly considered in vitro fertilization but decided that she didn't want her career to take a back seat to the time-consuming process. Instead, she has enjoyed being a stepparent to her husband's children.[11]

Like all female sports journalists, Oliver has had to deal with the criticism of people who don't believe women should be talking about men's sports. She brushes those comments off, just as she brushes off occasional comments about her appearance. Oliver has said she has no time for social media and doesn't have a public Twitter or Facebook account. Her husband lets her know if she's trending on social media, but he shields her from the worst of the mean tweets that might target her via Fox or other people's accounts.

"I don't deal with it. I don't seek it out," she has said. "I can't imagine what kind of life you lead if you have time to spew that kind of venom."[12]

In a career spanning thirty-plus years, Oliver has only had one "kick in the teeth" moment. That was in 2014 when she was replaced by Erin Andrews as the sideline reporter for the featured NFL Game of the Week. Oliver saw the handwriting on the wall when Fox lured Andrews away from ESPN two years earlier. This was a real coup for Fox, as Andrews, sixteen years younger than Oliver, had become a celebrity of sorts because of her appearances on ABC's *Dancing with the Stars*. Two years later, Oliver was told that she would no longer be doing NFL broadcasts with Joe Buck and Troy Aikman, whom she'd teamed with for more than a decade. Instead, she'd be moving to Fox Sports 1, helping the network to build that cable channel by doing long-form stories and feature interviews. This essentially meant that her career as a sideline reporter would be over after nineteen years. Oliver talked her bosses into letting her do one more year, her twentieth, on the sidelines, even if it meant working with a different broadcast team. She never believed being Black had anything to do with the change, but she doesn't rule out age. She was fifty-three when the change was announced. "It's not difficult to notice that the new on-air people there are all young, blond and 'hot.' That's not to say that Erin isn't capable. I think she's very capable," Oliver wrote in a first-person essay. "She's also popular on Twitter and social media, so I can

see how that would also make her highly sought after. Still, covering the NFL is a big deal. Stations like ABC and NBC entrust their programming to veterans. So when people talk about all networks making a turn to a particular type of girl on the sidelines, it doesn't hold water."[13]

Oliver weathered the upheaval gracefully and has since had her contract renewed. As of 2021, she was still reporting from the sidelines for Fox (even though she had to stay in the stands because of COVID-19 restrictions). As she enters her sixties, she is now in the phase of her career where she is being recognized more and more as a pioneer. In 2018, she received a prestigious Gracie Award given by the Alliance for Women in Media to recognize women who have made inspirational contributions to the industry and who are leaders in their field. That year, Oliver shared the stage with such women as Norah O'Donnell, Reese Witherspoon, and Samantha Bee.

"She continues to be the standard there. And that doesn't happen very often," says ESPN reporter Lisa Salters. ". . . They're quick to get rid of you when you get older and you're a woman. And she stays around because Fox recognizes the value in her connections, her relationships with teams, players, coaches. And Fox recognizes that not all reporters, not all sideline reporters, have that kind of capital within the league."[14]

Oliver has joked that she'd like to have a career as long as Barbara Walters's. She is working on her memoir, which is sure to shed light on how much things have changed since she began her sports broadcasting career thirty years ago.

"Pam is just important to everybody. Just her legacy. Her longevity. All women, all reporters—male, female, Black, white, Hispanic, it doesn't matter," said Oliver's colleague Kristina Pink, who considers Oliver a rock star. "The way she approaches her work is just an example to all of us."[15]

9

Having It All

On the evening of July 23, 1997, Karen Guregian, a sportswriter with the *Boston Herald*, was just sitting down to dinner with a date in the popular North End of Boston. When her flip phone rang, she figured it was work related, so she excused herself and answered it. The call was from her editor, telling her that Boston Celtics forward Reggie Lewis had collapsed while shooting baskets on a practice court that afternoon. He had been pronounced dead two hours later. Guregian wasn't the Celtics beat writer, but Lewis's health issues had been a significant, ongoing story since the Celtics star had collapsed three months earlier in the first game of an NBA playoff series with the Charlotte Hornets. Her editor was calling every reporter he could reach to help cover the story and get reactions to the news. Dinner hadn't arrived yet, but Guregian apologized and told her date she had to leave. Most men, especially if they were sports fans, would have understood and maybe even been excited for her. But "this particular gentleman was not evolved to the point where it didn't bother him," says Guregian. She doesn't remember if this was their first date, but it definitely was their last. "It's not like I blame him. I left him at the dinner table, but it was an all-hands-on-deck kind of thing. . . . After that, I figured out this [dating] wasn't going to be easy."[1]

By the mid-1970s, newspaper sports departments were changing with the times, and Watergate-inspired investigative journalism found its way into many sports departments. Profiles and human-interest stories also became a staple of the sports pages. One thing that didn't change about covering sports was the all-encompassing nature of the job. Writers tasked with generating a major feature piece on a weekly basis still had

daily responsibilities on their beat. To get the best stories, you had to hang out before, during, and after practices and games. And being one of the first women on a newspaper's sports staff only increased the pressure to perform.

While their twenty-something male colleagues—and even the athletes they covered—began marrying and starting families, many women sports journalists remained single or childless well into their thirties. There were literally no role models to emulate when it came to the effort to juggle dating, marriage, and parenting with a job that demanded so much time and such singular attention as sports writing does.

Marie Hardin, the dean of the Donald P. Bellisario College of Communications and a professor of journalism at Penn State University, has done extensive research on women in sports journalism careers. She calls women who work in sports departments "tokens."[2] It is meant not as a pejorative term but rather as a description of their status in an almost completely male environment. Her research shows that for many of these women, the five-year mark represents a pivotal point in their careers. In one study conducted over a five-year-period, five of ten women sports journalists had left the sports department by year four, and two more were contemplating such a move. Some transferred to the newsroom, where covering a beat is still an exhausting enterprise, but one that usually offers the chance to have some nights and weekends off. Hardin adds that often the women who left sports writing careers were feeling stymied for a variety of other reasons associated with their tokenism. Leaving the sports department in order to have a social life or to start a family made sense in the face of outright discrimination or the general sense that they were stalled in their career. She calls it a "great winnowing out that happens."[3]

Feeling stalled was one reason I left sports after only three years on the job, but it wasn't the only reason. I was the Portland *Press Herald*'s first woman sportswriter when I was hired in August 1981. If ever there was a token, I was it. Maine's largest daily newspaper was expanding its readership and its coverage. The sports editor was charged with finding a woman staffer to fend off any suggestions that sexism influenced hiring decisions. I was never subjected to any discrimination. On the contrary, the editor and his assistant editor helped me learn the ropes, fed me terrific story ideas, and approved ideas that reached beyond Maine.

I was winning awards for my deadline writing and my in-depth features, and as trajectories go, it was a promising one. But when my editor was promoted to the news desk, a fellow sportswriter became the new sports editor. He was probably just taking marching orders from someone above him, but it was still frustrating when he told me that I wouldn't be covering Red Sox spring training because I might have access issues. As a

backdrop to this, my twin sister had just gotten married, which for some reason tripped the switch on my own biological clock. My future husband worked days as the Sunday paper's business editor. My opposite schedule working nights and weekends made it difficult to contemplate marriage and a family. I had no role models to emulate and no mentors who could understand my dilemma and provide support. When a feature writing job opened up on the Sunday paper's staff, the decision to apply was an easy one. Soon I was married, starting a family, and enjoying all the perks that came with a (mostly) normal schedule.

Some of the pioneers who stayed in sports chose to nurture their careers instead of a family. They found in their careers all the excitement, fulfillment, and sense of purpose they needed. Guregian and Lesley Visser are good examples. Guregian has never married, while Visser is married but has never had children. Christine Brennan is a nationally known columnist for *USA Today* and a commentator/analyst for CNN, ABC News, NPR, and PBS's *Newshour*. She is not married, though she hasn't completely ruled out the possibility. She says staying single and not starting a family was not a conscious choice. For thirty-two years (and counting) her work life—jam-packed with travel, TV appearances, and interviews—has afforded little time for dating. One day she might be covering the Masters golf tournament for her *USA Today* column. Another day might find her at the Olympic swimming trials or the World Figure Skating Championships doing research for her next book. She has dated, she says, but often ended up feeling bored. "Or the ones I liked and didn't get bored with ended up getting scared off by me, my job, or my height," she wrote in her 2006 memoir.[4]

Brennan cherishes her independence, and now, in her early sixties, says she is in the "sweet spot" of her career. Family is still very important to her, though. She spends as much time with her seven nieces and nephews as she can squeeze into her busy life. She has gone on family vacations with them and brought them and other family members along when she's covered big events like the 1996 Olympic Games in Atlanta. In many ways, she says, they are her children. Brennan also fills what precious spare time she has with mentoring young female journalists (and some male journalists too). "It's what I love to do the most, and it is what I do the most," she says.[5]

Women who do manage to combine marriage and a family with a successful career in sports journalism say the keys are a supportive spouse and family and a single-minded determination to make it work. Paola Boivin, now the director of the Cronkite News Phoenix Sports Bureau at Arizona State University, started out covering sports at a small daily newspaper in California. She followed her future husband to Arizona, but they put off marrying and having children until Boivin was approaching

her midthirties and had established herself at the *Arizona Republic*. She often worked nights so that she could be with her babies during the day.

"There was like a year-long time when I remember literally meeting my husband at an exit of the freeway and handing him the baby carrier as I was going to work and he was coming home. . . . I guess I wanted it so badly that we figured out a way to do it."[6]

Though she was often home during the day with her two small children, she still had to be available for interviews, crying babies notwithstanding. One day, Boivin retreated to the garage and took notes on the sheetrock walls to drown out the noise and keep an interview going. Another time in 1996, she was asked to fly to Los Angeles to interview a professional hockey player because his team, the Coyotes, was relocating to Phoenix. Unable to find a sitter at the last minute, Boivin took her baby daughter with her.

"While I was interviewing this hockey player, he was staring at my shoulder," she recalls. "Finally he goes, 'I don't know how to tell you this, but your daughter is throwing up all over your shoulder.'" It was one of those laugh-or-cry moments, and, as she usually did, Boivin says she chose to laugh it off. "There were a lot of trying moments, but having a supportive husband and having a passion . . . made it possible to get through the hard times."[7]

Sometimes the hard times start even before the baby arrives. Andrea Kremer is the chief correspondent for NFL Network, a correspondent on HBO's *Real Sports*, and the analyst on Amazon Prime's livestream of *Thursday Night Football*. (In fact, she is the first and currently the only full-time female game analyst in the NFL.) Like many women journalists in the 1980s and '90s, Kremer put off having children until well into her thirties. After she became pregnant in 1999, she continued to work full-time as a sideline reporter while doing stories for both ESPN and ABC-TV. Due in late February 2000, Kremer had her doctor's blessing to travel from Los Angeles to Atlanta to cover Super Bowl XXXIV on January 30. Being eight months pregnant, she knew this would be her last assignment for a while. But a week before the Super Bowl, Kremer, already in Atlanta for pregame assignments, was eating dinner when she felt a strange sensation. She thought she was experiencing incontinence, but in reality she was becoming what she now calls "every pregnant woman's cautionary tale."[8]

Kremer's water had broken and fluid was leaking from the amniotic sac. She called her husband back in LA and got a ride with friends to the hospital. There, doctors decided to delay labor as long as possible because the baby was a month premature. That gave Kremer's husband plenty of time to reach Atlanta (he took the first red-eye flight out of LA that night). It also gave Kremer time to get some work done from her hospital bed.

Kremer recalled how her producers came to her hospital room so she could record voice tracks for her pregame stories. Her son was born a few days later, four days before the Super Bowl. Three weeks early but healthy, William Raymond and his mom stayed in the hospital for another week and a half. She watched the Super Bowl from her room, warning the neonatal nurse to wait until after the game to bring her son in for nursing. She only left her hospital room once—for two hours—to film an introduction to a story she'd been working on at ESPN's local studio. She was determined to see the piece through before she officially started her maternity leave. She can laugh about it all now because her son is six feet tall and a healthy young man. Still, she says, "giving birth three thousand miles away from home is not the way you envision it."[9]

Kremer's story made headlines and earned her an award as one of 2001's most influential working moms in *Working Mother* magazine. Kremer says her ability to compartmentalize different parts of her life helped her juggle motherhood and her high-pressure job. She worked from home a great deal after Will was born. Even after he started school, she put his schedule first whenever she could. There were times, of course, when it wasn't easy to separate work from motherhood. "One time we were going to the Museum of Science in Boston. I was doing this really cool project for NBC. We had a Tom Brady versus Peyton Manning [matchup] coming up. I reached out to every living NFL Hall of Fame quarterback and asked them: 'Who would you start your team with, Peyton Manning or Brady?' So, I'm chaperoning the trip and Roger Staubach calls me. I literally just sat on the ground, pulled out my notes and started writing," she recalls. "That's just what you do. The things that are important to do you make happen."[10]

But determination and passion can take you only so far. Another important dynamic is a good working relationship with an open-minded boss. Jackie MacMullan, just-retired national basketball writer for ESPN and part of the regular team on ESPN's *Around the Horn*, started out on the city desk for the *Boston Globe*. She grew up playing sports and reading the *Globe*'s hard-hitting sports columnists, which made her well suited for the job when she switched from news to sports in the mid-1980s. In her twenties, she pursued stories with the same energy and ambition that had made her a force to be reckoned with on the basketball court in high school and college.

When MacMullan hit her thirties, she and her husband decided it was time to start a family. Her daughter, Alyson, was born in March 1992. After the standard six-month maternity leave, during which she missed covering the Barcelona Olympics and USA Basketball's first Dream Team, MacMullan dove back into her job by covering the NBA as the *Globe*'s national basketball reporter.

MacMullan vowed to resume her career with the same vigor she'd displayed in her twenties. She decided she needed to approach the task of juggling parenthood with a high-pressure career just like the male writers around her seemed to. She had a husband who encouraged her

Jackie MacMullan with her two grown-up children, Douglas and Alyson. *Photo courtesy of Jackie MacMullan*

to pursue her career, even though he was working full-time too. He embraced the added parenting duties during her absences, assuring her that Aly—though colicky and not the greatest sleeper—would be just fine. But these were the years before cell phones and FaceTime and Zoom. During the NBA season, MacMullan was on the road for weeks at a time and had no reliable way to keep in touch. When she was home, she felt like she should be working. When she was on the road, she wondered what she was missing at home.

Things came to a head during the 1993 NBA Finals. Michael Jordan and the Chicago Bulls were playing Charles Barkley and the Phoenix Suns. Despite how conflicted she was feeling, MacMullan was determined to do her job and do it well. That meant hanging out at practices during the two-day breaks between games, competing with other national media for the most interesting story angles. With the Bulls up three games to one, MacMullan was rooting for Jordan to have a big game so she could get home the next morning. Jordan had scored 55 points in the previous game, and MacMullan was convinced that he wanted to wrap things up at home in Chicago as much as she wanted him to. Instead, "Barkley has this incredible game, and now we've got to go back to Phoenix, and there's another two days off between games, so you're talking about another three to four days away and I was exhausted," MacMullan recalls.[11]

She remembers being in tears on the media bus back to the hotel. When her *Globe* colleague Dan Shaughnessy asked her what was wrong, she sobbed, "I don't want to do this . . . this is not why I had a child." After a mostly sleepless night, MacMullan got to the airport and checked her bag to Phoenix. But as she waited at the gate, she made what she feared might be a career-ending decision: She called her editor, Don Skwar, and told him she needed to go home, but she didn't tell him why. "He said, 'Do what you've got to do,' so I got on a plane for Boston, thinking, *what have I done?*" MacMullan recalls. "I never would have done it if Shaughnessy hadn't been there too. I kept saying, to myself, 'I don't know if this is the right thing for the *Boston Globe*. But this is the right thing for me.'"

When MacMullan got home, not having had time to call ahead, her husband was surprised to see her. "He said, 'What are you doing here?' and I said, 'This is where I need to be.' He replied, 'Yeah . . . it's about time,'" she recalls. "He's such a cool dude. I probably saved my marriage without even knowing it."

As for the job? She wasn't as confident about that. MacMullan waited until the following Monday to call Skwar and ask for a meeting. She intended to resign, citing her inability to juggle her two roles along with what she considered her dereliction of duty. She didn't expect the reaction she got. He told her that *she* was the one who'd decided she had to do the job the way she'd been doing it. "And he was right," she recalls.

"I tried too hard to be too many things to too many people." Skwar and MacMullan came up with a plan for MacMullan to cover the NBA without traveling as much. For the next three years she no longer traveled for weeks at a time, instead taking advantage of the many sources and contacts she'd developed over the years.

By the time her son, Doug, came along in 1996, she had taken a job with *Sports Illustrated* to write about the NBA and file a weekly column. Even after the kids were in school and she wasn't afraid of missing first steps or bedtime stories, MacMullan was adamant about putting her family first. When her daughter was playing college basketball at Connecticut College, MacMullan gave Aly's game schedule to her new boss at ESPN Boston and told him she needed those nights off.

"Did I miss out on opportunities? Absolutely. Do I care about any of them? I do not," MacMullan says now. "I decided I want to live my life, and if my career doesn't go to the moon, that's okay. It will work out. . . . I was fortunate I worked for Don [Skwar] and Vince Doria, people who knew and cared about me and made allowances. I know that's not how it is for everyone. I'm well aware of that."[12]

If an understanding boss can help a woman keep a sports journalism career on track, an unsympathetic one can undermine it. Amber Theoharis had a supportive boss when she gave birth to her first child, a daughter, in 2010. Theoharis was part of the Baltimore Orioles broadcast team at Mid-Atlantic Sports Network (MASN) and was driving to Camden Yards to interview the Orioles' September call-ups when she realized something didn't feel right. She was only twenty-three weeks pregnant. Instead of continuing to the ballpark, she exited at her doctor's office. The doctor's examination revealed that Theoharis had started labor. She was rushed to the hospital, where she spent the next five weeks on her back to prevent her baby from being born prematurely. She wasn't supposed to move and she wasn't supposed to sit up. It was physically and emotionally challenging, but with the odds of survival at such a young gestational age at only 30 percent, Theoharis was determined to do everything she could to save her baby.

The Orioles broadcast team and others connected to MASN were supportive. They brought a big-screen TV into her hospital room so that she and the nursing staff could watch the Orioles and then the Ravens football games. She received well-wishes from the Orioles owners, the Angelos family, and the team's manager, Buck Showalter. Dylan was delivered via c-section at twenty-eight weeks and spent five weeks in the neonatal intensive care unit. When Theoharis and her husband brought her home in mid-November, she weighed 3 pounds, 7 ounces. She's approaching her teens now and doing just fine. "Preemies go on to do great things," says Theoharis. "They are little fighters right from the beginning."[13]

Amber Theoharis interviews Pro Football Hall of Fame running back Terrell Davis at the 2020 NFL Pro Bowl in Orlando, Florida. Theoharis is now carving out a multifaceted career on her own terms in sports broadcasting. *Photo courtesy of Artemis Sky Entertainment*

Theoharis left MASN in 2012 to become a studio host for NFL Network's *Total Access*. She retained that job after the birth in 2013 of her second daughter (who was also born prematurely, about four hours after Theoharis wrapped up her show). But two years later, in 2015, after her third child was born, Theoharis came back from her six-week maternity leave to discover that she had been replaced by the woman who had been filling in for her. The problem, according to Theoharis, was that the company president—the person she reported to before her maternity leave—had moved on and was replaced by someone who was looking to put his own mark on the programming. The football players with whom she cohosted *Total Access* implored the new president to restore Theoharis to the position, but he wouldn't consider it.

"I think that hurt me," Theoharis says in retrospect. "Here are these big, huge gazillionaire athletes . . . trying to tell him what to do. So he dug in and I never got that job back."[14]

Theoharis said she expressed her displeasure internally—even to the head of the network—to no avail. She continued to work at NFL Network until her contract was up in 2019. She now works part time for Fox and for Westwood One, where she hosts a studio show and covers the NFL. She also teaches a course in multimedia at the University of Southern California and has her own production company.

Theoharis says the most humiliating part of the whole ordeal at NFL Network was coming in to work, seeing her replacement sitting at her old desk and a box holding her belongings sitting in front of her locker in the dressing room, as if she'd been fired. "It was horrific. Humiliating . . . I went into the pumping room for new mothers and cried so no one would see me," she recalls. "All I had done was have a baby."

Theoharis had worked right up until the day her third baby was born—even though she'd already delivered two babies prematurely—because she loved her job and because she feared losing it. "I think every woman in this industry has that fear," she says. "You see how quickly you can be replaced when you're *not* pregnant. You'd like to believe the laws protect you, but they don't, because the reality is you are put in the position of having to sue a mammoth like the NFL and be blackballed by the industry . . . or stand down and be haunted by that decision for the rest of your life."[15]

Whether it's out of fear or whether it's out of sheer exhaustion, most women sports journalists (and many working women period) still find themselves putting off motherhood well into their thirties. It can take a decade to establish yourself in a sports journalism career. Hitting the pause button at a time when you need to be laser focused can seem like career suicide. In 2019, Jenny Dial Creech was writing columns for the *Houston Chronicle* while struggling to figure out how and where to pump

her breast milk at football stadiums and other venues on the road. "I would cover a game and get home at one in the morning, and my child is waking up at four. That's a very difficult thing," she says. "As a columnist, especially when it comes time for playoffs, you say, 'Well if they win, I'm flying to San Francisco on Friday. If they lose, I'm not.' . . . My child has a schedule. I do not."[16]

Overall, things are changing for mothers trying to manage life and career. Many teams now set aside rooms for female employees, including media members, to pump and store their breast milk. But women still have to negotiate on their own for such parenting-related benefits as flexible work hours and other things that men either don't anticipate or don't understand. And they risk being passed over for the choicest assignments or beats. Creech, now a deputy managing editor and columnist for the *Athletic*, maintains that many issues would be lessened if women writers were reporting to women editors. Creech was an editor briefly at the *Houston Chronicle*. She didn't enjoy being the only woman at meetings, she says, but she felt pressure to stick it out to represent the interests of the women on the staff. "In those meetings about who's covering what and who's traveling where, you need diversity in those rooms," she says. "You need somebody at the table who can speak for you, and there's not."[17]

But female managers won't eliminate women's problems, at least not until the playing field is level. It was a female middle manager, after all, who packed up Theoharis's belongings the day before she returned to NFL Network. "Nobody was willing to take a stand because they understood the fragility of their own position," Theoharis says. "It happens all the time in sports. All the time."[18]

Juggling schedules, lining up childcare months in advance, and living with the guilt of missing milestones will always be part of life for working mothers. For women sports journalists, the challenges that come with parenthood will continue to complicate the journey and force some of them to make difficult choices. But with increasing opportunities and more women in the ranks, perhaps the stumbling blocks won't become detours for the next generation of aspiring sports journalists. Marie Hardin says she has lots of graduates in sports journalism doing well and many young women coming into her office who want to go into the business. "I always tell them, 'Go do it, realizing that you may feel like your challenges are different from your male colleagues because of social norms, especially if you want to have a family,'" she says. "But I encourage them. Of course they should go after it."[19]

10

Karen Guregian:
Having It Her Way

In April 2020, former New England Patriots quarterback Tom Brady held his first conference call with reporters after signing with the Tampa Bay Buccaneers. *Boston Herald* sportswriter Karen Guregian was on the call with dozens of other reporters. When her name was announced as the next questioner, Brady called out to her, "Hi Karen. I'm going to miss you."[1]

Guregian has said hello and goodbye to plenty of professional athletes in her thirty-five years as a sports reporter. In that time, she's covered many of the triumphs and tragedies of the Boston sports scene. She was at the 2004 World Series in St. Louis when the Red Sox broke their eighty-six-year Curse of the Bambino with a flip of the ball from pitcher Keith Foulke to first baseman Doug Mientkiewicz. She was at the hockey game when Boston University freshman Travis Roy hit the boards and fell to the ice paralyzed from the neck down only eleven seconds into his first game in 1995. She got called away from a dinner date when the Celtics' Reggie Lewis collapsed on a practice court and died two hours later in July 1993. She was there when the Patriots won their first Super Bowl in 2002. She broke the story that Rob Gronkowski was headed to Tampa to join Tom Brady in 2020.

Guregian has survived layoffs, newsroom shuffles, and beat changes because of her seniority, but she is hardly one of those old-timers taking up space waiting for a buyout offer. A throwback to the bygone years of daily newspaper journalism, Guregian has survived and thrived because of her indefatigable energy and her rock-solid reporting.

Karen Guregian of the *Boston Herald* is shown talking to then New England Patriots quarterback Tom Brady at Patriots training camp. Guregian has been covering the NFL since 2007. *Photo courtesy of Karen Guregian. Photo taken by Boston Herald staff photographer Nancy Lane*

"[She is] one of those reporters out of some black-and-white movie: dedicated, relentless, and fiercely competitive," said former colleague Gerry Callahan.[2] Jackie MacMullan of ESPN also sings her praises. "She's an amazing reporter and a special person," MacMullan says, adding that the only reason she isn't better known beyond Boston is her penchant for flying under the radar.[3]

Guregian grew up in Chelmsford, Massachusetts, a former mill town next to the city of Lowell, about thirty miles from downtown Boston. The *Lowell Sun* was her hometown paper when Guregian was coming of age in the 1970s, but she faithfully read the *Boston Globe* sports section every afternoon after school, especially the stories of Lesley Visser, the *Globe*'s first full-time female sportswriter. While writing for her school newspaper and captaining her high school basketball, softball, and field hockey teams, Guregian dreamed of someday joining Visser and legendary columnists Peter Gammons and Leigh Montville on the *Globe* staff. She

also dreamed about writing for *Sports Illustrated*, of which she collected hundreds of copies over the years (only recently parting with all but fifty).

Talk about flying under the radar: Guregian actually began writing for the *Boston Herald* anonymously. She was a student in Northeastern University's five-year co-op program from 1979 to 1984, and she covered news during her college internships for the *Lowell Sun*. But her first love was sports, and to that end, she did freelance work for the *Herald* while still writing for the Lowell paper and attending school. In order not to jeopardize her internship, she created a series of fictitious bylines for her *Herald* sports stories. When the *Herald* eventually realized it was time to commit to Guregian, she dropped the pen names and began writing as herself.

At first, she was a general assignment reporter covering high school football games, tennis, and whatever else needed to be covered that day. Editors quickly realized they were wasting her talents, as she kept uncovering stories that other media outlets were missing. "I'm somebody who never shuts it off," says Guregian. "I don't know if I'm a little bit crazy, but some nights I can't sleep thinking I might miss something. . . . Who do I need to call? Who's going to be the best person to help me? . . . There's always some story and I always felt I owed it to the readers to give them something so they wouldn't toss the paper down or click to something else."[4]

Soon enough, Guregian was promoted to beat writer, covering the Boston Bruins full-time. Her second decade saw her promoted to beat columnist for all four of Boston's professional sports teams. She covered the Red Sox as they won their first World Series since 1918, and also covered two of the New England Patriots Super Bowls, as well as two Olympics. "I literally bounced around," recalls Guregian. "It was the best job."[5]

Since 2006, she's been covering the New England Patriots as a beat columnist. Her experience in news as a college intern has come in handy. She's covered a murder trial (Aaron Hernandez), league investigations (Spygate and Deflategate), and the fallout from the team's owner (Robert Kraft) being charged with soliciting a prostitute.

Guregian says she is as surprised as anyone that she has managed to stay at the *Herald* for her entire career. Yet her background hints at the importance of family and a sense of tradition and loyalty that would have made it hard for Guregian to contemplate leaving her roots. Guregian is part of a tight-knit family, descendants of immigrants who came to the Lowell area during and after the Armenian genocide. Her mother and father both worked in the Lowell mills, and once they moved to Chelmsford, they created a home for their three children that centered around family.

Over the years Guregian has had offers from other media outlets, but they were never offers she couldn't refuse. Early on in her career, she was approached by ESPN, which wanted her to be the "expert" on its NFL broadcasts. She would have been the person in the broadcast truck whispering into the sideline reporter's earpiece what questions to ask. Guregian says ESPN was looking for someone with real football knowledge and journalistic expertise because the sideline reporters at that time were either women who'd never covered football or former football players without any interviewing experience. Guregian was intrigued but realized she would have been giving up her own visibility as a reporter. And she also wondered why ESPN didn't consider hiring her, given her skill set, to be the sideline reporter. "I don't know if it was still a guy's club or if I just didn't fit the attractiveness profile," she says. However, she is glad to see so many knowledgeable women reporting from the sidelines, anchoring sports shows, and being part of sports show panels these days. "I love a lot of these shows now," she says. "They know what they're talking about."[6]

Guregian feels fortunate to have avoided the locker room issues that plagued many women sportswriters in those years when she was just starting out. Her penchant for flying under the radar and ignoring isolated affronts has served her well. Athletes and other sources quickly noticed that she was always around. They noticed her quiet confidence and her earnest interest in what they had to say. They often opened up to her in ways they didn't open up to other reporters.

"She's the ultimate professional," says Marisa Ingemi, who covered the Bruins for the *Herald* but was laid off in April of 2020. "That Patriots beat is tough. . . . The fact that she's got that trust says a lot about her as a person."[7]

Guregian's writing style is reminiscent of the kinds of sports stories fans used to read in the pages of *Sports Illustrated* every week. And her best story may well be a piece she wrote for *Sports Illustrated* in 1996. It came about, as fate would have it, because of her personal battle with cancer. In 1989, she was feeling run down and had a deep, persistent cough. She was initially misdiagnosed, but tests eventually revealed that it was stage 4 Hodgkin's lymphoma, a curable cancer if caught early enough, but aggressive in its later stages. Guregian continued working while she was undergoing chemotherapy. To her colleagues, it seemed she didn't miss a beat, but as anyone who has undergone cancer treatment knows, there are good days and bad days and mind-numbing bouts with fear and uncertainty. Single and alone, she says it would have been worse for her to sit around thinking about having cancer than to go out and do her job.

By October, she was declared cancer free, but in December she felt a lump. This time her oncologist told her that her only chance of survival was an experimental bone marrow transplant. The prospect was a daunting one. She had to go to the University of Nebraska Medical Center in Omaha, where doctors were pioneering the procedure. There she would be isolated from friends and family for weeks as her body fought to eradicate the cancer cells once and for all. Guregian says her experience as an athlete helped her battle the cancer. "It's like, the hell with this thing," she told *Sports Illustrated* in 1996. "It's not going to beat me. I have too much to live for."[8]

Illustrating how hard it is for Guregian to turn off her journalistic instincts, she even found a way to break a big story from her hospital bed in Omaha. The Boston Bruins were contemplating a replacement for coach Mike Milbury. One of the names being floated privately was longtime Boston University coach Jack Parker. When an NHL official called Guregian in her hospital room to wish her well, the two got to talking about the Bruins and he mentioned this possibility, which would have been a big deal. "I said, is that on the record, and he said, 'Sure why not?' He probably thought I would nod off and forget about it." Instead, she scribbled some notes on the back of a get-well card and called the *Herald* to dictate the scoop. When a copy of the newspaper arrived at the nurse's station on Guregian's floor, the nurses were amazed to see Guregian's name at the top of the tabloid's back page. "When I tell you I can't turn it off, that's probably the best example," Guregian says.[9]

Guregian had made a full recovery and was back on the Bruins beat when, three years later, all-star hockey player Mario Lemieux of the Pittsburgh Penguins held a press conference to announce that he was suffering from Hodgkin's lymphoma. The *Herald* sent Guregian to cover his announcement, and as a result, she and Lemieux became friends. When the news broke that Lemiuex's cancer had come back, *Sports Illustrated* hired Guregian to write about her friendship with him. The article not only fulfilled her childhood dream of writing for the magazine, it also displayed the graceful style of a talented writer able to place in context the intimate details and feelings of her subject. "He thought the worst was behind him" she wrote in her lead paragraph. "The black cloud that had haunted him for three years was gone, and Mario Lemieux, hockey's crown prince, was back in control of his kingdom."[10]

Guregian says she tried to make the article mostly about Lemeiux, but the editor insisted it be more of a "Mario and Karen" story. "I was kind of kicking and screaming against it," says Guregian. "But the best thing to come out of it was that it touched a lot of fellow cancer patients. . . . I had someone get in touch with me and say, 'I'm going to be going through it and I've got that story under my pillow as inspiration.'"[11]

Guregian, admittedly old-fashioned, also had to be coaxed onto Twitter. A former colleague on the Patriots beat, Ian Rapoport, was her mentor in that regard. She recalls how, when they went out to lunch or dinner, he'd be tweeting where they were, reviewing the food, and taking selfies of himself and Guregian. "I'd say, Ian, people are going to hate this," Guregian recalls. "But look where he is now [on NFL Network]." In the early days of life in the Twittersphere, Guregian was plagued, like most female reporters, by comments from neanderthals who told her she didn't know what she was talking about or that she belonged in the kitchen. She recalls one person who would rip every single thing she wrote. But "some of my more faithful readers took on the guy and eviscerated him," she says. "It was interesting to see that battle." These days, Guregian gets few suggestions that she should be home baking bread, but occasionally she will engage with negative tweets—not because she is offended but because they express some view based on inaccurate information. "I'll try to shoot down the bad ones," she says. "I'm not going to shrivel up from these things."[12]

In 2013, she got an offer to join the *Boston Globe*, the newspaper she'd dreamed of writing for as a child. But the *Globe* had just been sold and the newspaper industry was obviously losing its battle with the internet. Classified ad sections that had once expanded like the Incredible Hulk were now down to a couple of pages. The *Herald* quickly matched the *Globe*'s offer, and with more than twenty years of seniority, Guregian decided to stay with the *Herald*. It wasn't just the desire to play it safe that kept her there. She felt a sense of loyalty to her colleagues because of their generosity during her cancer treatment. Colleagues had donated sick time and frequent flyer miles so that family members could visit her in Nebraska. "That had a big impact on me," she says.[13]

As of mid-2021, the *Herald* sports department staff was down to seven writers who must edit their own and each other's copy. When the pandemic hit, reporters were mandated to take five weeks off unpaid out of the next ten weeks. When they returned, another round of layoffs ensued. The situation reminds Guregian of the final episode of the *Mary Tyler Moore Show*, which ran in the late 1970s. In that episode, the newsroom staff has all been let go and in the last scene, Mary takes one more look around the office before the curtain closes. "So maybe I'll be Mary Tyler Moore turning the lights out," Guregian says with a laugh.

Aside from that fantasy, Guregian has no exit strategy. "I still love watching the games and trying to bring readers something new, something different, an opinion they might not have [considered]," she says.[14]

Marisa Ingemi says Guregian gave her some advice when she joined the *Herald* in 2017. She told the young reporter to stick up for herself, to

put herself out there, and to believe in herself. "She told me, 'You're here for a reason,'" Ingemi recalls.[15]

That prescription has served Guregian well all these years. "I am who I am and I present myself that way," she says. "I don't try to be someone I'm not."[16]

11

Play-by-Play:
The Final Frontier

Leah Hextall remembers clearly how disconsolate she felt in 2016 when she was living at home with her mother in Winnipeg, Manitoba, thinking her career in sports broadcasting was over. Since 2005, she had progressed as a hockey analyst through several regional cable markets. In 2014, she was hired by Sportsnet, Canada's national cable rightsholder for National Hockey League broadcasts, as studio host for regional Calgary Flames games and the 5 p.m. NHL pregame show. Just two years later, however, she was laid off during a cost-cutting purge. In the ensuing months, she applied for five sportscasting jobs without success. Sitting on the floor of her mother's house one evening, she felt defeated. She couldn't imagine a future for herself in broadcasting.

The next morning, though, she awoke with an idea: Why not try calling games from the broadcast booth? She realized that she'd never heard a woman doing play-by-play for an NHL game. She also realized that it was about time one did. Hextall called her former boss at Sportsnet and pitched the idea of her calling a package of Canadian Women's Hockey League games. She also called legendary hockey announcer Mike "Doc" Emrick and hockey color commentator Cassie Campbell-Pascall for advice. In 2006, Campbell-Pascall was the first woman to do color commentary on *Hockey Night in Canada*. As a player, she won two Olympic gold medals for the Canadian national team and she is now a broadcaster for Sportsnet. Both Emrick and Campbell-Pascall told her to go for it. She is now making history as part of ESPN's play-by-play team for NHL broadcasts. Her goal in five years is to be known as Leah Hextall, play-by-play announcer, as opposed to Leah Hextall, *female* play-by-play announcer.

"That will mean that there are more women doing this and that we've proved we belong," she says.[1]

By 2021, women sports broadcasters were reporting from the sidelines, anchoring sports desks, and hosting their own sports talk shows. The one place they were still rarely seen or heard from on a regular basis was in the broadcast booth calling the games as the action unfolded. In the last five years, the door to the broadcast booth has opened a crack with women such as Jessica Mendoza and Doris Burke becoming secure in their roles as analysts for Major League Baseball and the National Basketball Association, respectively. In September 2021, Mendoza and Melanie Newman became the first female duo to broadcast a nationally televised Major League Baseball game.

Even so, the role of play-by-play announcer—the narrator of the action in real time—is still very much the final frontier for women in broadcasting. It's easy enough to ascertain why. Those who sit in the booth and call the games are the authorities on what is happening on the court, on the ice, or on the field. ESPN play-by-play veteran Beth Mowins described her role in 2017 as "the person driving the bus."[2] A woman may call just as flawless a game as a man, but if the audience doesn't accept her, the pressure to rely upon the safer choice (and there are plenty of men vying for announcer jobs) is difficult for network executives to overcome. Kate Scott of Fresno, California, would seem to have a good chance of becoming a nationally known play-by-play announcer in the next few years. Despite her rising star, she still has to fight for acceptance from listeners. She says the best tweet she got after one of her two NFL games in 2016 basically said, "I expected to not like you . . . but you didn't suck."[3]

Scott started in play-by-play at the suggestion of two women, one at ESPN and the other at CBS Sports. She'd sent her highlight reel and résumé to them, hoping for a job as a sideline reporter. Instead, she was asked by each of them if she had ever considered play-by-play because she had such a great voice. "They said, 'We know that's where this industry is going. That's kind of the final frontier for women . . . so if it is something you would consider, we would push you in that direction,'" Scott recalls. Soon after, Scott had to choose between a job in Chicago as a sports anchor and a position with the Pac-12 that included play-by-play. "I'm very much one of those people who feels like sometimes the world is trying to tell you something, so you better listen," she says.[4]

Scott has risen quickly through the ranks of play-by-play announcers. Not only has she been a well-respected voice on Pac-12 broadcasts, but she also was tapped to do two NFL preseason games (in 2016) and was the lead voice for an NHL game in March 2020—a game that was produced, directed, and announced by an all-female crew. In March 2021, she did the radio play-by-play for the NBA game between the Golden State

Warriors and the Chicago Bulls as part of another all-female crew. Scott did basketball play-by-play at the Tokyo Olympics in 2021, which led to her becoming the full-time, TV play-by-play announcer on Philadelphia 76ers' broadcasts for the 2021–2022 season. She feels a responsibility to educate listeners to the fact that women can be as knowledgeable and opinionated as men and that they are as easy to listen to once the initial surprise subsides. "Change is hard," explains Scott. "It's going to require a bit of growth toward accepting something new, not instantly judging the voice because it's a woman's."[5]

Indeed, resistance to change is the biggest factor holding women back. For fans who grew up listening to play-by-play legends such as Vin Scully or Al Michaels, having a male voice tell you what's going on down on the field seems like the natural order of things. To some listeners, the higher register of a woman's voice can, at the very least, seem out of harmony with the norm. Then there are the naysayers (judging from tweets that Burke and Mendoza have received), for whom the higher register brings back memories of their mothers telling them in no uncertain terms to go to their rooms. For these listeners, there will never be an acceptable woman.

"I have no doubt that 'hating the sound of her voice' is code for 'I hate that there was a woman announcing football,'" veteran NFL reporter Andrea Kremer told Julie DiCaro during a discussion about women announcers.[6]

DiCaro's 2021 book *Sidelined: Sports, Culture, and Being a Woman in America* is a no-holds-barred commentary on the misogyny that exists in sports today. She devotes a chapter to the challenges women face on the radio and in the broadcast booth, using her own experience on her former CBS radio show in Chicago as an example. She recounts how during her first year, she received a barrage of criticism. So she tried to model her voice after Sigourney Weaver (seemingly a good choice since there aren't many men who hate Sigourney Weaver). The anecdote would have been amusing if the ending had been happy. But as hard as she tried and as much as she practiced, DiCaro still received daily complaints about her on-air voice. "It was simultaneously too high, too low, too shrill, too girly, too raspy, and my favorite, too sexy," she wrote. She finally realized that it didn't really matter what she, or any other female radio voice sounded like. "They were complaining that we sounded like women."[7]

Hearing a woman play-by-play announcer might be a nonissue by now if things had worked out differently for Gayle Sierens in 1987. A sports reporter and sports anchor for WFLA-TV in Tampa, Florida, Sierens was a popular sports broadcaster. She had won an Emmy for her sports reporting in 1984, and ESPN—still searching for talent to add to its growing pool of female anchors and reporters—tabbed her for lots of freelance assignments. The big three national networks were starting to take notice

of the talented women around them. CBS had broken ground with Phyllis George and Lesley Visser in the 1970s and early '80s. But Michael Weisman, the executive producer of NBC Sports, wasn't interested in simply playing catch-up; he wanted to make a bigger splash and, as he mused later, really "break that glass ceiling."[8]

Weisman began to build a list of possible female play-by-play announcers to add to NBC's regional NFL Sunday broadcasts. Sierens, who was on the top of the list because of her low voice and high profile in the Tampa market, started training with legendary play-by-play veteran Marty Glickman. Glickman was the voice of the football Giants for twenty-three years and of the basketball Knicks for twenty-one years; he also did pregame and postgame shows for the Dodgers and Yankees for twenty-two years. NBC hired him to coach new announcers, including Marv Albert, because his style was straightforward, crisp, and authoritative, as was his criticism of sloppy play-by-play work. Sierens said in 2011 that she welcomed the chance to learn from Glickman. "He wasn't going to let me fail," Sierens recalled.[9]

Sierens grew up watching sports in Tampa with her mother and grandmother. She also was a high school athlete, though opportunities to play sports were limited in the pre–Title IX era. As a football reporter, Sierens already knew the importance of charting each player. From Glickman, Sierens learned the finer details of knowing when to expound upon material from her background charts, as well as how to hand the action off to the color person. Her debut came on December 27, 1987, in a game between the Kansas City Chiefs and the Seattle Seahawks in Kansas City, which was shown in twenty-eight markets in nine states.

In the pregame show, studio host Bob Costas asked Sierens if she thought her big chance was just a publicity stunt. Sierens admitted that it would probably be remembered as a gimmick if she did a terrible job. But she didn't. Sierens got high marks for her performance, made more difficult by the bank of reporters and photographers from all over the country, four deep in the press box, watching and recording her every move. She misidentified a player on the opening kickoff, but quickly recovered. She says she knew who the right player was but decided to trust her spotter, whose job it is to check the charts. "I didn't have enough confidence to go with what I knew," she recalled.[10]

The next day, newspapers around the country applauded Sierens's performance. Weisman offered her a six-game contract for the following NFL season. But Sierens was married and had a baby on the way. She had switched from sports to news anchor the year before to better accommodate her new role as a wife and working mother. The station manager, who had been lukewarm about her doing the game, asked her to choose between her news anchor job or this new play-by-play opportunity. A

six-game commitment wasn't exactly what she considered job security, so Sierens chose to stay at the station. Still, she does sometimes wonder what might have been. She still has the crib sheet she made for that historic game hanging on the wall of her South Tampa home. In Sierens's hand-writing, the names and numbers of each player are written in big block red letters. Her notes on each player are scribbled in blue pen beside each name. "If I was a 20-something or an unmarried 30-something, I would have rolled the dice in a heartbeat," she reflected in 2011.[11]

Another woman, Leandra Reilly, had been coached by Glickman as a candidate for a tryout, but was not assigned to an NFL game. Instead, she became the first woman to do play-by-play for an NBA game in February 1988. For football, Weisman pivoted to Andrea Kremer, then a producer and host at NFL Films, to fill Sierens's shoes. Kremer was widely viewed as the most knowledgeable woman covering football. After weeks of training, practice, and coaching from Glickman, she did one practice game in early 1989 with Dave Jennings and was offered a deal to call six games during the 1989 season. She turned the offer down and instead joined ESPN as the network's first female correspondent. That turned out to be a good move when Weisman was fired by the new president of NBC Sports, Dick Ebersol, putting an end to the effort to integrate women into the football broadcast booth.[12]

It took almost thirty years—*yes, three decades*—for a national network to provide another woman the opportunity to announce an NFL game. There were isolated attempts to bring women announcers onto the national stage, but these were more marketing ploys than actual advances. In 1993 Gayle Gardner, who was enjoying great success at the time as an NBC sports desk anchor, became the first woman to do play-by-play for a Major League Baseball game when she called a Colorado Rockies/Cincinnati Reds game. But most progress for women continued to take place on the regional level, and even there it often seemed like the slow, barely detectable creep of geological plates that occurs along a fault line.

The experience of Pam Ward at ESPN reveals the struggles pioneers have had to endure and how tenuous their career trajectories can be, especially when it comes to breaking down barriers at the highest levels. Ward was hired as one of five female ESPNews anchors in 1996. At that time, she made it clear that she wanted to continue to do play-by-play work, which she'd been doing for ESPN on a part-time basis. However, she waited four years to be assigned to call college football games for ESPN. Ward says she had *USA Today*'s sports media critic Rudy Martzke to thank. After reading one of his columns about women being best suited as sideline reporters, she stormed into her boss's office and confronted him with what she perceived to be a gender bias. "I dramatically threw the newspaper down on his desk and said, 'I don't want to have to read

this anymore. I want to be able to do football.' Her boss, executive editor John Walsh, paused for about two seconds and then replied, 'OK. We'll make that happen.'"[13]

On November 22, 2000, Ward became the first woman to work play-by-play on a Division I college football game when she called ESPN2's telecast of Bowling Green at Toledo. In 2001, Ward called her first full season of college football. She moved from Mid-American Conference games to the Big Ten, the real plum of college football assignments, and she announced several bowl games in the early to mid-2000s. During her tenure as a college football announcer, Ward was praised by coaches and those in intercollegiate athletics as a versatile, pioneering broadcaster. In 2010 she won an industry award for her media contribution in the field of intercollegiate athletics. Executives at other networks cited her professionalism, the quality of her voice, and her obvious preparation, making it seem as if she might one day get her wish to announce NFL games.[14]

But ESPN executives (and all broadcasting executives for that matter) are nothing if they are not skittish about fan reaction and the potential impact on ratings. Just two years later, ESPN reassigned Ward to announce women's college basketball, softball, and its expanding coverage of the WNBA. Ward believes she fell victim to the misogyny that seemed to surface like a tidal wave in the mid-2010s. It was then that YouTube, fan websites, and Twitter feeds were becoming increasingly bold, aiming their slings and arrows, dripping with vitriol, at women who dared infiltrate previously male domains. Ward says slipups that would be ignored if men had made them were often treated as if it were "the apocalypse." With so many male up-and-comers at ESPN being groomed for play-by-play jobs, Ward surmised that it was easy for the cable channel to justify the switch. "I feel like I'm the only broadcaster who has to be perfect," she said in 2012. "I know it is part of the culture now but . . . I think it is pathetic and mean-spirited."[15]

Ward has found a niche for herself covering women's sports, benefiting from the increased interest in women's college sports and the WNBA. But with Ward out of the college football rotation, that left only Beth Mowins calling high-profile football games for ESPN. Since joining ESPN in 1994, Mowins has called NCAA championships in basketball, softball, soccer, and volleyball and has been the voice of the women's college softball World Series for more than twenty years. She was also part of ESPN's coverage of the 2011 Women's World Cup in Germany.

In September 2017, Mowins got the call for which women had been waiting thirty years. She was invited to be the play-by-play announcer for the Los Angeles Chargers versus Denver Broncos game as part of ESPN's season-opening *Monday Night Football* doubleheader. In doing so, she became the first female broadcaster to call a nationally televised NFL

game since Gayle Sierens worked that regional telecast in Kansas City in 1987.

Mowins earned praise from colleagues and media critics for her performance that night and has since been invited to call several other NFL games. In 2021, she also joined Marquee Sports Network to broadcast a select number of Chicago Cubs baseball games. Mowins earned her master's degree in communications from Syracuse University's S. I. Newhouse School of Public Communications in 1990. That's the same school that produced such male play-by-play announcers as Marty Glickman, Bob Costas, Marv Albert, Sean McDonough, Dick Stockton, and Mike Tirico. She's earned a number of awards for her broadcasting work, yet every time Mowins does a high-profile game, viewers invariably threaten to mute the sound because they find her so "annoying." The criticism of Mowins shows not only that sexism

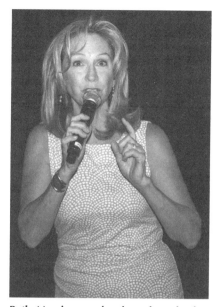

Beth Mowins speaks about her play-by-play career at the Association for Women in Sports Media convention in 2018. In 2017 she became the first woman in thirty years to call a National Football League game. She has also called Major League Baseball games on the Chicago Cubs TV network. *Photo courtesy of Arianna Grainey*

is alive and well but also that the critics have not a clue as to how the industry actually evaluates its broadcasters. "One of the many positives about Beth doing the game, in addition to her being a top-notch seasoned broadcaster, is that she has a great voice that cuts through all the ambient noise in the stadium," Andrea Kremer was quoted as saying after Mowins's history-making NFL game. "Whether you're in the booth or on the field, you need a resonant voice that can be audible. The voice is like an instrument and Beth has great pipes."[16]

Mowins also earns consistently high marks for her preparation and her ability to work with the color commentator she is paired with in the broadcast booth. Having been an athlete in high school and college, she likens her role to that of a point guard, handing off the ball to the teammate who scores the points. In some ways, Mowins says, she has been practicing her whole life for a role that really didn't exist for women when she was growing up. "When I was a kid watching games, I knew I wasn't going to be the star quarterback or the coach. But that other guy, calling

the game? If I worked at it, I might be him," Mowins said in the run-up to her 2017 game.[17]

Play-by-play is, by all accounts, a stressful job that often demands days of preparation for a single game or series. The announcer and the analyst are like players who prepare all week for the big game: reviewing notes, making chart boards, doing rehearsals and run-throughs, and then putting it all together into a tightly compacted live broadcast. Ann Schatz of Portland, Oregon, had been a veteran sports reporter for a couple of decades when she first found her way into a broadcast booth. Schatz's claim to fame as a TV reporter is that she was granted the only interview figure skater Tonya Harding did at the Winter Olympics in Lillehammer in 1994 after her teammate Nancy Kerrigan was attacked at the US Figure Skating Championships.

She started out as a sportscaster in her hometown of Omaha, Nebraska, after she graduated from Creighton University in 1979 with a degree in journalism. A few years later, she moved to Portland, Oregon, where she found the viewing public not as welcoming as her hometown viewers had been. She persevered, though, as a sports reporter and an anchor. She also spent time as the Portland Trailblazers sideline reporter as well as the color analyst for the Portland entry in the WNBA. But by the early 2000s, the broadcast industry was changing, becoming less employee friendly. Local sports coverage was dying on all fronts, and Schatz wanted out before her position was cut back even further. When she did her first play-by-play call, she knew this would not only extend her career but could be a heck of a lot of fun. "Have you ever had that experience where you stumble into something and you say, why not?" explains Schatz in her typically enthusiastic way, ". . . and then you think, 'This is it! This is what I'm meant to do!'"[18]

During the part of her career that preceded play-by-play, Schatz prided herself on her skills as a reporter and interviewer as well as her ability to think on her feet on the sidelines and behind the anchor desk. Perhaps play-by-play felt like her calling because it combines all those skills. Like most announcers, she tends to overprepare for a broadcast, in part because she needs to fill the gaps between plays, especially in softball, but also to make sure she's giving people interesting information that puts the action into context. Schatz is the voice of the Portland Thorns, a team in the National Women's Soccer League. She has found her steadiest work as a Pac-12 announcer, doing primarily college soccer, basketball, and softball games with a style and a flair that brings her broadcasts to life for fans and has gained her notice beyond the West Coast. "Up in the booth. That's when you know you've made it as far as I'm concerned . . . and it's coming," says Schatz.[19]

It may be coming, but women still need champions like Weisman was to Sierens back in 1987—decision makers who see the potential benefits of having women in the broadcast booth and are committed to breaking down the barriers to their inclusion. In 2018, Amazon Prime decided to champion Hannah Storm and Andrea Kremer, tapping them to be the first-ever all-female broadcast team for Amazon Prime's livestream of *Thursday Night Football*.

Executives at Amazon Prime told Kremer and Storm that if they weren't interested in teaming up for the livestream, they had no other women in mind and would just scratch the idea. Kremer and Storm were certainly the most logical choices to break the male monopoly on announcing pro football. They are walking encyclopedias when it comes to the facts and faces connected to the world of sports. It seems as if Storm has hosted every conceivable major sport during her career with CBS, ABC, and ESPN, where she now cohosts *SportsCenter*. She was the first play-by-play announcer for the WNBA and has been the lead announcer for other national sports broadcasts. Kremer, meanwhile, is the doyenne when it comes to covering professional football. She is the chief correspondent

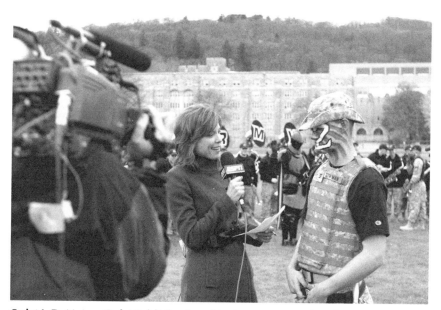

Cadet J. D. Moore, Cadet Spirit Band president, answers questions from Hannah Storm about the United States Navy Band. The Veterans Day tribute broadcast is one of hundreds of events Storm has hosted for ESPN over the years. *Photo by Master Sgt. Dean Welch/Dir. of Public Affairs & Communications.*

Andrea Kremer is a groundbreaking football analyst and journalist. She was selected as the 2018 recipient of the prestigious Pete Rozelle Radio-Television Award by the Pro Football Hall of Fame. *Photo courtesy of Elvis Kennedy © All rights reserved*

for NFL Network, does reports for HBO's *Real Sports*, and helped create an all-female sports journalism show on the CBS Sports Network. She was a producer with NFL Films and, in addition to her work with ESPN, has been a sideline reporter for NBC. She is a member of the Pro Football Hall of Fame, selected in 2018 as the recipient of the Pete Rozelle Radio-Television Award. She's also won two Emmys and a Peabody for her work.

Kremer and Storm didn't hesitate very long before saying yes to Amazon Prime. The deal made Kremer the first full-time female NFL game analyst, and together, Storm and Kremer became the first and only female broadcast team calling NFL games. When the news of this historic partnership broke, some called it a gimmick and others said no one would choose the alternate feed when they could watch the same game while listening to Joe Buck and Troy Aikman on Fox. But the critics may have forgotten that many in Amazon's target audience had abandoned their cable boxes and now relied on livestreaming for their sports viewing. The Amazon Prime livestream reaches 220 countries, a growing international audience that has the choice of listening to Kremer and Storm or an alter-

nate "scouts' feed." "Can you imagine that there are people in Indonesia thinking that listening to women talking about football is normal?" said Kremer in 2020.[20]

During their initial season, it took a few weeks for Kremer and Storm to find their rhythm. What you'll hear now is a polished broadcast, but one that feels like a natural conversation between the two hosts. Storm handles the play-by-play, but the hosts bounce their thoughts off each other as if they were sitting in the living room, eating popcorn and watching the game. Rather than just calling the action, they try to take it to the next level in terms of sharing their thoughts about play calling or how someone is playing.[21]

By the fall of 2021, Storm and Kremer were poised to begin their fourth season of broadcasting the livestream for Amazon Prime, which will own exclusive rights to *Thursday Night Football* in 2022. They take seriously the historic nature of their partnership and have expressed the hope that their example will inspire young women to consider play-by-play as one of their options, while also prompting decision makers to consider more women for play-by-play opportunities. "The key to having this be meaningful was not necessarily the first game, it was the fact that we're still here three seasons later," said Storm in December 2020. "That's what's meaningful. That's staying power. That's sustainability. That is a true, viable career option for somebody."[22]

NFL football is America's most-watched sport, which naturally makes it the zenith in terms of play-by-play opportunities. But female sports broadcasters have begun to establish careers in prominent play-calling and commentary roles within other major markets and in other sports. Many of these announcers are former athletes. In 2017, Debbie Antonelli, a former basketball player at North Carolina State, became the first woman since former professional basketball star Ann Meyers in 1995 to serve as an analyst on NCAA men's basketball tournament broadcasts. But she's been working men's games (just not tournament games) either on the sidelines or as an analyst since the 1990s.

Another former athlete (and coach), Doris Burke was the first woman to be named a national NBA analyst for ESPN in 2018. In 2020, she became the first woman analyst for the NBA Finals on ESPN radio. It wasn't just the hundreds of men's college basketball games she had called, but also the decade's worth of NCAA Division I women's basketball Final Fours and WNBA broadcasts that convinced ESPN that it was time to give Burke her due. She's also in the Naismith Memorial Basketball Hall of Fame as the recipient of the Curt Gowdy Media Award.

Jessica Mendoza, a two-time Olympic medalist as part of the US national softball team, is one of a handful of women currently holding analyst positions with Major League Baseball. She was hired by ESPN in

2008 and in 2015 became one of the team of hosts on the network's *Sunday Night Baseball* telecast. In October 2020, she became the first woman analyst on a national World Series radio broadcast. Currently, she is the analyst for ESPN's weeknight baseball games and is part of a team of pundits who appear regularly on ESPN's baseball shows. Mendoza thinks often about the impact her visibility can have for women. "This isn't about me doing a good job for myself at my own job, but really to be successful so that more men, who are hiring, understand women are just as equal to, if not better, at so many jobs that are out there," she told a local TV reporter in Portland, Oregon, where she lives.[23]

While being a former athlete lends credibility, having a passion for sports may be even more important. Leah Hextall doesn't consider herself an athlete, but she has hockey in her blood. Her cousin Ron played for the Philadelphia Flyers and her grandfather Bryan is in the Hockey Hall of Fame. Her father, Randy, who played Junior A hockey, taught her the game by diagramming plays and strategies at the kitchen table when she first began her broadcasting career. So it's not a surprise in the world of Canadian hockey that she was in the booth as part of an all-female broadcast for an NHL game in March 2021. She was also in the booth for the 2020 NCAA Division I men's championship hockey game, which went five overtimes before Minnesota-Duluth prevailed over North Dakota, 3–2. The game wasn't decided until 142 minutes and 13 seconds had passed. Hextall considers it a crucial game in her development because she proved to herself that she had what it took to do play-by-play. "Up until then I hadn't called myself a play-by-play [announcer]," she says. "After those five overtime periods and the periods before them, I realized, yes, I can do play-by-play."[24]

Hextall started calling plays less than five years ago. She credits her relatively swift rise through the ranks to her mentor, US Hockey Hall of Famer Doc Emrick, who called both professional and Olympic hockey games over a fifty-year career before retiring in 2020. "It's a common phrase, but she fits it perfectly: This woman has worked hard for years to become an overnight success," said Emrick in an e-mail exchange. "I am thrilled for her in getting what she has earned."[25]

In their first phone call, Emrick told Hextall that the most important thing she could do to advance her career was to get as many "reps" as possible. Keeping up with the flow of the game and finding creative ways to describe repeated actions takes practice. The only way for Hextall to practice in the middle of a Canadian winter was by calling junior-league and minor-league games on her own time. So she did. After that first winter, she sent her tapes out every time she heard of an opening for a hockey play caller. She was fired up, Emrick says, when a team in the East Coast Hockey League (two levels below the NHL) told her, "Sorry, but you *were* a finalist!"[26]

 Emrick didn't just coach her on the finer points of play calling; he also cautioned her to realize how lonely she would feel at times in the role of a trailblazer. "I'd never thought of it that way until he said that. But yes, trailblazing is a lonely place. It's lonely because even though you have support . . . there's no one else doing what you are doing," she says.[27]

Emma Tiedemann is the voice of the Double-A Portland Sea Dogs in Portland, Maine. She is one of a growing number of women whose goal it is to announce games at the major-league level someday. *Photo by Joanne Lannin*

Ever the optimist, Emrick believes it's only a matter of time before women play callers won't feel so alone. "Just as I go to an orchestral concert and take little note of whether the first violinist is male or female . . . or what gender an ER doctor is at the hospital . . . it will be the same for those women who are gifted at the elements of play-by-play," he says. "Gender won't matter if you can do the job."[28]

As Hextall's experience shows, proving you can do the job takes practice, and certainly the tiny sorority of women doing play-by-play in minor-league baseball's pipeline are aware of that. Emma Tiedemann of the Double-A Portland (Maine) Sea Dogs is in her late twenties, and she assumes she'll be calling minor-league games for the next ten to fifteen years before she has the experience to graduate from the minors to the majors, where she hopes to become the everyday voice of a major-league team.

Tiedemann is one of two women calling Double-A games on an everyday basis, and one of five women overall calling games—out of 120 minor-league baseball teams. Tiedemann was chosen for the job as the voice of the Sea Dogs over 130 other candidates. She moved up to Double-A from Single-A Lexington, where she was the South Atlantic League Media Relations Director of the Year in 2019. To be the everyday voice of a major-league team has been Tiedemann's dream since she was fifteen and sat beside her grandfather while he did play-by-play for a University of Texas at Dallas game. He told her that she could chime in while keeping score if she wanted to. She chimed in on almost every play, and that's when she fell in love with play-by-play.

"Someone once described it as sports improv," she explained to me in 2021. "And with baseball, you get to call a game every night."[29]

Tiedemann and her four minor-league counterparts are each other's biggest fans. They text and Snapchat on a daily basis and help each other out in any way they can. That's because minor-league play-by-play announcers don't just show up, put on their headsets, and start talking. They are responsible for compiling stats and game notes, scheduling interviews between players and coaches and the media, reporting roster moves to MLB, suggesting social media posts, and, every once in a while, helping with the tarpaulin before games.

"You're running around like a chicken with its head cut off until you put on the headset," says Tiedemann. "But once you put it on, it's the most relaxing and rewarding job to just sit down and call a game. . . . It makes everything else worth it."[30]

Tiedemann's and other women's hopes of someday calling major-league games would seem to be improving, as MLB has made a commitment to grooming more women for the play-calling role. In July 2021, Melanie Newman of the Baltimore Orioles broadcasting team made his-

tory when she did the play-by-play for a game between the Orioles and Tampa Bay Rays that was streamed live on YouTube. What was unique about the game was that Newman's supporting crew in the booth, on the field, and in the studio were all women, something MLB has said it would like to do more of in the future.

Newman again made history on September 29, 2021, when she and Jessica Mendoza were the first-ever all-female announcing team for ESPN's nationally televised Wednesday night Major League Baseball game. Newman's rise has been relatively swift, as she spent six years in the minor leagues before becoming part of the Baltimore Orioles radio/television broadcast teams two years ago. Like Hextall, Newman looks forward to the day when women in the broadcast booth will no longer make headlines.

"The novelty aspect of this, it's time to move past it and to graduate from it because the reality at the end of the day is that gender, race, religion, really anything—none of those qualifications have bearing on how qualified you are to do any job, not just broadcasting," Newman said just before the all-woman broadcast in July. "We're excited; it's a first and it's great. But let's get to the point where it's just another broadcast."[31]

12

Suzyn Waldman: Pioneer in the Broadcast Booth

Suzyn Waldman grew up near Boston, but she is living life to the tune of Frank Sinatra's "New York, New York." Since 2005, she has been the number two person on New York Yankees radio broadcasts on WFAN, teaming up with John Sterling to provide the color commentary for every Yankees game. It's the capstone to an iconic thirty-five-year broadcasting career in which she's weathered all manner of indignities but also garnered all manner of accolades. Without peer in her industry, she is considered a rock star by women hoping to follow her path.

"I'm kind of a fangirl about her, even though my fiancé reminds me I don't need to be [since] she's in my industry," says Emma Tiedemann, the voice of the Boston Red Sox Double-A affiliate in Portland, Maine. "But she's incredible and a great supporter of us too."[1]

What makes Waldman's story even more incredible is that sports broadcasting was Waldman's accidental career. Ever since she first heard a show tune and realized she could carry one of her own, she was sure she was destined to sing on Broadway. And for fifteen years Waldman lived out that dream, with roles in several Broadway productions. She is proudest of her starring role opposite Richard Kiley in a revival of *Man of La Mancha* that toured nationally from 1977 to 1979. But Broadway musicals were changing, and Waldman, who describes herself as a "very, very good singer" had a big voice in the mold of Ethel Merman, Mary Martin, or Barbra Streisand. When she auditioned for the role of *Evita* in the Andrew Lloyd Webber production, she was told she needed to change the tone of her voice to fit the music. Instead, she decided to change careers.[2]

Suzyn Waldman has been the color analyst and commentator for the New York Yankees radio broadcasts since 2005. Her groundbreaking career is an inspiration to a growing number of young women hoping to call Major League Baseball games someday. *Photo courtesy of the New York Yankees*

Sports was Waldman's secondary passion, developed during her growing-up years in Newton, Massachusetts. She often accompanied her grandfather to nearby Fenway Park to watch the Red Sox, where they sat in box seats behind the on-deck circle. From an early age she was keeping score and developing an understanding of the nuances of the game. (She says she also developed a crush on Red Sox slugger Ted Williams.)

Waldman stayed a fan and a student of the game even after she moved to New York. Whenever she was on the road with a Broadway production, she would call up that city's team's front office and ask if she could sing the national anthem as a way to get into the ballpark. One day, as she was awaiting her cue to go on the field in Minnesota, she struck up a conversation with Red Sox star Jim Rice. Wes Parker, who was broadcasting the game for NBC that day, was standing nearby and overheard Waldman asking Rice how he was adjusting to the off-speed junk that pitchers were throwing him in lieu of fastballs.

"Have you ever thought about doing this for a living?" Parker asked her after Rice had walked away.

"Doing what for a living?" Waldman replied.

"If you can get Jim Rice to talk to you, you've got a future in this business," Parker said.

That brief comment led Waldman to take a couple of courses in broadcasting as she continued to work while contemplating her next career move. Waldman's break came in 1987 when WHN radio in New York City decided to change its format to all sports and became WFAN. Red Sox broadcaster Ken Coleman, with whom Waldman had become good friends over the years, helped her get an interview with the station's general manager. She was hired to "rip and read," doing sports score updates every fifteen minutes as they came off the teletype machine.[3]

Right from the beginning, though, it seemed that colleagues and managers wanted nothing to do with Waldman. Producers would take her tapes and edit them so that she "sounded like a moron." She was criticized for her distinctive Boston accent and unceremoniously shipped to the overnight desk. Waldman was surprised at the way she was treated by her detractors at the station. She'd learned how to navigate setbacks during her time in theater. But in theater, you were either too fat, too skinny, too old, or too young for the part. At WFAN, she knew the criticism had nothing to do with her looks. And it certainly had nothing to do with her knowledge of sports. Her fatal flaw, she realized, was simply being female. Undeterred, Waldman proceeded to turn her demotion to the overnight desk into an opportunity by taking a tape recorder to Yankees, Knicks, or Rangers games before her shift began. That way, instead of just reading other reporters' quotes and ripping updates off the wire, she was able to produce reports that featured the sound bites she'd captured. Newspaper reporters hated that she could scoop them because her reports aired overnight while theirs didn't appear until the next morning. In essence, she made herself indispensable at WFAN, and her persistence has made her one of the most notable pioneers in broadcasting.

"To not be able to do something because I'm female . . . I just wasn't going to take it," recalls Waldman. "It had nothing to do with being a pioneer. I just wasn't going to fail because some male didn't think I could do it. . . . If I'd started this at twenty, I don't know whether I could have done it. Being older, having had a career in theater, I wasn't afraid. What were they going to do to me?"[4]

Winning the acceptance of colleagues and management was only the first hurdle, however. Like most beat reporters, Waldman faced harassment in the locker room—not from the Yankee players and staff, but from players on other teams. One night Toronto Blue Jays outfielder George Bell, who had not talked to the media all year, started screaming at Waldman when he saw her, telling her to get the hell out of the locker room. Another ballplayer, Jesse Barfield, came to the rescue that night. "He said, 'Suzyn, I went 3-for-4 tonight. Don't you want to talk to me?'" Waldman

recalled on a 2020 podcast. "What I found back then was an amazing amount of kindness and an amazing amount of cruelty, and not a lot in between."[5]

Many radio listeners were also apoplectic at having their sports scores and highlights delivered to them by a woman. Once Waldman began covering the Yankees exclusively and doing midday sports reports for WFAN, the vitriol increased. In the mail, she received used condoms, toilet paper with feces on it, and vile letters, some of which included death threats. Yankees owner George Steinbrenner tasked stadium security with keeping her safe. Sometimes, she found that her car had already been started for her when she got to her parking space, which meant that a bomb threat had been called in while she was covering the game. Sometimes, security in unmarked cars would follow her all the way home. "I had a detail of cops that whole season [1989]," she recalls. "What precipitated it? I was female and I was on the radio talking about the New York Yankees. . . . It was a horrible time."[6]

The season ended on a high note for Waldman, though, as she was assigned to cover the World Series between the Oakland A's and the San Francisco Giants. (The Yankees had finished fifth and out of the playoffs.) Just as Game 3 in San Francisco was set to begin on October 17, a magnitude 6.9 earthquake shook Candlestick Park and knocked power out throughout the stadium. The only phone line that did not fail was Waldman's. She had been on the air with Gary Cohen, the voice of the New York Mets, and so they kept their phone line open as Waldman sought out players and officials to interview from the upper deck of the stadium. When the series was postponed ten days, most reporters left the city, but Waldman stayed to do more reporting. She won an international radio award for her work covering the aftermath of the earthquake, and it was, she says, "the first time I was taken seriously."[7]

That year also cemented her relationship with the mercurial Steinbrenner. When they first met, he made it clear he wasn't a fan of women in nontraditional roles. "I don't like women to be pilots, policemen, or in the military. I like women to look pretty and spend my money," Steinbrenner said during their first meeting in 1988. Waldman didn't miss a beat. "Okay, I can do that," she said. "Now let's talk about the pitching staff." Steinbrenner laughed and continued the interview. Waldman had her share of tiffs with Steinbrenner (who didn't?) but she ignored his gruffness and his slights and stood up to him. He finally came around to realizing how tough and fearless she was. In fact, they became very good friends.[8]

Waldman's broadcasting career continued to steadily progress, and she landed a number of opportunities to do play-by-play and commentary on both radio and television. In 1992, while still covering the Yankees on radio, Waldman got the opportunity to do a weekend series in Houston

for the New York Mets. It was her first chance to do play-by-play and commentating on the major-league level. In 1994, she was the first woman to do national major-league games for the Baseball Network, and she continued to do them for the next two years, all while still at WFAN.

It was during this time that Waldman discovered she had breast cancer. She handled what might have been a significant setback to her career with her usual determination. She had surgery just three weeks before spring training in 1997 and underwent chemotherapy during the first half of the season. During road trips, the Yankees stored her medicine in their clubhouse and had a small refrigerator set up in hotel rooms so that she could give herself shots and continue to work. She missed very few days, but as she recalled in a *Sports Illustrated* article in August 1997, not a day went by that she didn't worry about passing out or throwing up. Still, she said, "I worked too hard for that shot on television. . . . I was going to have to die for me not to be on the air."[9]

In the next few years, Waldman's career continued to soar. She did televised play-by-play and commentary on the MSG Network and on Fox and continued to cover the Yankees. In 2000, she was paired with Jody MacDonald for the coveted 10-to-2 slot on WFAN. She left WFAN to join the brand-new YES Network as a pre- and postgame reporter, partnering with Ken Singleton, Bobby Mercer, and Jim Kaat to do various games. In 2005, Waldman took on the role for which she is best known when she began teaming up with John Sterling as the official radio broadcast voices of the Yankees. (Pause to cue up Frank Sinatra here.)

Waldman's style as a color commentator differs from that of many of the men who fill the role for other MLB broadcast teams. Many of them are former ballplayers who spend at least part of their time talking about the technical aspects of a given play or at-bat. They can call upon their own experience to support their opinions and analysis. Waldman, on the other hand, relies on her pregame reporting and her rapport with players for her insights. For example, if she's standing at the batting cage and sees Yankees slugger Aaron Judge working on his stance, she will ask him about it. If he hits a home run, she might explain to fans the work he put in earlier that day. But if he strikes out? "I'm not going to say, well I think he should get more on his back foot. . . . What I'm bringing is why something happened, not what I would have done," she says.[10]

Waldman has been criticized for being too partial to the Yankees at times. Yet she can be as critical as any analyst if she feels a player or the manager isn't doing his job. After the Yankees were eliminated from the playoffs in 2015, manager Joe Girardi seemed to want to blame it all on injuries. She reported Girardi's quote to listeners but added, "We heard a lot about injuries in there [the Yankee clubhouse], but it happens to all these teams," Waldman said sarcastically. "I don't want to hear it."[11]

When her partner, Sterling, took some time off in 2020 during the pandemic-shortened season, there was some talk that Waldman might assume the play-by-play duties. While she says she would have switched roles if asked, she is much happier as a color commentator. She didn't feel any need to prove she could do play-by-play, she says, particularly since she'd done it in the mid-1990s and found that she didn't enjoy it as much. "I love what I'm doing," she says. "What I think I bring to the broadcast is humanity: . . . stories about players, some things the fans wouldn't know just by reading the newspaper or watching the games on TV."[12]

Waldman is respected as a broadcaster who has stuck it out and helped change the landscape for women. She's in the New York State Broadcasters Hall of Fame and was one of four people nominated in 2021 for the National Radio Hall of Fame in the Longstanding Network/Syndication category. She also won a lifetime achievement award from the Alliance for Women in Media in 2015 and is part of the Diamond Dreams exhibit, a room devoted to women in baseball at the Baseball Hall of Fame in Cooperstown, New York. There—along with her microphone and pictures from her broadcast career—is the score card from the 2009 World Series, commemorating her place in baseball history as the first woman to ever broadcast a World Series game.

Jessica Mendoza, who has made a name for herself as an MLB color commentator for ESPN, credits Waldman for being a catalyst to her career. She told Waldman about the time she and her boyfriend were driving along and turned on the radio to the Yankees game. Upon hearing Waldman, she turned to her boyfriend and said, "See, I can do this."[13]

But while she may be an inspiration to many women, Waldman feels she was often just tolerated, not accepted in the industry. She wonders why there are still only a handful of women doing baseball play-by-play or color commentary, most of them at the minor-league level. "I'm still the only one with an everyday job in the booth, but it is changing," Waldman says. "You hope that women see you and think they can do something because there you are."[14]

13

Doris Burke: At the Top of Her Game

For a sports-loving seven-year-old kid whose family had just moved one hundred miles from West Islip, New York, to Manasquan, New Jersey, the best surprise she could have found in the backyard of her new home was a basketball. Among her schoolmates, she might have felt like she had "bad hair, bad clothes, bad skin, bad teeth," but when she grabbed that ball and dribbled it over to the basketball court at the park just steps from her house, Doris Burke felt as if her future was securely in her own hands.

"That moment was the moment I first fell in love with basketball," Burke said in 2017. "I picked up that ball and I never put it down."[1]

Burke has replaced the ball with a microphone, but basketball is still front and center in her life. In a career spanning thirty-plus years, she is regarded by many as the best broadcaster—female or male—doing basketball commentary today. She was the first woman sports broadcaster to be awarded the Curt Gowdy Media Award by the Naismith Memorial Basketball Hall of Fame in 2018. That year she also won the National Sports Media Association's National Sportscaster of the Year Award. In 2021, Burke received the Mary Garber Pioneer Award from the Association for Women in Sports Media.

Burke has chalked up many firsts for women in sports broadcasting. She was the first woman to call a New York Knicks game on radio and television broadcasts and to call a Big East men's basketball game on television. In 2017, she became the first woman to serve as a regular NBA analyst on television. In 2020, she became the first female game analyst on a network radio broadcast during the NBA Finals.

ESPN's Doris Burke received the Curt Gowdy Media Award from the Naismith Memorial Basketball Hall of Fame in 2018 for recognition of her career as a basketball analyst. She is revered by fans, coaches, and players because of her knowledge of the game. *Photo by Joanne Lannin*

What places Burke in a league of her own—among a field crowded with talented announcers of both genders—is her knowledge of the game, coupled with her devotion to meticulous research and her ability to think fast on her feet. NBA broadcaster Jeff Van Gundy, whom Burke has known since her playing days at Providence College, has called her "the LeBron James of sportscasters."

"She does it all—great interviewer, commentator, studio analyst—everything," Van Gundy told *Deadspin* in 2017. "And she is an expert at it all—women's and men's college basketball, the NBA, and the WNBA. . . . [T]here's no better broadcaster out there right now."[2]

Burke attributes her success simply to her passion for the game of basketball. She was the youngest child in a family of eight. Many of her older siblings were already out of the house when she was growing up, and so she spent her time practicing her moves on the basketball court at nearby Indian Hill Park. She could have been at the beach, only a mile from her home. But for upwards of four hours a day, she was on the court, practicing her shooting and creating games and competitions with herself to

keep her focused. In the fourth grade, she won a purple warmup jacket in a shooting contest in which all her competitors were boys. She spent the rest of that year wearing the jacket when she went to the park. She imagined herself doing pregame layups and making game-winning shots.

"When I think of Doris, I think of Indian Hill Park," said Patti Reid, a childhood friend and teammate. "Literally every day, she was in that park playing basketball."[3]

In high school Burke (then Doris Sable) was the kind of athlete coaches wish they could clone. She combined a take-charge mindset with an ability to see the whole floor on both offense and defense. As all video highlights do, Burke's high school reel shows her scoring lots of points, many by way of a stop-and-pop jump shot off the dribble, which was uncommon in the girls' game in the early 1980s. But they also show her as a defender in the middle of the press, anticipating pass after pass and making steal after steal; they show her diving for the ball, crashing the offensive boards, and fearlessly taking charges. As its point guard, Burke led her high school team to a 71–10 record from 1981 to 1983. She was the school's all-time leading scorer, with more than 1,300 points.[4]

While Title IX had been enacted in 1972, Burke didn't realize that Division I colleges were giving scholarships to women to play basketball until she watched a college women's basketball game on TV in 1980. She researched colleges on the East Coast and explored a few campuses, deciding that Providence College would be a good fit. She began winning Big East honors in her freshman year. By the time she graduated, she held several Providence College and Big East Conference records that stood for many years. Those were the days before women had a professional league in the United States to aspire to, and many of the best college players went overseas to play after graduation. If Burke hadn't blown out her knee her senior year, she could have been one of them. Instead, she became an assistant coach at her alma mater.

Two years later, after she married and started a family, Burke decided to quit coaching. She didn't see herself as being cut from the same cloth as Tennessee's Pat Summitt, someone able to combine the 24/7 nature of coaching at the Division I level with the responsibilities of a family. As fate would have it, Providence College decided that year to start broadcasting its women's games on the radio. Burke was asked if she might be interested in giving play-by-play a try. It was a good way to stay connected to the basketball program while being able to be home at night for her family.

Soon after, she was pressed into service to call a Providence College men's game when one of the announcers didn't show up for the afternoon contest with the University of Pittsburgh. Burke had no time to prepare because she'd found out about the opportunity less than two hours before

game time. She was also feeling distracted (to say the least) by a visit that morning to the emergency room where her son, Matthew, a toddler at the time, had to have stitches in his head after he fell off a bench onto a concrete floor. When Burke arrived at the arena, she barely had ten minutes to talk to the opposing team's coach and another ten minutes with the Providence coach. She proceeded to turn in a performance that made it seem as if she'd been preparing for days.[5]

"My strength is that I know the game so well," she said several years later. "Whatever shortcomings I had because of lack of experience, I could always overcome those because the bottom line was, I knew the game."[6]

Burke started doing more men's games for Providence and for the Big East Conference. She considers that time, between 1990 and 1997, critical to her development. The creation of the WNBA in 1997 was also a pivotal point for Burke. It afforded her the first opportunity to call professional basketball games, first for the New York Liberty and then for the New York Knicks on television and radio from 1998 to 2001.[7]

Burke began to gain more visibility when she became the color analyst for ESPN's Women's Final Four broadcasts. She also was doing some regular season NCAA men's and women's games as well as WNBA games. In 2003, ESPN approached Burke with an offer: The network wanted her to do more high-profile games, but there was a catch. Instead of sitting in the broadcast booth, she'd be the sideline reporter, digging up information and relaying it to the announcers during time-outs. She'd also do pre- and postgame interviews with coaches and players.

Burke was hesitant. This was obviously a promotion that afforded her even more visibility. But she didn't want to be pigeonholed as a sideline reporter, as many female broadcasters are, when her mind and her heart were in the x's and o's and the flow of the game. She said yes, though, and continued to work as a color analyst for women's and men's college broadcasts. It was a way of continuing to remind ESPN decision makers that analyzing the action was really her forte.

While she might not have considered sideline reporting her strong suit, she turned the job into an art form with her devotion to research and preparation. Soon she was reporting from the sidelines of NBA games as well. She would typically get to the arena early on the morning of a night game to interview coaches and players about strategies they'd be employing and challenges they'd face. As a result, she won acclaim as someone whose interviews delved into what the players might be feeling or struggling with, win or lose, eliciting much more than the canned comments they were used to giving.[8]

"What's great about Doris is how she does both men's and women's games with the same fervor, the same passion," says Jackie MacMullan,

who has written five books about basketball. "She's no-nonsense. She commands respect."[9]

Indeed, players and coaches quickly noticed Burke's dedication and her knowledge of the game and began to sing her praises. Rick Carlisle, coach of the Indiana Pacers, said that Burke comes across as having played and coached at high levels, but unlike some other former coaches/players who analyze games, she "has the gift for making the complex simple."[10]

NBA fans also noticed how polished and personable she was on the sidelines. In 2016, the video game publisher 2K, which had featured Burke as a sideline reporter in its *NBA2K* games since 2010, moved her up to color analyst. ESPN management apparently took the hint, or maybe the video game maker had an inside scoop; at any rate, in 2017, Burke became a full-time analyst for regular-season NBA games on TV.

That same season, Burke made headlines and lit up Twitter for the way she handled the postgame trophy presentation ceremony at the conclusion of the NBA Finals. "Kudos to Doris Burke," "Doris Burke is the Meryl Streep of sports broadcasting," and "Doris Burke made it look smooth and seamless," were typical of the tweets.[11]

Burke had been doing the NBA trophy presentation since 2015 as a sideline reporter. She'd also done a number of presentations at the college level. Still, she has said that it took years for her to feel comfortable because of the responsibility she feels to ask questions that will elicit the best responses. In 2017, Burke was too busy to be nervous. She asked thirteen questions to seven different people in less than twelve minutes, and none were those generic, "How does it feel to be champ?" queries. For example, she asked Warriors power forward Draymond Green to put the victory in context with his suspension in Game 5 the previous year.

"As an interviewer, I don't think you can dance around the subject," Burke said. "Certainly the interview subject knows if you are dancing, and the viewer knows that you are dancing. If it's a hard question, you just have to ask it." In interviewing Kevin Durant, the series MVP, Burke harkened back to the moment when Durant lost in the finals in 2012 and fell into his mother's arms at the end of the game. Burke asked Durant to compare this winning moment to that loss five years earlier; his answer was as poignant as one might have expected.[12]

A male announcer may well have asked Durant the same question about his mother, but for Burke it was personal. Being a good mom is something she worried constantly about when her kids were young and her broadcasting career was just getting off the ground. In those days when she was working hard to learn her craft and to convince her bosses that she deserved to advance in her career, she sometimes worked more than one hundred basketball games in a season. One February, she did

twenty-three games in twenty-eight days, including nine games in nine days in nine cities. Although her husband, Gregg, was home with the kids, Burke still felt torn. "I remember being in a parking lot, I think it was in New Mexico. I was to be at a shoot-around at 9 a.m. their time. And I got off the phone with Sarah and Matthew and I sat in that parking lot and cried for a little bit. Because I had been away so much," she said in 2002. "It got to the point where I was calculating how much time I had been away from the kids. It was very difficult for me. Gregg was not working. But I'm their mom. Moms are moms. I wasn't there."[13]

In her Naismith Memorial Basketball Hall of Fame induction speech in 2018, Burke said she appreciated the sacrifices her children made during their growing up years. "Sarah and Matthew, you were not afforded the luxury of a mom who was home every night," she said, tearing up as she spoke. "I have the best job in the world for somebody that loves the game. But that pales in comparison to the pride I have for being your mom."[14]

It's clear that Burke isn't afraid to show her vulnerable side. She also cried when she got the news that ESPN was making her job as an NBA color analyst a full-time gig. She can also laugh about her faults. During one NBA game, she predicted that a player would be called for a foul. When the foul was called, she said, "I do like being right. Ask my ex-husband."[15]

Burke had to be coaxed into loosening up and revealing her personality on air. In her early days, she had an earnestness about her that was easy to criticize if one was looking for a reason not to like her. She wore the same blue blazer to every game and sometimes tied her hair back in a ponytail. Colleagues suggested she might get more and better opportunities if she ditched the blazer and literally let her hair down. Burke took the advice, and over time, changed her image. She also took her son's advice after he suggested she notice how much fun the announcers seemed to be having during an Olympic broadcast. Matthew was fourteen at the time, according to Burke, when he said, "What you fail to understand, Mom, is if you're having a good time on the air, we're having a good time with you."[16]

Burke has obviously come a long way since those days. She's not only among the most respected basketball announcers doing NBA games, but she also has the biggest fan following. Who else can claim to have her face on a T-shirt that the rap star Drake wore to an NBA game several years ago? The shirt reads, "Woman crush everyday." Drake's point was clear when he saw Burke on the sidelines at an NBA game and made a heart with his hands. In reply, Burke mouthed the words, "Thank you."[17] The irony is that Burke does not seek the limelight. In fact, she is a very private person away from the court. "She's not a self-promoter at all," says MacMullan.[18]

Of course there will always be haters, but they are often shouted down on Twitter by Burke's legion of fans. Burke said she has had it easy compared to the women who came before her. She has called New York Yankees color analyst Suzyn Waldman "a legend," and she credits such pioneering basketball sports journalists as MacMullan and Robin Roberts with paving the way. As astute about her own situation as she is at analyzing the action on the court, she believes that the players and coaches who accepted her right away created a "soft landing spot" for her. "Those men and their acceptance of me and the respect they've shown to me on the air, that has changed fans' opinion of me," she said.[19]

All the same, Burke is very much a pathbreaker for women in sports broadcasting. Many hope her ascension to the top echelons of sports broadcasting will translate into tangible gains for other up-and-coming female announcers. Former ESPN broadcaster Katie Nolan has created a series of satiric "secret society" videos in which she and other female broadcasters plot ways to "ruin sports for men." In their YouTube episodes, the walls of the secret society's meeting hall are covered with pictures of Burke, their patron saint.[20]

"The most important thing any of us can say to Doris Burke right now is simply 'thank you,'" ESPN's Sarah Spain said in 2020. ". . . [E]very woman out there who absolutely crushes it, like Doris has, is paving a path for the ones coming behind."[21]

14

#MeToo Comes to Sports

It was late one night in February 2018 when *Missoulian* sportswriter Amie Just received a series of text messages from Montana State University play-by-play announcer Jay Sanderson.

"Come down here. We can get drunk and make bad decisions! Lol!!"

"Looks like we have a love connection!!"

"Don't fight it . . ."

Just, who was covering the Montana State football team at the time, responded to all three texts by making it clear she was not interested. Finally, in exasperation, she wrote: "I f—ing hate you." To which Sanderson replied, "No, you don't. You LOVE me . . ."

Sanderson tried again a few hours later at 3 a.m. inviting her to hang out with him after the basketball team's morning shoot around. "I'd love to see more of you Lol . . . Where would you want to go?"

According to Just, Sanderson continued to make her feel uncomfortable when they were in a room or at an event together. In July 2018, the attention turned physical when he touched her buttocks. She shared with friends how shocked she was soon after it happened but did not report the incident to anyone.[1]

Just had grown up in Nebraska, where watching college football on a Saturday afternoon was like going to church on Sunday. The move to Montana after she graduated from the University of Kansas in 2017 didn't faze her, even though she was the first woman ever to cover the Montana State football team. But with Sanderson's harassment escalating, she knew she had to move on. "You don't want to go grocery shopping and

run into the person who assaulted you. That's reliving your trauma," she told me in a 2019 interview.[2]

When the *Times-Picayune* in New Orleans offered her a job covering Louisiana State University in September 2018, Just announced her plans to leave. But first, she went to Montana State officials and filed a formal sexual harassment complaint under Title IX against Sanderson, whose contract included work for the university. "I was looking for closure for myself and trying to protect other women," she says.[3]

In January 2019, the university ruled that it was likely that Just had been sexually harassed in a way that undermined her ability to do her job. Citing family matters, Sanderson resigned from his position and moved back to Kansas before the university issued its ruling. He denied Just's accusations in news accounts after the ruling became public.[4] Just contends that many of the things Sanderson did were "a lot more gross than the things that were in the report," but because they were not witnessed by anyone else and could not be corroborated by texts, "you can only investigate what you can prove."[5]

Sexual harassment is not confined to women in sports journalism. As the #MeToo movement continues to reveal, it is rampant in workplaces where the culture has been traditionally dominated by men in positions of power. What makes harassment so insidious in the world of sports is the many directions from which it can come. Female reporters have been called bitches, sluts, and worse, and threatened with physical harm by the athletes on their beat, often in retaliation for simply entering their locker rooms. They've been propositioned, bitten, pinched, and groped by male colleagues who may feel threatened by their growing numbers and stature. They've endured sexual innuendo and received unsolicited naked photos from coaches and team personnel via texts and tweets, just for being friendly in the course of seeking information while covering a beat.

Wherever the harassment comes from, women must weigh the consequences before stepping forward to report the incidents. Many decide not to, especially if they are just starting out in their careers. They look around to see if they have any allies willing to support them. If not, they deem it safer to do their jobs without complaint and learn to tune out the indignities.

That's what Jen Lada, a feature reporter with ESPN, did when she was fresh out of college, covering a team that her longtime former boyfriend was playing on. The team's head coach pulled her aside one day in the arena, and with a "cocky smirk" on his face, proceeded to tell her he'd heard all about her dating history: "intimate, sexual preferences, the things I liked and didn't like," she said on Sarah Spain's *That's What She Said* podcast. "I remember being horribly embarrassed. . . . There were still people close enough by to overhear."

Lada didn't report the incident, although she told Spain that she certainly would do so if it happened today. She was just starting out and didn't want to be known as "the woman calling men out for their boorish behavior." In retrospect, she said, the coach was probably banking on her reluctance to tell anyone else about it. "I went about my business and I got a thicker skin, which is what a lot of women do when they are put in these situations," Lada said.[6]

Amie Just and Jen Lada fit the profile of women most often preyed upon by sexual harassers. In their twenties, just out of school, trying to establish themselves in their first jobs, they had few people to turn to for support. Making an issue of the harassment could easily backfire, impeding their ability to do their jobs—or worse, leading to a change in their assignment.

That was Lisa Nehus Saxon's mindset in the early 1980s. She was the first woman baseball beat writer for the *Los Angeles Daily News* from 1983 to 1987. She continued on as the backup beat writer and as a columnist until she left sports writing to become a journalism instructor in 2001.

Saxon was hired as a full-time sportswriter in 1979 and worked her way up to the Angels beat in 1983. Young and naive, she had no inkling that her gender would be an issue on the Angels beat. The Angels allowed her into their clubhouse, but what she faced once she was inside the confines of the locker room was "daily abuse." Players shouted things like "the bitch is back" and "fire in the hole" as soon as she walked in. Having grown up with three brothers, Saxon said it was easy enough to ignore those kinds of comments, but the physical abuse and the more personal insults almost wore her down that first year. She had jockstraps thrown at her almost every day, saw players masturbate in front of her, and on one occasion was forced to sit in a chair while a player pointed his penis at her and asked what she would do with it. Saxon managed to get the upper hand with a sarcastic rejoinder, yet afterward she felt powerless to do anything but pretend the incident didn't happen.

"Other players were there, but they didn't say anything. I just said 'Wow,' got up and covered the game, and then came back down to get quotes after the game," Saxon told me in 2021. "Sexual harassment wasn't really part of the vernacular [in 1983]. So I just rolled with it, thinking that my job was to advance the ball."[7]

All Saxon had ever wanted to be since she was in the sixth grade was a baseball writer. Her growing-up years were punctuated by the sounds of transistor radios on warm summer nights tuned to Vin Scully or Dick Enberg, the play-by-play announcers for the Dodgers and Angels. She'd taught herself how to keep score when she was eight. Despite the nightmarish aspects to her job as a baseball writer, she still felt she was living her dream. "I fought so hard to get into the clubhouse, so if now I'm

Lisa Nehus Saxon with one of her mentors, Vin Scully of the Los Angeles Dodgers. Saxon endured both good times and bad times as an early pioneer in the battle for equal access for and acceptance of women in sports media. *Photo courtesy of Claire Smith*

complaining about what the clubhouse is like, there's a disconnect there, right?" Saxon says.[8]

What kept her going in those early years—and what many women say kept them going—were the allies they found along the way. Saxon remembers fondly an encouraging pep talk from Scully and a four-hour conversation with Angels manager John McNamara in which he talked her out of quitting. "He told me, 'If you're not willing to do this, then who is? You know baseball. Don't let anyone else dictate your fun.'" Saxon soldiered on, creating a playlist of songs (on 8-track tapes) to bolster her spirits on her drive to the ballpark every day. First up was Helen Reddy's "I Am Woman." Then came Glen Campbell's "Rhinestone Cowboy" and finally Blue Magic's "Sideshow"—"Because I was the sideshow in the locker room," she says.[9]

If sexual harassment was only whispered about in the 1970s and '80s, the phrase exploded into the public's consciousness in the early 1990s. It was fueled in part by Lisa Olson's humiliating confrontation with a group of New England Patriots football players in the locker room after a game in September 1990. The details of the Patriots' crude and lewd display, along with the slap on the wrist they received from the NFL, spurred women sportswriters to break their silence about what they were enduring. They realized that the landscape would not change unless they began to speak up and support each other.

San Jose Mercury News reporter Kristin Huckshorn, in an insightful essay about Olson and the harassment she endured, wrote that for every Lisa Olson, there were one hundred locker room incidents that were never reported. She questioned her own and other women's prior reluctance to advocate for themselves. "We were models of perfect comportment, a cross between Miss Manners and Mary Richards . . . figuring silence is the price of admission," Huckshorn wrote. She ended her 1990 essay by saying of Olson's activism: "[She] is destroying the fragile status quo. . . . She makes me wonder: If I had spoken up all along, would this still be happening now?"[10]

The attitudes of many men also began to change, as newspaper editors and publishers sought policy changes from the teams they covered. "Even if you don't think a woman should be in the locker room," wrote Tony Kornheiser in December of 1990, "ask yourself how your boss would have handled this if where you work, some men loitered near a female co-worker and grabbed their crotches and made lewd suggestions. . . . How long would it take for those men to be fired or at least suspended?"[11]

The following year, sexual harassment became front page news when Anita Hill testified during the Senate confirmation hearings for US Supreme Court justice Clarence Thomas. In October 1991, Hill, who had worked for Thomas, testified that he had asked her out socially and

subjected her to sexual harassment on a number of occasions. She testified under oath that Thomas talked about his sexual prowess and anatomy and about films that portrayed group sex and sex with animals. Thomas was confirmed anyway, but in the year after the hearings, the *New York Times* reported that the Equal Employment Opportunity Commission saw a 50 percent increase in sexual harassment filings. In the month after the hearings, Congress passed a law that allowed sexual harassment victims to seek damage awards as well as back pay and reinstatement.[12]

As human resources departments in finance, entertainment, law, and other corporate entities began dealing with the rising number of complaints, sports teams—and even ballplayers—began to wake up to the notion that they could be held accountable for their behavior. Saxon, by then the backup beat writer covering the Los Angeles Dodgers, remembers random players coming up to her to ask if she was writing a book. Some apologized for disrespecting her. "But you never harassed me," she would tell some of them. "They would say, 'It's not what I did; it's what I didn't do.'"[13]

Over the next few years, teams were wary of the bad publicity that harassment incidents could generate. After a *Los Angeles Times* columnist reported that Dodgers pitcher Kevin Brown had dropped his pants and farted in Saxon's direction, a team representative called her and asked if there was anything they could do to make this better. Saxon was thinking to herself that this was nothing compared to other things she'd endured. "But I said, 'Just tell him he has to answer my questions. And if he wants to apologize, tell him he has to do it in person with his son there so his son knows that this is not okay.'" Brown started answering her questions but he never apologized.[14]

Two decades into the twenty-first century, such childish behavior rarely occurs at the professional level. Athletes have been coached to conduct themselves in a professional way when dealing with the media, and most do, fearing fines or bad publicity. But many female sports journalists still face the dilemma of trying to balance the need to be friendly and establish a rapport with their sources without coming across as flirting. Brittany Ghiroli of the *Athletic* recounts an incident when she was the beat reporter covering the Baltimore Orioles. A player invited her to his hotel room, hinting that he had a big scoop for her. She was reluctant but figured it would be safe enough. But when the door opened to his room, she saw candles on the table and heard romantic music playing in the background. When she asked the player why he thought she was interested in him, he explained it was because she'd been so nice to him. "It's my job to be nice to these players. It's my job to get to know them and ask for phone numbers. . . . Unfortunately it gets misconstrued," she said in 2019.[15]

My one brush with boorish behavior as a sports journalist came in 1981 when I went to the training camp of the New England Gulls, one of the teams in the newly formed Women's Basketball League. The Gulls were coming to Portland, Maine, the following January for a game, so I drove to North Andover, Massachusetts, in October to do a story on the fledgling league before their season began. Jim Loscutoff, who played for the Boston Celtics in the 1960s with such greats as Bob Cousy, Sam Jones, and Bill Russell, was coaching the team. As we walked out to the parking lot together after the interviews, I peppered "Jungle Jim" with questions about those Celtics teams of the 1960s. He must have taken my interest in the Celtics of old as an interest in him because the next thing I knew, he was asking me if I wanted to go to a hotel. I was taken aback, but of course I didn't show it. I politely begged off with some lame excuse like having to get home to feed my dog. When I learned that Loscutoff had been fired after the team's 0–6 start, I was relieved. His proposition had been creepy and disappointing, and it put into perspective for me why women are often reluctant to say or do anything that might be misinterpreted as flirting.

These days, you don't have to be in the same room with someone to have your curiosity and friendliness misinterpreted. Texts and tweets, which many reporters consider important tools for covering their beats, are dangerous weapons in the hands of a determined harasser. That's what a reporter covering the Chicago Cubs in 2016 found out when Cubs director of scouting Jared Porter began sending her seemingly innocuous, "friendly" texts and tweets. But it soon escalated into Porter sending pictures of bulging pants and an erect penis. The woman, a foreign reporter covering international players, told an ESPN reporter that she didn't want to report the harassment to the team because in her home country she would be shamed for her role in the incidents. Over the next year, she avoided Porter, even after he left the Cubs for a job with the Arizona Diamondbacks. Porter was fired as general manager of the New York Mets after ESPN ran the story (without naming the woman) in January 2020. According to ESPN, the reporter has left sportswriting, explaining that the harassment was a turning point for her: "I started to ask myself, 'Why do I have to put myself through these situations to earn a living?'"[16]

Not all female sports reporters have to deal with harassing tweets from people they encounter while doing their jobs. But most, if not all, have been subjected to online harassment from anonymous "followers." Misogynists delight in using multiple Twitter accounts to spread their vitriol. To some reporters, these anonymous assaults can be just as disconcerting and soul-killing as physical harassment. "I hear people say all the time, 'Twitter's not real life.' It is real life, especially if you work in

Julie DiCaro was a guest panelist at the Association for Women in Sports Media convention in 2018. She hosts a radio talk show and has written a book about the harassment that women in sports media face on a daily basis. *Photo courtesy of Arianna Grainey*

an industry where you have to be online every day," says Julie DiCaro, author of *Sidelined: Sports, Culture, and Being a Woman in America.*[17]

DiCaro remembers the Twitterstorm she endured when she took on an online sports site called Barstool, which many younger men follow religiously but which she has criticized for its undertone of misogyny and homophobia. The site's devoted followers often take to Twitter to harass those, like DiCaro, who call out the blogs or podcasts that are openly hostile to women. DiCaro quotes one of the site's staffers, who tweeted out, "If I were Julie DiCaro, I'd be sleeping with one eye open . . . because the universe is coming for that ass."[18]

"It feels like this is a dying breed of men who can't handle the fact that women have infiltrated yet one more bastion of maleness that they want to keep for themselves," said DiCaro in 2016. "But, you know, I grew up watching the Bears on my dad's lap, and I grew up at Wrigley Field watching the Cubs, and they don't get to keep it all to themselves anymore."[19]

DiCaro has become a vocal advocate for women who are subjected to verbal and sexual harassment and abuse. In 2017, she and Sarah Spain created an award-winning public service announcement called "Mean Tweets," which featured male volunteers reading some of the tweets

Spain and DiCaro had received over the previous couple of years. The video went viral and sparked consternation and calls for action, not only because the comments were so vile but also because the men—expecting the kind of laugh-inducing mean tweets heard on *Jimmy Kimmel Live!*— were so visibly shaken by what they were asked to read.

Christine Brennan has mentored many young female journalists over the years as a professor of practice at Northwestern University, her alma mater, and through the Association for Women in Sports Media. Brennan says that among the issues that come up most often with aspiring female journalists is how to handle defamatory and disgusting tweets. Brennan realizes that Twitter is an important tool for journalists; she utilized it to break the biggest scoop of her life in March 2020, when an Olympic Committee official told her the Tokyo Olympic Games were being postponed because of the pandemic. Still, Brennan says it is appalling the way Twitter fails to adequately police itself. She advises women not to engage with the trolls who latch onto them and try to make their lives miserable. She worries that the barrage of abuse might dissuade young journalists from continuing to pursue a career in sports media. "I'm sure it already has," she says. "We're going to lose great young talent because they're going to say, 'I don't want to deal with this cesspool on Twitter. I'm going to go to law school or get into a more anonymous corporate career.'"[20]

Most women journalists try to ignore vile tweets unless they come across one that needs to be reported as a bona fide threat of violence. Amie Just was treated to a chorus of Twitter trolls after her sexual harassment claims against Sanderson became public. Ironically, some of the followers who'd said they would miss her when she left were among her detractors. Some used the Donald Trump defense, saying they didn't believe her accusations because she wasn't pretty enough to be assaulted.

Just says she weeds through all of her tweets, but if she starts feeling overwhelmed, she logs off and goes paddleboarding or something else relaxing to calm herself down. "Most of it doesn't faze me anymore," she said, adding that she finds it comical at times that "here are these grown men spending their free time trying to come up with insults about me. . . . We only have so much time on this planet, and they are choosing to waste some of that time making fun of me on the internet."[21]

The stories that seem to generate the worst personal insults and threats are those that report on the sexual misconduct of prominent sports figures. That's why some reporters may turn off public settings for a few days after writing a story on a controversial topic that is sure to polarize people. Others weather the storm by reaching out for support from their followers. One tactic some reporters use is borrowed from the trolls themselves. Instead of having their name out there in the Twittersphere, some reporters create accounts using aliases with little identifying information.

In so doing, they can follow the tweets of sources, players, and others from whom they might need information. They can even promote their stories anonymously.

Some women decide they don't need Twitter at all, but most young journalists continue to have a love-hate relationship with social media. They say it is vital in helping them to establish their brand and get themselves noticed by media outlets when jobs come up. In fact, there are courses and seminars on how to use Twitter to promote your work, and some media outlets require reporters not only to promote their own work but the work of colleagues as well.

"Sure, there are a few old crusty sportswriters who refuse to use social media, but for a younger generation, your follower count can get you in the door for more and more prominent jobs," wrote DiCaro.[22]

If anyone could be excused for eschewing social media, it would be DiCaro. As a talk radio host in Chicago, she waded into controversial topics every day, and every day she incited the ire of the army of trolls who made it their mission to harass her. But she refused to give in to them. She believes that social media platforms such as Twitter, Facebook, and Instagram need to redefine their "community standards" to allow them to consider obsessive, threatening tweets as a reason to ban users. She also urges employers to take more seriously the complaints of female employees who are dealing with constant harassment online by offering security and technical support. And she calls on female employees to start demanding support for the psychological and emotional effects of online harassment.[23]

Unfortunately, mean tweets may always be part of the equation for journalists. But when it comes to the sexual harassment they encounter from sources, coworkers, and other officials they interact with on the job, women are determined to effect change. The AWSM held a panel discussion in March 2021 to help young female journalists band together and navigate harassment issues. Rhiannon Walker, a reporter for the *Athletic*, was one of the panelists. She went public about the Washington Football Team executive Alex Santos, who sexually harassed her soon after she began covering the team in 2019. According to an investigation by the *Washington Post* in July 2020, sexual harassment was embedded in the team's corporate culture. Santos, the director of pro personnel, had made the mistake of not just harassing employees who worked under him but also Walker and Nora Princiotti, two young women covering the team. While the team employees were not named in the *Post* article, Princiotti and Walker agreed to be.

Princiotti, who moved on to work for the *Ringer*, a sports and pop culture website, detailed how Santos on two or three occasions in 2017 pulled his SUV up alongside her as she was walking out of the stadium.

"He told me I had a great ass for a little white girl," she told the *Post*. "The general sentiment was that I should wear less clothing." Princiotti said she was appalled by the comments by Santos and other members of the front office that she had to deal with every day. "There was an overwhelming sense that no one would ever do anything about this stuff."[24]

Princiotti came forward in 2020 at the behest of Walker, who had reported her own disturbing interactions with Santos to the team. Walker, new to the beat in March 2019, said that Santos approached her at a steak house popular with team officials and journalists. After Santos made several inappropriate comments about how she had "worn the f—k out of her jeans" the day before, Walker bluntly told him she was in a committed relationship and would never date a married man or someone she worked with anyway. Santos replied that he would wear her down with his charm, and then he pinched her on the hip in full view of those at the bar.

"Despite being angry about the entire situation, I still tried to be polite, because pissing off or clowning the director of pro personnel would only have negative repercussions. I didn't want to be shut out of the relationships I'd just forged that offseason," she said in 2021 as part of a first-person account of what happened.[25]

Still, the harassment had a chilling effect on Walker's ability to do her job. She stopped asking Santos for information about players, questioned whether she could continue to cover the team, and found herself falling into depression. At the urging of her editors at the *Athletic*, Walker reported the incident to the team. The *Athletic* pushed hard for the team to reprimand Santos, who did apologize to Walker. But he wasn't fired until the full extent of the other employee allegations against him came to light in the *Washington Post* article; then, finally, he was let go, along with two other Washington football personnel named in the article.[26]

Implicating the organizations that have ignored, sheltered, or promoted the harassers in their midst seems to be having an impact. Ghiroli and Katie Strang wrote a lengthy piece for the *Athletic* in January 2021 that detailed the experience of five female sports journalists who said they had been harassed by Mickey Callaway over the previous five years, during which time he worked for three different Major League Baseball teams. Callaway was said to have sent shirtless photos to and asked for nude photos from some of the women reporters with whom he dealt. He was said to have massaged female reporters' shoulders when he thought no one was looking. One reporter said he thrust his crotch near her face during an interview. Another reporter said he offered to share inside information about the Mets if she would get drunk with him. The article questioned why three different organizations failed to vet his social media activity in the course of hiring him, despite the fact that his actions

were "the worst-kept secret in baseball." He was suspended and then fired as the pitching coach of the Los Angeles Angels after the article appeared.[27] After an investigation, Major League Baseball banned Callaway from baseball at least until 2023. Calloway apologized to the women in a statement but also said that he hadn't understood the discomfort he'd caused. Angels manager Joe Maddon suggested that teams and Major League Baseball in general would be looking at the hiring process differently going forward.[28]

Freelance reporter Gina Mizell is on the AWSM board of directors and helped put together the panel on sexual harassment. For years, she says, women sportswriters have been privately sharing their lists of people (like Calloway) to avoid or to be careful around. But now, more and more women are registering complaints, naming names, and demanding action. "It's not hush-hush anymore," Mizell says. "People are showing such strength and courage to talk about really hard things. . . . I hope that's a sign of things to come. People not being ashamed to come forward, being willing to share what's happened to you, that's something that can make change."[29]

It became crystal clear that the #MeToo movement had finally come to sports in June 2021. That's when Kat O'Brien, a former sports reporter for the *Fort Worth Star-Telegram* and *Newsday* wrote a stunning essay for the *New York Times* about being raped by a Major League Baseball player in 2002.

O'Brien said she had not told a soul about the rape until recently—not her mother, her sister, her best friend, or even her editor at the time, who was a woman. She continued to cover baseball for several more years but finally decided that she needed to give up sportswriting, in part because she feared that what happened to her would be found out, but also because she had grown tired of the sexual harassment that female reporters were routinely subjected to in baseball locker rooms.

O'Brien said she was moved to come forward in 2021 after reading about Jared Porter's sexual harassment of a sports reporter in 2016. She decided not to name the ballplayer who raped her because she was sure she would be harassed by his defenders. "Even all these years later and in the wake of the #MeToo movement, a former professional athlete wields considerable power," she explained.[30]

O'Brien's goal, she wrote, was to add her voice to the growing chorus of women speaking out against sexual harassment in sports in order to make it easier for others to come forward. But it will take time before women at all levels of sports journalism feel safe to reveal the harassment they face—especially in places where they are a distinct minority and their harassers have seniority over them. Still, the willingness of such women as O'Brien, Walker, and Just to speak out may prove to be a tipping point.

After Just revealed the sexual harassment she'd endured in Montana, she received texts, tweets, and e-mails from women all over the country thanking her for her bravery. It wasn't easy putting her name out there, she says, but as a journalist she knows all too well that revealing her name gives her experience more credibility. "It forces people to reconcile that this happened to a real person. It gives the story that much more power when you can put a face to an act," she said on a podcast in 2020.

She agrees that the sports world has a long way to go in treating women with the respect they have earned: "You have to defend your entire personhood all the time, and it sucks. . . . We as a society have to do better about victims and survivors of sexually based harassment crimes. If you're robbed, nobody says you were asking for it. Nobody questions that it actually happened to you. You have no qualms about reporting it. . . . We need to value women. Period."[31]

15

We've Come a Long Way

Marisa Ingemi's career seemed to be off to a good start. Only a few years out of college, she was already covering the Boston Bruins for the *Boston Herald* and building a résumé and a reputation that she hoped might one day land her a job as a national hockey writer. But with sports departments shrinking because of challenging economic times, being a new hire in sports journalism can feel like living on borrowed time. In the years since the recession in 2008, the number of jobs at print newspapers has plummeted as buyouts and layoffs have led to more reliance on free-lancers and interns, even at union-represented newspapers.

Sure enough, Ingemi was laid off in early 2020 after eighteen months at the *Herald*. She spent the next sixteen months pitching stories as a freelancer and picking up play-by-play gigs for local sports events. She did sports information work for a couple of local colleges and applied for more than one hundred jobs, all the while hoping to latch on somewhere as a hockey beat writer. She was convinced that was her calling, or at least something she wasn't finished doing. She is proud of the stories she strove to tell while covering hockey, stories that explored things most beat writers ignore. "Anyone can write a Bruins recap . . . I really challenge myself to write what no one else has written," she says.[1] Finally, in July 2021, the stars aligned for Ingemi. The *Seattle Times* needed a beat reporter to cover the NHL expansion Seattle Kraken. She'd been writing some freelance pieces in the weeks before the NHL expansion draft for an online media outlet, which helped bring her résumé to the top of the application pile. "Getting back on an NHL beat means the world to me,"

Ingemi said on her Twitter account. "It's all I've wanted to do these past 16 months."[2]

In the past decade, more and more women have aspired to careers in sports journalism. But they have faced increasingly long odds of fulfilling their dreams. The percentage of women with jobs in sports journalism has remained abysmally low. A 2019 survey of fourteen major newspapers, two wire services, four television networks, and eight online news sites conducted by the Women's Media Center (WMC) showed that only 10 percent of sports content was produced by women.[3] A more recent survey—of one hundred newspapers and online media outlets in 2021 by the Institute for Diversity and Ethics in Sports (called the Associated Press Sports Editors Racial and Gender Report Card)—revealed that female editors and columnists have made extremely modest gains in the three years since the previous survey. With men still accounting for 83 percent of sports editors, 82 percent of columnists, and 85 percent of reporters, it's not surprising that the media outlets still earned an overall grade of F for gender diversity—the sixth straight failing grade since the triennial surveys began in 2006.[4]

"It's [the lack of diversity] been a problem for a long time, and it will take time to correct. And it's still a major problem for women and especially for women of color," said Lisa Wilson, the former president of the APSE, who oversaw the 2021 survey.[5]

When the previous survey was released in 2018, Christine Brennan called the numbers "appalling." She partially blamed the problem on "a little bit of an old boys' network," but attributed most of it to the cratering of the economy in 2008. Brennan has mentored lots of young women who would be great candidates for reporting positions, if only so many sports departments hadn't shrunk so dramatically in the past ten years. "You would have hoped there would be so many openings that these young women could get their start and their chance. Instead, those openings have failed to materialize," she says.[6]

Even ESPN, which employs a higher percentage of women in its news operations than any other media outlet, has laid off people since the 2018 survey. While it's difficult to ascertain what percentage of layoffs in sports media have involved women, it's clear that the purges haven't helped in the effort to level the playing field for women.

Just a few years ago, increasing the ranks of middle managers and editors was thought to be the best way to improve the lot of all women sports journalists. With more women in meetings where assignments are doled out and candidates for jobs are interviewed, women decision makers could potentially be important allies for other women hoping to start their sports journalism careers. These days, however, sports departments resemble the setting of an episode of *Star Trek* where time, space, and

people stand still, save for a few hardy souls who managed to escape the freeze. In many sports departments, the faces might have changed, but there are likely the same number of women as there were ten years ago. "It is disappointing to be the only one in the room that looks like you," says Iliana Limón Romero, the deputy managing editor in sports for the *Los Angeles Times*. Limón Romero was the sports editor of the *Orlando Sentinel* before moving to LA in March 2021.

Limón Romero has observed that many media outlets are committed to diversifying their sports departments and hiring more female editors like her, but that there are many challenges to doing so. First and foremost, she says, is that ever since the recession in 2008, finding and choosing candidates has become complicated by the trend toward downsizing. "Every hire has felt like, gosh, this person is going to have to carry a heavy workload. This person absolutely has to work out. . . . [I]f they eventually leave, I may not be able to replace them," Limón Romero says.[7]

Weeklies and small to midsize papers used to be the training ground for most journalists. But between 2004 and 2018, eighteen hundred newspapers closed their doors. All but sixty were weeklies where young journalists often learned many aspects of reporting, editing, and publishing.[8] Those losses are felt up the chain, as the pool of women with proven track records shrinks. In such an environment, Limón Romero explains, it's only natural that managers feel compelled to hire the proven entity, the candidate for whom others in the industry can vouch.

"I hear from many people saying I have this job opening and I'd love to hire a woman . . . who do you know?" says Limón Romero. "And the problem is, this awakening of sorts, or this push we're in the midst of, that pipeline isn't as robust."[9]

Recruiting female reporters, as opposed to editors, might seem an easier task. But even there, tough economic times create obstacles. Since 1989, the *Los Angeles Times* has been the home of longtime hockey writer and sports columnist Helene Elliott. But according to Limón Romero, the *Times* sports department has only one other female reporter. The department lost five sportswriters shortly before she arrived in early 2021, but there were no plans to fill any of the open positions.

This stasis in hiring has made training, mentoring, and networking all the more important. For this reason, AWSM was founded in 1987. Its focus has been to increase the number of women in sports media careers, as each year it selects six to seven college students for paid summer internships at participating media outlets. The interns also receive a $1,000 scholarship. The media outlets include the *Dallas Morning News*, the *Minneapolis Star Tribune*, ESPN, and the *Orlando Sentinel*. AWSM also sponsors a mentorship program in which young journalists working in media are paired with a midcareer professional for one year. In addition,

there are twenty student chapters of AWSM on college campuses around the country which provide vehicles for networking.[10] AWSM's showcase event is its annual convention, a three-to-four-day affair where attendees participate in workshops and seminars that teach best practices and provide real-world advice from some of the veterans in women's sports journalism.

"You usually leave feeling like you can run through a wall," says Limón Romero, who is the chair of AWSM's board of directors.[11]

Another training avenue specifically for editors is the APSE diversity fellowship program. The goal since it was started in 2011 has been to help midcareer professionals develop leadership skills.[12]

Reina Kempt, the director of sports for the *Louisville Courier Journal*, is a graduate of both the APSE fellowship program and a Poynter Institute fellowship program. At the time of her APSE fellowship, she was a copy editor and page designer for the *Baton Rouge Advocate* in Baton Rouge, Louisiana. She applied for the fellowship after confessing to her editor that she was bored with copy desk work and wanted to be more involved with the planning of coverage.

At the conclusion of the program, Kempt was promoted to deputy sports editor at the *Advocate*. The *Louisville Courier-Journal* soon reached out to her. The paper was looking for a new sports editor, and as a Gannett-owned paper, it has pledged to diversify its staff to match the demographics of the Louisville community by 2025. Kempt, only twenty-nine at the time, says she stood out from other applicants because of a column she'd written for the *Advocate* in June 2020 soon after George Floyd was killed by a Minnesota policeman. In her column Kempt expressed her unique perspective as an African American woman about the need for police reform. Having been coached and mentored during her youth basketball days by local police officers, she was shocked during her time as a scholarship athlete at Louisiana Tech to be stopped multiple times for no good reason and to have her car searched on several occasions. The even-handed but passionate column went viral and put Kempt on Louisville's radar.[13] The city was still reeling from the turmoil over Breonna Taylor's death at the hands of police a few months before Floyd's.

"Companies in general, even outside of journalism, are starting to realize that your company is not whole without inclusiveness and without diversity," says Kempt, who was hired by the *Courier-Journal* in September 2020. "They said they were looking to develop someone like me to lead the department, and that was exactly what I wanted, so it was just the right fit."[14]

Not only are media outlets committed to diversifying staff, they are also keeping an eye on what seems to be a growing interest in a number of women's sports, which would bode well for female journalists. In 2021,

the NCAA Division I Softball Championship series on ESPN averaged 1.84 million viewers, up 15 percent over 2019, while the WNBA's tip-off doubleheader on ABC-TV averaged 605,000 viewers, an increase of 25 percent over 2020's tip-off weekend. Mary Jo Kane, director of the Tucker Center for Research on Girls and Women in Sport at the University of Minnesota is convinced that women viewers are driving these increases in ratings for women's sports. "If you show it, we will come," said Kane. "Treat it with respect and we will tune in, attend, and consume on social media."[15]

Yet for many traditional media outlets with shrinking news holes, balancing coverage is still more a desire than a directive. Even websites, which theoretically have no limits on content, are not swelling with coverage of women's sports. As an example, espnW was created with great fanfare back in the mid-2000s, but that platform has seen cuts in the last few years. In the past few years, however, alternative websites and podcasts hosted by women have sprung up with the mission to fill in the gaps and provide more balanced sports coverage. Some of these alternative sites, such as the podcast *Keeping Track* with Alysia Montano, Molly Huddle, and Roisin McGettigan, are devoted to women's sports; others, such as *The Gist* and *Black Girls Talk Sports with Rekaya Gibson*, produce episodes that are balanced in terms of their interviews with male and female athletes. Not only are these podcasts providing insightful, alternative views on women's sports and female athletes, they also are providing female sports journalists the opportunity to develop their skills outside the usual mainstream channels.

The experience of women sportswriters internationally is following a similar course, as a growing interest in and coverage of women's sports has led to an increase in female sports journalists. When Debbie Spillane started out in 1984, she was one of only a handful of women covering sports in Australia. Now, she says, she encounters "dozens and dozens" of women on sporting fields throughout the country. Spillane, who has been a cricket umpire and a rugby coach (and also owned a record store before she became a sports journalist), was hired as the first full-time female sports broadcaster by the Australian Broadcasting Corporation. Spillane says the biggest obstacle women still face in Australia is being taken seriously as on-air analysts. "Women can present sports and do interviews and be on some of the panel shows . . . but women aren't allowed to have an opinion," she said in 2020. "That's one of the areas that's still an obstacle and a big one."[16]

Suzanne McFadden is the editor of *LockerRoom*, a website devoted to women in sports in New Zealand. McFadden has been a sports journalist for thirty-five years and has covered the Olympics, Commonwealth Games, and five America's Cups. McFadden likes to think that both the

quantity and quality of women's sports coverage in New Zealand has increased, even at the *New Zealand Herald,* her former employer, since she started the website in 2018. "Last year, we published 284 feature stories on New Zealand women in sports, which probably wouldn't have been told elsewhere," she said. "Since our launch, other news organizations have picked up their game in terms of covering women's sport as well. It's reassuring that we're heading in the right direction."[17]

In Great Britain, where the percentage of women sports journalists was a measly 3 percent in 2016, women have become much more visible as TV pundits and presenters in recent years.[18] They also are being hired by some of the more traditional newspaper publications, such as the *Daily Mail* and the *Times,* because of their expanded coverage of women's football (soccer in the United States). Katie Whyatt is a London-based women's football correspondent for the *Athletic.* Previously, she was the first full-time women's football reporter working for a national paper, the *Daily Telegraph,* a daily broadsheet based in London. "It was a role that meant so much to me because I knew how women's sport, rightly or wrongly, often reflects and determines broader societal opportunities for women and how they are treated," Whyatt wrote in a first-person column for the *Athletic.*[19]

The rise of the *Athletic* has also provided expanded opportunities for women in this country. Soon after the subscription website was founded in 2016, it started luring journalists away from traditional newspapers. Its online website covers 270 teams from the NFL, NBA, MLB, NHL, and college sports. The *Athletic* also made an ambitious push to cover women's sports—hiring stringers to report on each of the WNBA teams as well as other women's sports.[20]

But even the *Athletic* has retrenched in the wake of the pandemic, forcing some of its most promising young talent to scramble for work. Former AWSM scholar Gina Mizell was laid off by the *Athletic* in June 2020. Mizell, an Arizona State University graduate, had left a full-time job covering the NBA's Denver Nuggets for the *Denver Post* to join the *Athletic*'s expanding staff. She was an NBA beat writer, the only woman doing it full-time, covering the Phoenix Suns and traveling to thirty-five of forty-one road games in 2019. For several months after being laid off, she did what all out-of-work journalists do: She blogged, tweeted, freelanced, and sent out résumés. In November 2020, she landed a job with the Phoenix Suns as a communications consultant. She wrote features for the team's website, edited other writers, and had a hand in all written communications. She learned about marketing and other things she hadn't had to give much thought to during her career as a newspaper beat writer. Finally, her persistence paid off. In late the late summer of 2021, she landed a job with the *Philadelphia Inquirer* covering the NBA's Phila-

delphia 76ers."You have to be well-versed," she says. "That versatility is what makes you a more attractive hire."[21]

While networking is paramount, women sports journalists say it is important to be as multifaceted as possible in order to stand out from the crowd. Amber Theoharis, a former Emmy Award–winning broadcaster with NFL Network, teaches a course at the University of Southern California that shows her students how to be multimedia personalities and to establish their brand as a way to market themselves. "These students now have the luxury that I never had. I had to wait for someone to hire me for my art and my work and my journalism to get out there," she explains. "They can turn their cell phone on and post a social media opinion about a game that just happened or about even bigger issues affecting sports today."

By the end of the semester, Theoharis says her students have researched and developed a topic they are passionate about and created a podcast, written a sports column, filmed a TV debate, and created social media posts to help spread the word and establish a following. "I tell students that you always have to have your hands in multiple things because this business is so brutal and so fluid. Never put all your eggs in one basket," she says.

Theoharis practices what she preaches. Since leaving NFL Network, she has become a freelance broadcaster, anchoring MLB and college football for Fox. She also anchors NFL studio coverage and does sideline reporting for Westwood One. She has also started a production company, Artemis Sky Entertainment; is working on an animated musical anthology; and is looking to do a sequel of the 2020 Netflix animated film *Animal Crackers*. She was the cocreator and coproducer of *Weight of Gold*, a documentary about Olympic medalists and their mental health struggles after the glory fades. She has also branched out into the tech world, developing a gaming application called WinQuik, which dovetails, she says, with sports fans' growing interest in predictive gaming and legalized gambling.

"I wanted to build something myself that I own," she says. "I wanted to be able to hire other women from the industry who were constantly swimming upstream working in sports. We have assembled an all-star crew, and it's an amazing feeling to create meaningful projects because diverse talents were given room to thrive."[22]

Entrepreneurship isn't for the faint of heart, though. Most women would still prefer an organization standing behind them when they seek a press pass or an interview. Jane McManus, the director of the Center for Sports Communication at Marist College, has embarked on a research project about the sports media industry in an effort to quantify what the market looks like and what the future holds. She believes that right now, jobs in sports journalism are either entry level or "at the top of the heap,"

while mid-level jobs that afford a comfortable living have disappeared. But she is also optimistic about the future. She thinks it is extremely important in the short term for young women to find ways to gain experience in low-paying jobs while new pay models evolve. Such things as subscriptions to specific content as well as profit-sharing arrangements with writers may bring back some of those mid-level jobs that have disappeared.

"First of all, you have to be mentally prepared for the austerity you'll face, and secondly, you have to understand what skills you are going to need," she explains.[23]

That's what helped Marisa Ingemi persevere for sixteen months after her unemployment ran out and she continued to scramble for freelance work. "It's been a tough time to be a free agent reporter," she says. By the time she interviewed with the *Seattle Times* for the position covering the NHL's expansion team, Ingemi was freelancing for such media outlets as NBCSports.com, Yahoo! Sports, the *New York Times*, and FiveThirtyEight. Her clip file (stories on muckrake.com) showed a steady drumbeat of stories that would rival those of a full-time beat writer. At the time she was hired, Ingemi became the third woman in a department of twenty-two at the *Seattle Times*, including editors. As her experience shows, the future for women in sports journalism is promising, if they are flexible, persistent, and willing to play the long game in an evolving media landscape. "It's all about connections," she says.[24]

Flexibility. Patience. Persistence. Those qualities define not only the young women just starting out in sports journalism today, but also the pathbreakers who, for the past half century, have paved the way for other women.

"Women in sports media adapt; we're great ninjas," says Limón Romero at the *Los Angeles Times*. "I started off as a reporter. I wasn't going to be an editor. But we adapt, and I think the adaptability of women in general is pretty remarkable. We get a lot of things done."[25]

Notes

CHAPTER 1

1. Diane K. Gentry, "Mary Garber," Oral History Project, Women in Journalism, Washington Press Club Foundation, 1990, http://www.wpcf.org/mary -garber/ (February 1, 2020).

2. David Kaszuba, "They Are Women, Hear Them Roar: Female Sportswriters of the Roaring Twenties" (PhD thesis, Pennsylvania State University Graduate School, College of Communications, December 2003), https://etda.libraries.psu .edu/catalog/6174, 47-103 (February 1, 2020).

3. Jenni Carlson, quoted in "Mary Ellen Garber," Legacy.com, September 23, 2008, https://www.legacy.com/obituaries/name/mary-garber-obituary ?pid=117851411 (February 1, 2020).

4. Gentry, "Mary Garber."

5. Frank Barrows, "Before Equal Rights or Pioneers, There Was Persistent Mary Garber," *Charlotte Observer*, September 27, 1980, https://www.newspapers .com/image/623601465/ (February 1, 2020).

6. Gentry, "Mary Garber."

7. Mary Garber, "Reynolds High Short on Ends, Strong Elsewhere," *Gastonia Gazette*, October 22, 1947, https://www.newspapers.com/image/19818184/ (February 1, 2020).

8. Mary Garber, "Reynolds Kicking Ace Doesn't Miss," *Charlotte News*, October 29, 1947, https://www.newspapers.com/image/617912464/?terms=%22Mary% 20Garber%22%20and%20%22Reynolds%20High%22&match=1 (January 26, 2020).

9. Gentry, "Mary Garber."

10. Gentry, "Mary Garber."

11. Gentry, "Mary Garber."

12. Gentry, "Mary Garber."

13. Bob Galloway, quoted in "Mary Garber," Legacy.com.

14. Gentry, "Mary Garber."

15. Gentry, "Mary Garber."

16. Gentry, "Mary Garber."

17. Gentry, "Mary Garber."

18. Gentry, "Mary Garber."

19. Gentry, "Mary Garber."

20. George Vecsey, "An Overdue Honor for a Pioneer Sportswriter," *New York Times*, May 3, 2008, https://www.nytlimes.com/2008/05/03/sports/03vecsey.html (February 1, 2020).

21. "Everybody Has a 'Mary Story,'" *Winston-Salem Journal*, September 22, 2008, https://journalnow.com/news/local/everybody-has-a-mary-story/article_2cb5e69a-df7d-5056-ad04-5b27c5fc94f2.html (July 19, 2021).

CHAPTER 2

1. Lesley Visser, *Sometimes You Have to Cross When It Says Don't Walk: A Memoir of Breaking Barriers* (Dallas: BenBella Books, 2017), 10.

2. Lesley Visser, interview with the author, August 23, 2019.

3. Visser, *Sometimes You Have to Cross When It Says Don't Walk*, 46.

4. Nell Scovell, "The Best Sports Section in History," *Grantland*, November 2, 2011, https://grantland.com/features/the-best-sports-section-history/ (September 14, 2019).

5. Barbara Matson, "She Took the Ball and Ran with It," *Boston Globe*, August 4, 2006, http://barbaramatson.com/lesley-visser-profile/ (September 14, 2019).

6. Visser interview.

7. Visser interview.

8. Visser interview.

9. Visser interview.

10. Visser interview.

11. Visser interview.

12. Betty Cuniberti, "Visser Changes Women's Role in TV Sports," *Kansas City Star*, September 24, 1994, 39, https://www.newspapers.com/image/683189863/ (February 2, 2020).

13. Visser interview.

14. John Nelson, "Visser 1, Knight 0 in Verbal Joust," *Toledo Blade*, March 22, 1994, https://news.google.com/newspapers?nid=1350&dat=19940322&id=cldPAAAAIBAJ&sjid=XAMEAAAAIBAJ&pg=6620,6136523&hl=en (February 2, 2020).

15. Visser interview.

16. Visser interview.

17. John Steigerwald, "Tuesday Morning QB Doesn't Like Visser for Swann Trade," *Pittsburgh Post-Gazette*, March 21, 1998, https://www.newspapers.com/image/94367893 (February 2, 2020).

18. Matson, "She Took the Ball and Ran with It."

19. Jane McManus, interview with the author, July 5, 2021.

CHAPTER 3

1. Christine Brennan, interview with the author, June 4, 2021.

2. Ricki Stern and Annie Sundberg, "Let Them Wear Towels," *Nine for IX* (ESPN Films, November 7, 2013), https://www.imdb.com/title/tt2979800/?ref_=fn_al _tt_2 (September 1, 2019).

3. Roger Angell, *Late Innings: A Baseball Companion* (New York: Simon and Schuster. 1982), 142.

4. Rachel Lenzi, "AWSM Honors Jane Gross as 2018 Mary Garber Pioneer Award Winner," Association for Women in Sports Media, http://awsmonline .org/latest-news/jane-gross-pioneer (February 2, 2020).

5. Shirley Povich, "Dick Young. Always Aggressive and Always Fearless," *Washington Post*, September 6, 1987, https://www.washingtonpost.com/archive/ sports/1987/09/06/sportswriter-dick-young-usually-aggressive-and-always -fearless/ec1e0c6c-8ab7-47dc-9484-24c27ecf87a7/ (September 8, 2019).

6. Diane K. Gentry, "Mary Garber," Oral History Project, Women in Journalism, Washington Press Club Foundation, 1990, http://www.wpcf.org/mary -garber/ (February 1, 2020).

7. Diane K. Shah, *A Farewell to Arms, Legs, and Jockstraps: A Sportswriter's Memoir* (Bloomington, IN: Red Lightning Books, 2020), 118.

8. Angell, *Late Innings*, 149–50.

9. Melissa Ludtke, interview with the author, September 8, 2019.

10. Emma Baccellieri, "The Everlasting Legacy of Melissa Ludtke, Who Dared to Join the Boys Club of the Baseball Press," *Sports Illustrated*, September 28, 2018, https://www.si.com/mlb/2018/09/28/melissa-ludtke-lawsuit-anniversary (March 3, 2021).

11. Ludtke interview.

12. Ludtke interview.

13. Ludtke interview.

14. Ludtke interview.

15. Baccellieri, "The Everlasting Legacy of Melissa Ludtke."

16. Ludtke interview.

17. Baccellieri, "The Everlasting Legacy of Melissa Ludtke."

18. Mariah Burton Nelson, *The Stronger Women Get, the More Men Love Football.* (New York: Avon Books 1994), 230.

19. Emily Langer, "Jennifer Frey, Former Writer for the Post's Sports and Style pages, Dies at 47," *Washington Post*, March 28, 2016, https://www.washing tonpost.com/national/jennifer-frey-former-writer-for-the-posts-sports-and -style-pages-dies-at-47/2016/03/28/d5f97b96-f500-11e5-9804-537defcc3cf6 _story.html?utm_term=.99f1f8f03be2 (March 3, 2021).

20. Paola Boivin interview with the author, May 4, 2020.

21. Virginia Watson-Rouslin, "The Men's Room," *The Quill*, January 1987, 20.

22. Susan Fornoff, *Lady in the Locker Room. Adventures of a Trailblazing Sports Journalist* (Oakland: GottaGoGolf, 2014), 16.

23. Joanne Lannin, "Assignment: Sports," *Women's Sports and Fitness*, March 1987, 77.

24. Lannin, "Assignment: Sports," 77.

25. Lesley Visser, interview with the author, August 30, 2019.

26. Shah, *Farewell to Arms, Legs, and Jockstraps*, 115.

27. Brennan interview.

28. Lisa Olson, "A Lesson From the Chick," *Boston Herald*, September 24, 1990, 74.

29. Lisa Disch and Mary Jo Kane, "When a Looker Is Really a Bitch: Lisa Olson, Sport, and the Heterosexual Matrix," *Signs: Journal of Women in Culture and Society* 21, no. 2 (1996): 294, 303, https://www.journals.uchicago.edu/doi/abs/10.1086/495067?journalCode=signs (March 3, 2020).

30. Johnette Howard, "Olson's Battle Has Yet to Be Won," *Washington Post*, June 7, 1993, https://www.washingtonpost.com/archive/sports/1993/06/07/olsons-battle-has-yet-to-be-won/06cd1436-9a49-4e00-93f2-f6cbd244842e/ (March 3, 2020).

31. Ed Sherman, "Lisa Olson Wins AWSM Pioneer Award," *Sherman Report*, November 12, 2012, http://www.shermanreport.com/lisa-olson-wins-awsm-pioneer-award/ (March 3, 2020).

32. Lisa Horne, "Female Reporters in the Locker Room: Does It Work?" *Bleacher Report*, January 15, 2009, https://bleacherreport.com/articles/111519-female-reporters-in-the-locker-room-does-it-work (March 3, 2020).

33. Boivin interview.

34. Rachel Lenzi, interview with the author, August 4, 2019.

35. Lenzi interview.

36. Lenzi interview.

CHAPTER 4

1. La Velle E. Neal III, "With Honor, Writer Still Blazes Trail," *Minneapolis Star Tribune*, July 30, 2017, https://www.newspapers.com/image/323640905 (March 3, 2021).

2. Claire Smith, interview with the author, March 18, 2021.

3. Smith interview.

4. Kristen Lappas, *A League of Her Own: The Claire Smith Story* (Victory Pictures, 2017), https://vimeo.com/232694670 (March 3, 2021).

5. Lappas, *A League of Her Own*.

6. Claire Smith, "In the Steroid Era Fans Want Truth. Or Do They?", *Baltimore Sun*, January 5, 2007, https://www.baltimoresun.com/news/bs-xpm-2007-01-05-0701050247-story.html (October 5, 2021).

7. Smith interview.

8. Lori Riley, "Claire Smith's Locker Room Exile a Reminder of How Far We've Come," *Hartford Courant*, July 14, 2013, https://www.courant.com/sports/hc-xpm-2013-07-13-hc-riley-column-0714-20130713-story.html (March 3, 2021).

9. Smith interview.

10. Smith interview.

11. Smith interview.

12. Lappas, *A League of Her Own*.

CHAPTER 5

1. Maureen O'Donnell, "Jeannie Morris, Pioneering Chicago Sportscaster, Dead at 85," *Chicago Sun Times*, December 14, 2020, https://chicago.suntimes .com/2020/12/14/22155624/jeannie-morris-sportscaster-pioneer-wbbm-wmaq -obituary (April 8, 2021).

2. Richard Sandomir, "Jeannie Morris, Trailblazing Chicago Sportscaster, Dies at 85," *New York Times*, December 31, 2020, https://www.nytimes .com/2020/12/24/business/jeannie-morris-dead.html (October 1, 2021).

3. O'Donnell, "Jeannie Morris."

4. David Haugh, "Jeannie Morris Recognized for Pioneeering Efforts," *Chicago Tribune*, March 6, 2014, https://www.chicagotribune.com/sports/bears/ct-xpm -2014-03-06-ct-jeannie-morris-haugh-spt-0307-20140307-story.html (August 8, 2020).

5. Charles Maher, "Women Move in on Sports Mike," *Los Angeles Times*, January 20, 1975, https://www.newspapers.com/image/386266958/?terms="Women move in on sports mike"&match=1 (August 8, 2020).

6. Dan Pompei, "Jeannie Morris, Author and TV Trailblazer, Lived a Long Season Full of Wonder," *Athletic*, December 14, 2020, https://theathletic .com/2260306/2020/12/14/jeannie-morris-chicago-obituary/ (April 8, 2021).

7. Tommy Tomlinson, "Andrea Kirby on Living on Both Sides of the Camera," *Southbound* [podcast], February 21, 2018, https://www.wfae.org/podcast/ southbound/2018-02-21/southbound-andrea-kirby-on-living-on-both-sides-of -the-camera (August 8, 2020).

8. Ashley Denny, "Women in Sports Broadcasting: Beauty Queens or Credible Reporters?" *Ashley Denny, Sports Journalist* [blog], June 23, 2014, https://ashley dennyjournalist.wordpress.com/2014/06/23/women-in-sports-broadcasting -beauty-queens-or-credible-reporters/ (August 8, 2020).

9. Tomlinson, "Andrea Kirby."

10. Sally Jenkins, "Who Let Them In?" *Sports Illustrated*, June 17, 1991, 85–91.

11. Maher, "Women Move in on Sports Mike."

12. Untitled article in *Tampa Bay Times*, June 8, 1975, https://www.newspapers .com/image/318691049/?terms=Jane chastain&match=1 (August 8, 2020).

13. Paul Jones, "90 Seconds to Tell All about Sports," *Atlanta Journal-Constitution*, November 17, 1973, https://www.newspapers.com/image/ 398611746/?terms=Jane Chastain&match=1 (July 30, 2020).

14. David Fink, "Chastain, TV Pioneer: I Had To Pay a High Price," *Pittsburgh Post-Gazette*, August 4, 1986, https://www.newspapers.com/image/88930395/ (July 30, 2020).

15. Maher, "Women Move in on Sports Mike."

16. Maher, "Women Move in on Sports Mike."

17. Phyllis George, foreword, in Betsy M. Ross, *Playing Ball with the Boys* (Cincinnati: Clerisy Press, 2011), xv.

18. George Solomon, "Jimmy the Greek Fired by CBS for His Remarks," *Washington Post*, January 17, 1988, https://www.washingtonpost.com/archive/politics/ 1988/01/17/jimmy-the-greek-fired-by-cbs-for-his-remarks/27536e46-3031-40c2 -bb2b-f912ec518f80/ (July 30, 2020).

19. "Trailblazer Actress and Sportscaster Jayne Kennedy, Then and Now," *Groovy History*, April 7, 2019, https://groovyhistory.com/jayne-kennedy-then-and-now (July 30, 2020).

20. Betsy M. Ross, interview with the author, September 4, 2020.

21. Amy Argetsinger, "Phyllis George, Miss America Who Became a Trailblazing Sportscaster, Dies at 70," *Washington Post*, May 17, 2020, https://www.washingtonpost.com/local/obituaries/phyllis-george-miss-america-who-became-a-trailblazing-sportscaster-dies-at-70/2020/05/17/49527f66-9845-11ea-ac72-3841fcc9b35f_story.html (August 24, 2020).

22. "It Must Be the Season for Gayles," *Philadelphia Daily News*, December 31, 1987, https://www.newspapers.com/image/186492397/?terms="It must be the season for the Gayles" (August 8, 2020).

23. Jenkins, "Who Let Them In?"

CHAPTER 6

1. Michael Freeman, *ESPN: The Uncensored History* (New York: Taylor Trade, 2001), 12–13.

2. Freeman, *ESPN*, 134–40.

3. Freeman, *ESPN*, 175–86.

4. Jim Brady, "ESPN Shows Progress, Faces Challenges, Regarding Women in Sports," ESPN, December 20, 2017, https://www.espn.com/blog/ombudsman/post/_/id/906/espn-shows-progress-faces-challenges-regarding-women-in-sports (July 20, 2021).

5. Richard Lapchick, "The 2018 Associated Press Sports Editors Racial and Gender Report Card," ESPN, May 2, 2018, https://www.espn.com/espn/story/_/id/23382605/espn-leads-way-hiring-practices-sports-media (March 3, 2021).

6. Associated Press, "Ex-ESPN Anchor Rhonda Glenn Dies," ESPN, February 13, 2015, https://www.espn.com/golf/story/_/id/12322397/rhonda-glenn-broadcaster-golf-historian-dies (April 2, 2020).

7. Bethany Kandel, "At the Top of Her Game," *Suffolk News-Herald*, December 27, 1987, https://virginiachronicle.com/?a=d&d=SNH19871227.1.24&e=-------en-20--1--txt-txIN-------- (October 5, 2021).

8. Kandel, "At the Top of Her Game."

9. Andrea Kremer, interview with the author, June 23, 2020.

10. Bob Raissman, "Gayle Loses Force at NBC," *New York Daily News*, September 2, 1990, https://www.newspapers.com/image/467808376 (July 30, 2020).

11. Sally Jenkins, "Who Let Them In?" *Sports Illustrated*, June 17, 1991, https://vault.si.com/vault/1991/06/17/who-let-them-in-women-have-invaded-the-mens-club-of-tv-sportscasters-but-they-get-less-airtime-pay-and-prestige (August 8, 2020).

12. Betsy M. Ross, interview with the author, August 26, 2020.

13. Linda Cohn, *Cohn-Head: A No-Holds-Barred Account of Breaking into the Boys' Club* (Guilford, CT: Lyons Press, 2008), 127, 144.

14. Jeff Jacobs, "Lead Story(Teller) on SportsCenter Is Linda Cohn," *Hartford Courant*, February 19, 2016, https://www.courant.com/sports/hc-jacobs-col-linda-cohn-0218-20160217-column.html (August 8, 2020).

15. Andrew Bucholtz, "Holly Rowe Filled in on Play-by-Play on WVU-Gonzaga after Dan Shulman and Jay Bilas' Remote Booth Lost Power," *Awful Announcing*, December 2, 2020, https://awfulannouncing.com/espn/holly-rowe-filled-in-on-play-by-play-on-wvu-gonzaga.html (July 5, 2021).

16. Chad Finn, "Journalism Pioneer Jackie MacMullan, Former Globe columnist, to Retire from ESPN," *Boston Globe*, August 18, 2021, https://www.boston.com/sports/media/2021/08/18/jackie-macmullan-espn-boston-globe-retiring/ (August 20, 2021).

17. Jackie MacMullan, interview with the author, August 4, 2020.

18. Hannah Storm, "I Sat Next to Elvis," ESPN, June 17, 2011, https://www.espn.com/espn/commentary/news/story?page=storm-110617 (March 5, 2021).

19. Brian Steinberg, "ESPN Chief Weighs in on Maria Taylor–Rachel Nichols Dispute," *Variety*, July 13, 2021, https://variety.com/2021/tv/news/espn-jimmy-pitaro-maria-taylor-rachel-nichols-1235019254/ (August 8, 2021).

20. Richard Deitsch, "Sports Media with Richard Deitsch," *Stitcher*, July 7, 2021, https://www.stitcher.com/show/sports-media-with-richard-deitsch/episode/kavitha-davidson-and-jane-mcmanus-on-the-new-york-times-story-on-rachel-nichols-and-maria-taylor-85252184 (August 8, 2021).

21. Kevin Draper, "A Disparaging Video Prompts Explosive Fallout within ESPN," *New York Times*, July 4, 2021, https://www.nytimes.com/2021/07/04/sports/basketball/espn-rachel-nichols-maria-taylor.html (August 8, 2021).

22. "Jemele Hill on Sha'Carri Richardson's Suspension, Olympic Rules and Fallout at ESPN," *CBS This Morning*, July 5, 2021, https://www.youtube.com/watch?v=ENOHzuAarK0 (August 8, 2021).

23. Andrew Marchand, "ESPN Embarrassed Itself during the Rachel Nichols Saga," *New York Post*, August 25, 2021, https://nypost.com/2021/08/25/espn-embarrassed-itself-during-the-rachel-nichols-saga/ (October 1, 2021).

24. Steinberg, "ESPN Chief Weighs in on Maria Taylor–Rachel Nichols Dispute."

CHAPTER 7

1. Robin Roberts, *From the Heart: Eight Rules to Live By* (New York: Hyperion, 2008), 90.

2. "Robin Roberts," Sports Broadcasting Hall of Fame, 2016, https://www.sportsbroadcastinghalloffame.org/inductees/robin-roberts/ (April 8, 2021).

3. Roberts, *From the Heart*, 26–28.

4. "Robin Roberts," Sports Broadcasting Hall of Fame.

5. Roberts, *From the Heart*, 43.

6. Mel Robbins, "Mel Robbins Speaks with Robin Roberts about Following Your Heart," *Advice for Living*, January 29, 2010, https://www.youtube.com/watch?v=1RzzYXe2NJA (January 9, 2021).

7. Roberts, *From the Heart,* 73–74.

8. Roberts, *From the Heart,* 69–70.

9. Roberts, *From the Heart,* 75.

10. Michael Freeman, *ESPN: The Uncensored History* (New York: Taylor Trade, 2001), 173.

11. "Robin Roberts," Sports Broadcasting Hall of Fame.

12. Roberts, *From the Heart,* 51.

13. Freeman, *ESPN,* 173.

14. Roberts, *From the Heart,* 91.

15. "Robin Roberts," Sports Broadcasting Hall of Fame.

CHAPTER 8

1. Ernie Suggs, "Pam Oliver Garners Respect in a Man's World," *Black Voices Quarterly,* reprinted in. *St. Louis Post Dispatch,* September 8, 2002, https://www.newspapers.com/image/141206952 (February 12, 2021).

2. Harry Lyles Jr., "Pam Oliver Shows Us How to Be a Legend," *SB Nation,* January 30, 2019, https://www.sbnation.com/nfl/2019/1/30/18202778/pam-oliver-interview-career-advice-sports-media (February 21, 2021).

3. Ray Buck, "TNT Sideline Reporter Found Herself in Center of History," *Fort Worth Star-Telegram,* April 28, 2008, https://www.newspapers.com/image/653399192 (February 17, 2021).

4. Lyles, "Pam Oliver Shows Us How to Be a Legend."

5. Lee Hawkins, "NFL Reporter on Her Career and Mean Tweets," *Wall Street Journal* video, January 31, 2014, https://www.youtube.com/watch?v=DzT12AAh2ms (February 17, 2021).

6. Suggs, "Pam Oliver Garners Respect in a Man's World."

7. Michael Granberry, "Fox Scores a Touchdown with On-Air Sports Talent Pam Oliver," *Wichita Eagle,* November 12, 1998, https://www.newspapers.com/image/702844796 (February 12, 2021).

8. Suggs, "Pam Oliver Garners Respect in a Man's World."

9. Martin, "Pam Oliver Opens up on 25 Years as Fox's Sideline Reporter."

10. Bob Raissman, "Concussion Story Gets Real for Fox's NFL Sideline Reporter Pam Oliver," *New York Daily News,* August 31, 2013, https://www.nydailynews.com/sports/football/raissman-concussion-story-real-oliver-article-1.1442575#ixzz2df0prFDO (October 1, 2021).

11. Martin, "Pam Oliver Opens up on 25 Years as Fox's Sideline Reporter."

12. Hawkins, "NFL Reporter on Her Career and Mean Tweets."

13. Pam Oliver, "Game Change: Pam Oliver Breaks Her Silence on Her Career Shake-up," *Essence,* September 3, 2014, https://www.essence.com/news/pam-oliver-game-change/ (February 12, 2021).

14. Martin, "Pam Oliver Opens up on 25 Years as Fox's Sideline Reporter."

15. Martin, "Pam Oliver Opens up on 25 Years as Fox's Sideline Reporter."

CHAPTER 9

1. Karen Guregian, interview with the author, July 1, 2021.
2. Marie Hardin, and Erin Whiteside, "Token Responses to Gendered Newsrooms: Factors in the Career-Related Decisions of Female Newspaper Sports Journalists," *Journalism* 10, no. 5 (October 2009): 627–46, https://doi.org/10.1177/14648849090100050501 (July 15, 2019).
3. Marie Hardin, interview with the author, July 13, 2019.
4. Christine Brennan, *Best Seat in the House* (New York: Simon and Schuster 2006), 205.
5. Christine Brennan, interview with the author, June 4, 2021.
6. Paola Boivin, interview with the author, August 18, 2019.
7. Boivin interview.
8. Gracie Bonds Staples, "A Funny Thing Happened the Last Time the Rams, Andrea Kremer Were Here," *Atlanta Journal-Constitution*, January 31, 2019, https://www.ajc.com/lifestyles/funny-thing-happened-the-last-time-the-rams-andrea-kremer-were-here/b5CwAyuDJYdXDPo8ikpxvO/ (June 23, 2020).
9. Andrea Kremer, interview with the author, June 23, 2020.
10. Kremer interview.
11. Jackie MacMullan, interview with the author, July 8, 2020.
12. MacMullan interview.
13. Amber Theoharis, interview with the author, May 14, 2021.
14. Theoharis interview.
15. Theoharis interview.
16. Jenny Dial Creech, interview with the author, July 17, 2019.
17. Creech interview.
18. Theoharis interview.
19. Hardin interview.

CHAPTER 10

1. Karen Guregian, interview with the author, July 7, 2020.
2. Bill Colson, "To Our Readers," *Sports Illustrated*, January 22, 1996, 4.
3. Jackie MacMullan, interview with the author, June 23, 2020.
4. Guregian interview.
5. Guregian interview.
6. Guregian interview.
7. Marisa Ingemi, interview with the author, August 8, 2020.
8. Colson, "To Our Readers."
9. Guregian interview.
10. Karen Guregian, "It's Always There," *Sports Illustrated*, January 22, 1996, 46.
11. Guregian interview.
12. Guregian interview.
13. Guregian interview.
14. Guregian interview.

15. Ingemi interview.

16. Guregian interview.

CHAPTER 11

1. Leah Hextall, interview with the author, July 8, 2021.

2. Sally Jenkins, "More Women in Sports Television Means Less Boring Guy TV," *Washington Post*, May 17, 2017, https://www.washingtonpost.com/sports/redskins/why-beth-mowins-getting-an-nfl-play-by-play-job-matters/2017/05/17/245c3318-3b1a-11e7-8854-21f359183e8c_story.html?utm_term=.c60892cf8f2d (September 8, 2020).

3. Kate Scott, interview with the author, September 22, 2020.

4. Scott interview.

5. Scott interview.

6. Julie DiCaro, *Sidelined: Sports, Culture, and Being a Woman in America* (New York, Dutton, 2021), 34.

7. DiCaro, *Sidelined*, 30–31.

8. Betsy M. Ross, *Playing Ball with the Boys: The Rise of Women in the World of Men's Sports* (Cincinnati: Clerisy Press, 2011), 62.

9. Ross, *Playing Ball with the Boys*, 63.

10. Ross, *Playing Ball with the Boys*, 64.

11. Ross, *Playing Ball with the Boys*, 65.

12. Richard Sandomir, "First Woman to Call N.F.L. Play-by-Play, and the Last," *New York Times*, January 28, 2009, https://www.nytimes.com/2009/01/29/sports/football/29women.html (September 24, 2020).

13. Ross, *Playing Ball with the Boys*, 68.

14. Leonard Shapiro, "Lauded for College Football Work, ESPN's Pam Ward Wants a Shot at Calling NFL Games," *Washington Post*, July 27, 2010, https://www.washingtonpost.com/wp-dyn/content/article/2010/07/27/AR2010072702775.html (July 10, 2020).

15. Richard Dietsch, "Mike Emrick, Pam Ward Lead Spring Media Power List," *Sports Illustrated*, May 29, 2012, https://www.si.com/more-sports/2012/05/29/medialist-june (July 10, 2020).

16. Julie DiCaro, "Safest Bet in Sports: Men Complaining about a Female Announcer's Voice," *New York Times*, September 18, 2017, https://www.nytimes.com/2017/09/18/sports/nfl-beth-mowins-julie-dicaro.html (July 10, 2020).

17. Jenkins, "More Women in Sports Television Means Less Boring Guy TV."

18. Ann Schatz, interview with the author, October 9, 2020.

19. Schatz interview.

20. Haley Elwood, "Hannah Storm & Andrea Kremer," *Playmakers*, December 20, 2020, https://www.chargers.com/audio/playmakers-hannah-storm-andrea-kremer-week-15-2020 (May 5, 2020).

21. Brian Giuffra, "Hannah Storm and Andrea Kremer Fusing Friendship with Football," *Big Lead*, December 25, 2020, https://www.thebiglead.com/posts/

hannah-storm-andrea-kremer-fusing-friendship-football-amazon-broadcast-an nouncers-01et7zknfdh8 (May 5, 2020).

22. Giuffra, "Hannah Storm and Andrea Kremer Fusing Friendship With Football."

23. Orlando Sanchez, "ESPN Broadcaster Jessica Mendoza, Who Lives in Oregon, at Top of Her Game," KGW, January 29, 2021, https://www.kgw .com/article/sports/jessica-mendoza-espn-baseball-history-bend-oregon/283 -958fc7f2-152f-4276-b93f-47a9e8f6a7eb (April 15, 2021).

24. Hextall interview.

25. Mike Emrick, interview with the author, July 12, 2021.

26. Emrick interview.

27. Hextall interview.

28. Emrick interview.

29. Emma Tiedemann, interview with the author, May 5, 2021.

30. Tiedemann interview.

31. MASN Orioles, "Melanie Newman on Upcoming MLB Game Called Entirely by Women," July 17, 2021, https://www.youtube.com/watch?v=iqnQPOPIDDw (October 3, 2021).

CHAPTER 12

1. Emma Tiedemann, interview with the author, May 15, 2021.

2. Suzyn Waldman, interview with the author, February 19, 2021.

3. Waldman interview.

4. Waldman interview.

5. Mike Greenberg, "Suzyn Waldman and Vin Scully," *I'm Interested with Mike Greenberg* [podcast], October 6, 2020, https://www.espn.com/radio/play/_/ id/30052439 (February 15, 2021).

6. Waldman interview.

7. Waldman interview.

8. Waldman interview.

9. John Solomon, "Goodbye Broadway, Hello Bronx," *Sports Illustrated*, August 25, 1997, https://vault.si.com/vault/1997/08/25/goodbye-broadway-hello -bronx-suzyn-waldman-left-the-musical-stage-and-now-covers-the-new-york -yankees (February 15, 2021).

10. Waldman interview.

11. Jason Barrett, "Before Mendoza, Waldman Blazed a Trail For Women," Barrett Sports Media, October 12, 2015, https://barrettsportsmedia.com/2015/10/12/ before-mendoza-waldman-blazed-a-trail-for-women/ (February 15, 2021).

12. Waldman interview.

13. Waldman interview.

14. Waldman interview.

CHAPTER 13

1. Lyndsey D'Arcangelo, "How Doris Burke Became the Best Damn Basketball Broadcaster There Is," *Deadspin*, August 8, 2017, https://deadspin.com/how-doris-burke-became-the-best-damn-basketball-broadca-1797546866 (July 7, 2021).

2. D'Arcangelo, "How Doris Burke Became the Best Damn Basketball Broadcaster There Is."

3. Joseph Atmonavage, "The Making of Doris Burke," NJ.com, May 31, 2018, https://projects.nj.com/investigations/doris-burke/ (July 7, 2021).

4. Atmonavage, "The Making of Doris Burke."

5. Lori Riley, "In the Men's World," *Hartford Courant*, March 3, 2002, https://www.courant.com/news/connecticut/hc-xpm-2002-03-03-0203030799-story.html (July 7, 2021).

6. Steve Driscoll, "Doris Burke: In Photos Everything to Know about the ESPN NBA Analyst," *The Spun*, May 19, 2021, https://thespun.com/nba/doris-burke-in-photos-nba-espn-media-career-family-drake (July 7, 2021).

7. "Doris Burke Thanks LeBron James, Chris Paul in Curt Gowdy Media Award Speech," ESPN, September 7, 2018, https://www.youtube.com/watch?v=aZhhqfvqkZA&t=37s (July 7, 2021).

8. Noam Scheiber, "Doris Burke Has Game," *New York Times*, April 28, 2018, https://www.nytimes.com/2018/04/28/business/doris-burke-nba.html (May 5, 2021).

9. Jackie MacMullan, interview with the author, August 5, 2021.

10. Scheiber, "Doris Burke Has Game."

11. Debbie Emery, "ESPN's Doris Burke Wins Praise on Twitter for Effortless NBA Championship Trophy Presentation," *The Wrap*, June 12, 2017, https://www.thewrap.com/espns-doris-burke-wins-praise-for-nba-championship-trophy-presentation-articulate-insightful-and-effortless/ (July 30, 2021).

12. Richard Deitsch, "Confetti, Chaos and Championships: How Broadcasters Handle the Trophy Presentation," *Sports Illustrated*, June 19, 2017, https://www.si.com/media/2017/06/19/broadcasters-trophy-presentation-assignment-burke-nantz-johnson (July 7, 2021).

13. Riley, "In the Men's World."

14. "Doris Burke Thanks LeBron James, Chris Paul in Curt Gowdy Media Award Speech."

15. John Duffley, "Doris Burke Roasted Her Ex-Husband on TV, Proving She's the Greatest," *FanBuzz*, August 17, 2020, https://fanbuzz.com/nba/doris-burke-husband/ (July 7, 2021).

16. D'Arcangelo, "How Doris Burke Became the Best Damn Basketball Broadcaster There Is."

17. Steve Driscoll, "Doris Burke."

18. MacMullan interview.

19. Steve Serby, "ESPN's Doris Burke Opens up about Coronavirus Struggle, NBA's Return Concerns," *New York Post*, June 27, 2020, https://nypost.com/2020/06/27/doris-burke-opens-up-about-coronavirus-struggle-nbas-return-concerns/ (July 7, 2021).

20. "Inside the Exclusive Clubhouse for the Women in Sports Media," *Always Late With Katie Nolan*, March 6, 2020, https://www.youtube.com/watch?v=oY0dIjVS_ho (July 7, 2021).

21. Chrissy Paradis, "Doris Burke Is the Trailblazer This Industry Needs," Barrett Sports Media, September 18, 2020, https://barrettsportsmedia.com/2020/09/18/doris-burke-is-the-trailblazer-this-industry-needs/ (July 7, 2021).

CHAPTER 14

1. Andrew Bucholtz, "Montana State Broadcaster Jay Sanderson's Resignation Came Amidst Sexual Misconduct and Sexual Harassment Investigation," *Awful Announcing*, January 4, 2019, https://awfulannouncing.com/ncaa/montana-state-broadcaster-resignation-sexual-misconduct.html (March 16, 2021).

2. Amie Just, interview with the author, September 4, 2019.

3. Just interview.

4. Bucholz, "Montana State Broadcaster Jay Sanderson's Resignation Came Amidst Sexual Misconduct and Sexual Harassment Investigation."

5. Just interview.

6. Sarah Spain, "Sexism in Sports," *That's What She Said* [podcast], November 26, 2016, https://www.espn.com/radio/play/_/id/18161863 (March 15, 2021).

7. Lisa Nehus Saxon, interview with the author, April 3, 2021.

8. Saxon interview.

9. Saxon interview.

10. Kristin Huckshorn, "Female Sportswriter Finally Rocks the Boat," *A Kind of Grace: A Treasury of Sportswriting by Women*, ed. Ron Rapoport (Berkeley, CA: Zenobia Press, 1994).

11. Tony Kornheiser, "Travesty in the Locker Room," *Washington Post*, December 2, 1990, https://www.washingtonpost.com/archive/lifestyle/1990/12/02/travesty-in-the-locker-room/6800d9cf-9adb-4704-af00-ec3eb9263b78/ (September 15, 2019).

12. "Sexual Harassment 20 Years Later," *New York Times*, October 21, 2011, https://www.nytimes.com/2011/10/22/opinion/sexual-harassment-20-years-later.html (April 5, 2021).

13. Saxon interview.

14. Saxon interview.

15. Jeff Pearlman, "Brittany Ghiroli: Nationals Beat Writer, The Athletic," *Two Writers Slinging Yang* [podcast], December 16, 2019, https://podcasts.apple.com/us/podcast/brittany-ghiroli-nationals-beat-writer-the-athletic/id1252080948?i=1000459807937 (March 5, 2021).

16. Mina Kimes and Jeff Passan, "New York Mets GM Jared Porter Acknowledges Sending Explicit Images to Female Reporter When He Worked for Chicago Cubs," ESPN, January 19, 2021, https://www.espn.com/mlb/story/_/id/30737248/ny-mets-gm-jared-porter-acknowledges-sending-explicit-images-female-reporter-worked-chicago-cubs (March 15, 2021).

17. Whet Moser, "With #MoreThanMean, Julie DiCaro and Sarah Spain Take on the Harassment of Female Journalists," *Chicago*, April 26, 2016, https://www.chicagomag.com/city-life/april-2016/morethanmean-julie-dicaro-sarah-spain-mean-tweets-video/ (March 15, 2021).

18. Julie DiCaro, *Sidelined: Sports, Culture, and Being a Woman in America* (New York, Dutton, 2021), 135.

19. Moser, "With #MoreThanMean, Julie DiCaro and Sarah Spain Take on the Harassment of Female Journalists."

20. Christine Brennan, interview with the author, June 4, 2021.

21. Just interview.

22. DiCaro, *Sidelined*, 106.

23. DiCaro, *Sidelined*, 124.

24. Liz Clarke and Will Hobson, "From Dream Job to Nightmare," *Washington Post*, July 16, 2020, https://www.washingtonpost.com/sports/2020/07/16/redskins-sexual-harassment-larry-michael-alex-santos/ (March 15, 2021).

25. Rhiannon Walker, "I Want to Move Forward from This," *Athletic*, July 17, 2020, https://theathletic.com/1934661/2020/07/17/rhiannon-walker-i-want-to-move-forward-from-this/ (March 12, 2021).

26. Walker, "I Want to Move Forward from This."

27. Brittany Ghiroli and Katie Strang, "Five Women Accuse Mickey Callaway of Lewd Behavior: 'He Was Completely Unrelenting,'" *Athletic*, January 2, 2021, https://theathletic.com/2360126/2021/02/01/mickey-callaway-mets-lewd-behavior / (March 15, 2021).

28. Alden Gonzalez, "Mickey Callaway Banned Until at Least End of 2022 Season, Fired by Los Angeles Angels," ESPN, https://www.espn.com/mlb/story/_/id/31516235/mlb-bans-mickey-callaway-least-2023-season-investigation (May 23, 2021).

29. Gina Mizell, interview with the author, April 15, 2021.

30. Kat O'Brien, "I Am Breaking My Silence about the Baseball Player Who Raped Me," *New York Times*, June 20, 2021, https://www.nytimes.com/2021/06/20/opinion/baseball-sexual-abuse-harassment.html?smid=tw-nytimes&smtyp=cur (June 20, 2021).

31. Jordan Horrobin and Jimmy Watkins, "In Defense of Snoop Dogg" with Amie Just of the *Advocate*, *The Young Unprofessionals* [podcast], March 8, 2020, https://www.buzzsprout.com/765434/2954344-in-defense-of-snoop-dogg-with-amie-just-of-the-advocate (March 15, 2021).

CHAPTER 15

1. Marisa Ingemi, interview with the author, September 9, 2020.

2. @Marisa_Ingemi, Twitter.com, July 17, 2021.

3. "The Status of Women in U.S. Media 2019," Women's Media Center, 14, 26, https://womensmediacenter.com/reports/the-status-of-women-in-u-s-media-2019 (May 20, 2021).

4. Richard Lapchick, "Sports Media Remains Overwhelmingly White and Male, Study Finds," ESPN, September 22, 2021, https://www.espn.com/espn/

story/_/id/32254145/sports-media-remains-overwhelmingly-white-male-study
-finds (October 2, 2021).

5. Richard Lapchick, "Sports Media Remains Overwhelmingly White and
Male, Study Finds."

6. Christine Brennan, interview with the author, June 4, 2021.

7. Iliana Limón Romero, interview with the author, May 22, 2021.

8. Penelope Muse Abernathy, "The Expanding News Desert," UNC Huss-
man School of Journalism, https://www.usnewsdeserts.com/reports/expanding
-news-desert/loss-of-local-news/loss-newspapers-readers/ (July 2, 2021).

9. Limón Romero interview.

10. "About AWSM," Association for Women in Sports Media, http://awsmon
line.org/we-are-awsm (June 4, 2021)

11. Limón Romero interview.

12. "Diversity Fellowship and Committee," Associated Press Sports Editors,
https://www.apsportseditors.com/category/diversity-fellowship-committee/
(June 4, 2021).

13. Reina Kempt, "Kempt: I Know We Have Good Men and Women in Blue . . .
but the System Is Still Flawed," *Acadiana Advocate*, June 6, 2020, https://www
.theadvocate.com/acadiana/sports/article_e01d67fa-a833-11ea-b087-5b80984
a12bc.html (June 7, 2021).

14. Reina Kempt, interview with the author, June 6, 2021.

15. Bill Shea, "Sports on TV: Women's Sports Continue Their Ratings Surge
Despite Systemic Inequities," *Athletic*, June 15, 2021, https://theathletic.com/
2653534/2021/06/15/womens-sports-tv-ratings-french-open-euro-2020/ (June 4,
2021).

16. "A Cracking Chat with Trailblazing Aussie Sports Journo, Debbie Spill-
ane," *The Roar*, https://www.theroar.com.au/cricket/video/a-cracking-chat
-with-trailblazing-aussie-sports-journo-debbie-spillane-2-882301/ (May 20, 2021).

17. Lucas Aykroyd, "Facing the Challenges of 2021: Women Sports Journal-
ists Worldwide Speak Out," *Global Sport Matters*, April 9, 2021, https://global
sportmatters.com/business/2021/04/09/womens-sports-journalists-worldwide
-speak-out-stereotypes-opportunities/ (June 16, 2021).

18. Suzanne Franks, "Women Hit the Headlines in Sport: So Why Aren't There
More Writing About It?" *Guardian*, August 18, 2016, https://www.theguardian
.com/media/2016/aug/18/women-sport-rio-olympics-female-sports-journalists
(May 20, 2021).

19. Katie Whyatt, "I Want to Tell the In-depth Stories Women's Football De-
serves," *Athletic*, October 12, 2020, https://theathletic.com/author/katie-whyatt/
(May 20, 2021).

20. Oliver Franklin-Wallis, "Inside the Athletic: The Start-up That Changed
Journalism Forever," *GQ Hype*, March 2, 2020, https://www.gq-magazine.co.uk/
sport/article/the-athletic (June 16, 2021).

21. Gina Mizell, interview with the author, May 5, 2021.

22. Amber Theoharis, interview with the author, May 10, 2021.

23. McManus interview.

24. Ingemi interview.

25. Limón Romero interview.

Selected Readings

The following is an annotated bibliography of selected readings that were helpful and insightful, particularly in the early stages of my research.

Angell, Roger. *Late Innings: A Baseball Companion*. New York: Simon and Schuster, 1982.
 Through exhaustive interviews with both male and female sports journalists, Angell reveals in chapter 7, "Sharing the Beat," the tenor of the times (during which women were still fighting for respect and locker room access).
Brennan, Christine. *Best Seat in the House*. New York: Simon and Schuster, 2006.
 Brennan was part of the second wave of women who broke into sports journalism in the 1980s. Her book provides a firsthand view of what it was like during those years.
Cohn, Linda. *Cohn-Head. A No-Holds-Barred Account of Breaking into the Boys' Club*. Guilford, CT: Lyons Press, 2008.
 This memoir of a broadcasting pioneer reveals in great detail the challenges and personal sacrifices women faced on their way to the highest levels of sportscasting.
DiCaro, Julie. *Sidelined: Sports, Culture, and Being a Woman in America*. New York: Dutton, 2021.
 By weaving elements of her personal narrative into many chapters, DiCaro reveals the misogyny still prevalent in sports culture and makes a persuasive case for the changes that she proposes.
Disch, Lisa, and Mary Jo Kane. "When a Looker Is Really a Bitch: Lisa Olson, Sport, and the Heterosexual Matrix." *Signs: Journal of Women in Culture and Society* 21, no. 2 (1996): 303. https://www.journals.uchicago.edu/doi/abs/10.1086/495067?journalCode=signs.
 This scholarly article breaks down the psychological forces at play during the New England Patriots' sexual harassment of a female reporter in 1990.

Fornoff, Susan. *Lady in the Locker Room. Adventures of a Trailblazing Sports Journalist.* Oakland: GottaGoGolf, 2014.

Originally published in 1993, Fornoff's memoir is a lively narrative, full of anecdotes that bring to life the times during which she covered baseball, particularly in Oakland, California.

Freeman, Michael. *ESPN: The Uncensored History.* New York: Taylor Trade, 2001.

This no-holds-barred look at the early days of ESPN documents the harassment that women faced, particularly behind the scenes of the fledgling cable station.

Gentry, Diane K. "Mary Garber." Oral History Project, Women in Journalism. Washington Press Club Foundation, 1990. http://www.wpcf.org/mary -garber/.

This two-part oral history is an interview with Mary Garber, who provides an entertaining and enlightening recap of her career. Facts and quotes used in this book come from the transcript.

Hardin, Marie, and Erin Whiteside. "Token Responses to Gendered Newsrooms: Factors in the Career-Related Decisions of Female Newspaper Sports Journalists." *Journalism* 10, no. 5 (October 2009): 627–46. https://journals.sagepub .com/doi/10.1177/14648849090100050501.

This paper reports on research that followed ten women over a five-year period and discusses the reasons many of them decided to leave their sports journalism careers.

Huckshorn, Kristin. "Female Sportswriter Finally Rocks the Boat." In *A Kind of Grace: A Treasury of Sportswriting by Women,* edited by Ron Rapoport. Berkeley, CA: Zenobia, 1994.

Huckshorn's essay, which first appeared as a newspaper column, became part of this collection of writing by the women who were covering sports in the 1990s.

Kaszuba, David. "They Are Women, Hear Them Roar: Female Sportswriters of the Roaring Twenties." PhD diss. Pennsylvania State University Graduate School, College of Communications, December 2003. 47–103. https://etda .libraries.psu.edu/catalog/6174.

This well-researched, fascinating dissertation explores the careers of some of the women who broke barriers to write about sports in the early twentieth century.

Nelson, Mariah Burton. *The Stronger Women Get, the More Men Love Football.* New York: Avon, 1994.

Nelson relies on research and interviews to make the case that sports was the last bastion for men wanting to hold onto power in the wake of the women's movement.

Roberts, Robin. *From the Heart: Eight Rules to Live By.* New York: Hyperion, 2008.

In the first of Roberts's two memoirs, she writes about her time as a sportscaster and shows why she is one of the pioneers of women in sports broadcasting.

Shah, Diane K. *A Farewell to Arms, Legs, and Jockstraps: A Sportswriter's Memoir.* Bloomington, IN: Red Lightning Books, 2020.

This first-person account of Shah's life as a journalist includes excerpts from some of her columns. They are revealing and entertaining, as are her stories about run-ins with such baseball stars as Mickey Mantle and Reggie Jackson.

Stern, Ricki, and Annie Sundberg. "Let Them Wear Towels." *Nine for IX*. ESPN Films, November 7, 2013. https: / /www.imdb.com /title /tt2979800 /?ref_=fn_ al_tt_2.

This fifty-one-minute documentary explores the issue of locker room access through the recollections of such early pioneers as Melissa Ludtke, Betty Cuniberti, Jane Gross, Claire Smith, and Joan Ryan.

Visser, Lesley. *Sometimes You Have to Cross When It Says Don't Walk: A Memoir of Breaking Barriers*. Dallas: BenBella Books, 2017.

Visser's memoir is full of details about what it was like to be among the first woman sportswriters and broadcasters in the modern era.

Index

About the Author

Joanne Lannin wrote for the *Portland Press Herald/Maine Sunday Telegram* in Portland, Maine, for twenty-two years. She was the first female sports reporter at the *Press Herald*. This is Joanne's fourth book about women and sports. The most recent was *Finding a Way to Play: The Pioneering Spirit of Women in Basketball*. Joanne is a retired English and journalism teacher and she still plays basketball in an over-fifty league. She lives in the Portland, Maine, area with her husband, Rik, and their two rescue pups.